D1367245

life.

love.

beauty

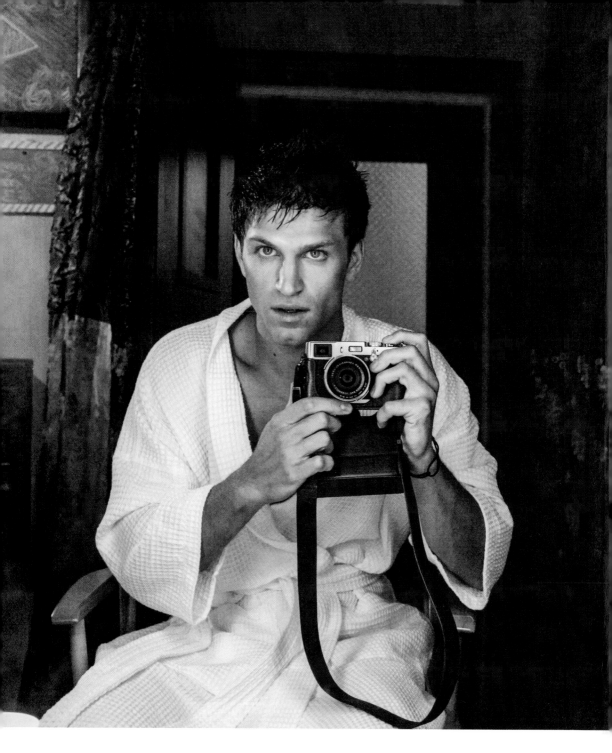

life.
love.
beauty

KEEGAN ALLEN

ST. MARTIN'S PRESS ≈ NEW YORK

www.stmartins.com

Designed by Steven Seighman

 Library of Congress Cataloging-in-Publication Data
Allen, Keegan.
 life.love.beauty / Keegan Allen.
 pages cm
 ISBN 978-1-250-06570-4 (hardcover)
 ISBN 978-1-4668-7712-2 (e-book)
 1. Portrait photography—California—Hollywood. 2. Hollywood (Calif.)—
Pictorial works. 3. Allen, Keegan, 1989– I. Title.
 TR680.A47 2015
 770.92—dc23
 2014033614

St. Martin's Press books may be purchased for educational, business, or promotional use. For information on bulk purchases, please contact the Macmillan Corporate and Premium Sales Department at 1-800-221-7945, extension 5442, or write to specialmarkets@macmillan.com.

First Edition: February 2015
10 9 8 7 6 5 4 3

For my Mom and Dad,

*You gave me the world to play in
and my lens to capture it. . . .*

*Love,
Keegan*

Acknowledgments

I would like to acknowledge:

My mother and my father, Joan and Phillip. Without my mother constantly at my side, supporting my every artistic thought and whim, I would not have been able to create this art book. I love you, Mom. Thank you. My father gave me tremendous love and support and the tools and emotions to collect these images. Thank you, Dad. I love you and miss you every day.

My book agent, Todd Shuster of Zachary Shuster Harmsworth. Todd believed in this book and my photography from the beginning.

George Witte, Sara Thwaite, Steve Snider, Steven Seighman, David Lott, Vincent Stanley, Joanie Martinez, Nick Small, Laura Clark, and everyone on my team at St. Martin's Press for your energy and focus bringing this book to life and shaping it into something special.

Jeffrey Craig Miller of Miller Korzenik Sommers LLP.

Nanci Ryder and my entire team at BWR.

My entire APA team, led by Jeff Witjas, Tyler Grasham, Barry McPherson, and Paul Santana . . . your commitment to my work is respected.

Thank you to the mother of my career, Marlene King, her partner Shari Rosenthal, and their beautiful children, Emerson and Atticus. Thank you to Lisa Cochran, Oliver Goldstick, Joseph Dougherty, Leslie Morgenstein, Bob Levy, Gayle Pillsbury, and Bonnie Zane (who I auditioned for

in a hat for the role of Toby), Josh Bank, Peter Roth, and my dear friends and colleagues Troian Bellisario, Ashley Benson, Lucy Hale, and Shay Mitchell. Supporting each of you is an honor.

Thank you to Ian Harding, Tyler Blackburn, Janel Parrish, Sasha Pieterse, Nolan North, Drew Van Acker, Julian Morris, Norman Buckley, Ron Lagomarsino, Chad Lowe, Lesli Glatter, Bryan Holdman, Maya Goldsmith, Hynndie Wali, Jonell Lennon, Kyle Bown, and everyone else in my ABC Family/Warner Bros. family.

Thank you to my attorney, Karl Austin, and the entire legal team at JTWAMM.

To Mike Rose and Debbi Fields for sharing your supportive love and family in so many magnificent ways. Thank you so much; I love you.

Thank you, B., for taking your time with me and helping me grow in photography, art, and the love of the subtle imperfections that make life beautiful. Without you, I would not have come to New York. Thank you from the deepest part of my heart, for everything you taught me while igniting my relentless inspiration. I cherish it and I love you.

Thank you to Eric Farnell for always being an outstanding friend and helping me shoot last-minute insane adventures.

Thank you, Keith Calkins, for always helping me create, write, and chase my art.

Thank you, Lindsey Mejia, for helping go through the monstrous pile of film negatives and scanning them while moving mountains to get it done in time. Tibor, thank you for always being a great Leica friend over the years.

Thank you, Liz Goldwyn, Gia Coppola, Jacqui Getty, Lana Del Rey, Emmy Rossum, and James Franco, for fueling my art and including my camera and me on so many projects.

Special thank you to Rainey Qualley, Remington Nelson, Adam Secore, Zelda Williams, Sophie Hart, Diego Boneta, Brett Dier, Barbara and Lloyd Thaxton, and Erik and Nanette Estrada.

Thank you to my Leica family: Samy's Camera, Icon Photo Lab, and Color Resource Center NYC.

Thank you to John Pollono, James Badge Dale and James Ransone, Bernie Telsey, Will Cantler, Bob Lupone, Jessica Chase, Megan Ringeling, and my MCC family.

Thank you to the Chateau Marmont, André Balazs, and Alessandra Balazs.

Thank you to my manager/mentor, Konrad Leh at Creative Talent Group, who takes my art and ideas and brings them to life in my career each day with honesty and integrity.

Finally, I thank God and all of the people that appreciate my art in its different forms.

Preface

Thank you all so much for joining me on this photographic journey. Some of you know me from the ABC Family series *Pretty Little Liars* and may be familiar with my work as an actor. Long before I ever began my theatrical training, I fell in love with photography, sharing my life and love through my camera lens. Working in Hollywood has given me the freedom to photograph many candid, behind-the-scenes moments from that world. I have also captured a myriad of my passions, including nature, architecture, theater, filmmaking, traveling, portraiture, family, and some fans, and this book takes you through a photographic voyage of my life so far. I have included stories, poems, random observations, and musings with many of these images and also indicated the technical details of the camera and film I've used to create them. I hope you enjoy *life.love.beauty* as much as I did living and capturing it.

At a very early age, I became obsessed with cameras. I shot this image with the help of my father out of our dining room window. It is my first memory of using a camera: Los Angeles burning in the 1992 riots; a cacophony of yelling and crackles at all hours. The smell of tear gas would burst in and out of the windows and everywhere was the *middle of the fray*. I remember the concerned looks on my parents' faces as we watched live coverage on the news and locked our doors and windows. Sublime later put out an anthem to the moment, the song "April 29, 1992 (Miami)." I was too young to realize the danger, but I remember it vividly because it was the first time I had a burning need to capture a moment on film.

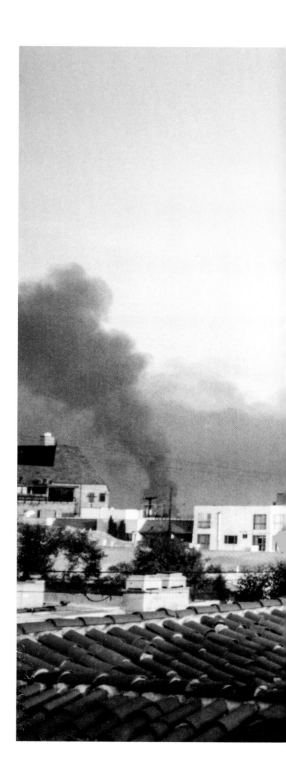

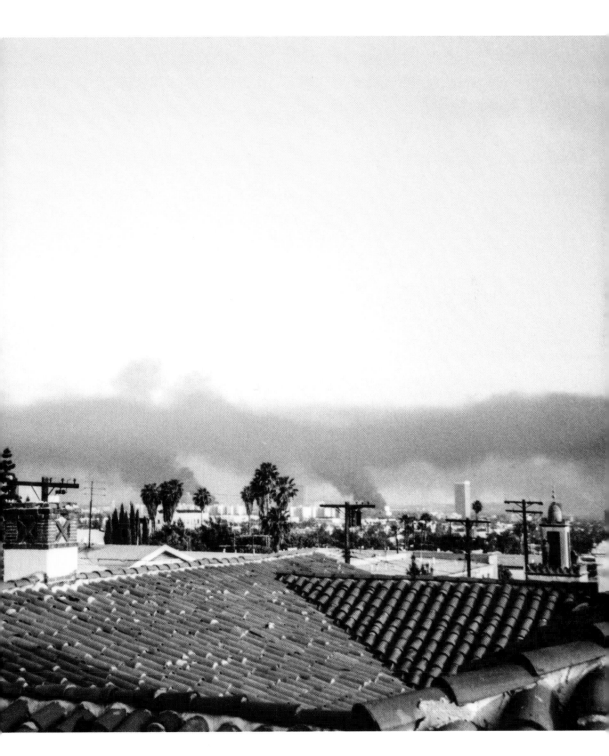

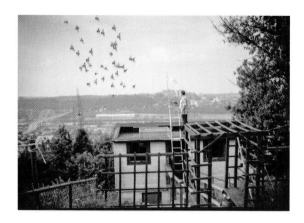

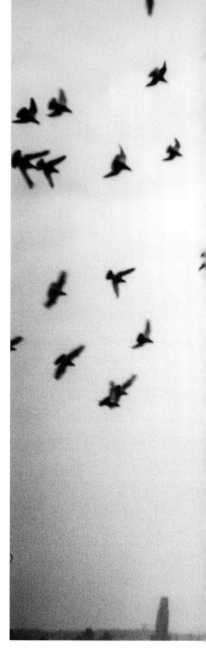

During the final days of being a nine-year-old, I gave in to the overwhelming desire to start capturing my life as I saw it.

This is the first photo I shot on my dad's camera *all by myself.*

I remember thinking up a composition and waiting for a long time while our neighbor took all of his pigeons out one by one and started to exercise them. He pulled out his white flag, but not to surrender . . . it was to train them for racing at dusk after a heat-wave summer day in Pittsburgh.

Tons of fireflies were out, hovering around, landing on my hands and on the camera lens, throwing off the light meter, and drawing my attention to them. It had been such a humid day and I was soaked from head to toe, as I would take a quick cold shower with all my clothes on and then go back outside to keep from overheating. I had wiped the lens with my wet shirt, which gave the final image a soft effect. All of these elements compose what you see. It was so many years ago, yet so vivid in my mind.

I was turning ten years old in two days and I had been begging my dad for this camera. It was a miracle when he let me "borrow" it to use that afternoon and he just . . . never asked for it back again. He would smile and watch me fiddle with the settings and dials to get the right exposures. I wouldn't shoot a lot since film was expensive to buy and process, but I always had a camera with me from that point on. I would have it in my backpack when I went to school or around my neck at home. I think he was proud that he had turned me into a shutterbug.

When he took a photo, he always made it a big deal, as the moment would soon be gone and all that would be left was our interpretation and composition mixed with our influence on the subject or lack thereof.

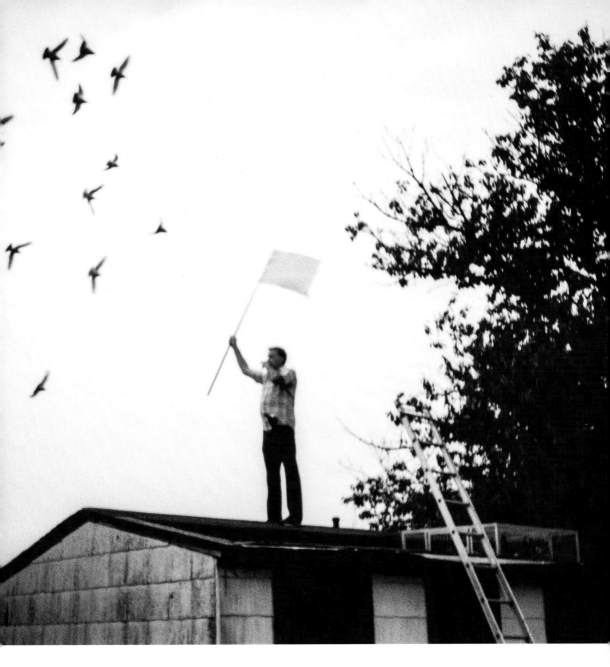

I wasn't good at taking photos for fine-art purposes; I was more interested in capturing these moments. It occurred to me that *so many moments* were on the horizon in my life, and this camera was a miniature time machine, allowing myself and anyone else to step inside the image and interpret whatever world we saw. I started experimenting and collecting different cameras and different films but always kept my focus on sharing my experiences with whoever wanted to take a look at my life.

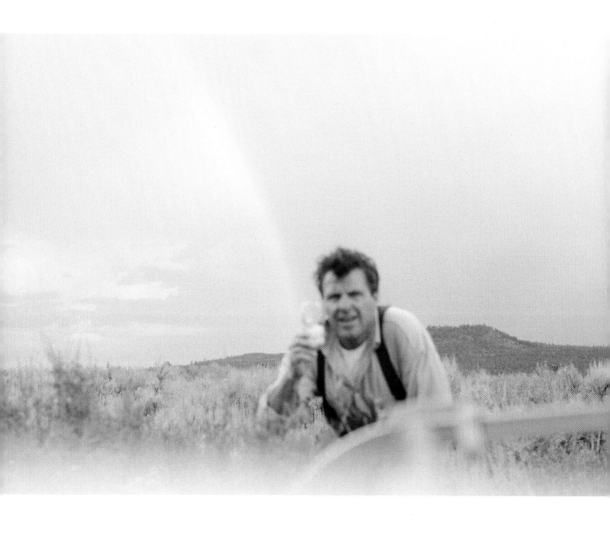

I was eleven years old when I took this image of my father. He had taken pictures of me throughout my life at this very location—but now, armed with his camera and a new ambition for capturing moments, I posed him under a rainbow going into his cup. I feel like a part of me is still with my father in those fields today. It is in memories like this that his connection with me is most alive. Dad, I still miss you each day.

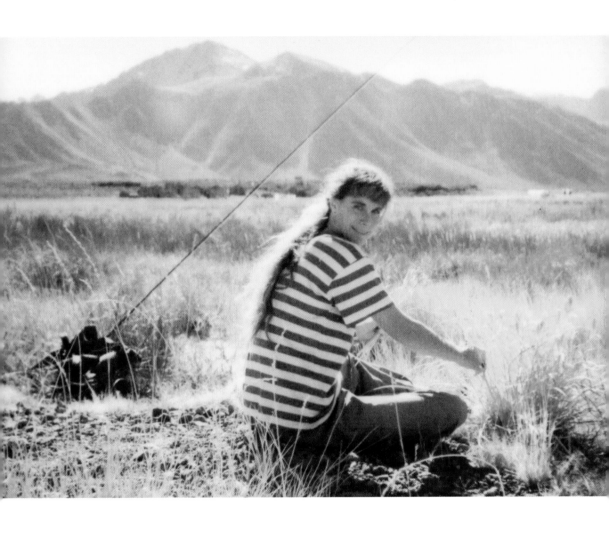

If it weren't for this artist gathering flowers, I would not be writing this now. My mother has filled my life with love and art since I was born. My father reading screenplays, my mother painting, and Bob Dylan playing throughout the house was the artist fuel she raised me on. Everything in life is beautiful to my mother; every moment of life is love and beauty. She is a huge inspiration for this book.

I carried a Polaroid camera with me everywhere I could—it was my instant gratification, a means of seeing exactly what I got, when I wanted. In the art deco walk-ups there's always a "don't-look-down voice" in the back of your head as a kid—but I poured the camera over the side and clicked the shutter.

This is Scooby—my pup I had growing up. She was my best friend and my childhood. I cried when I first got her because I was afraid she would be squished, she was so small. She would dig holes and tumble through ivy. This was her favorite spot. Losing her was very hard—losing your best friend, who knows all your secrets, is there to sit beside you when you're sad, and there to play when you're happy. The night before she died she came to my bed as if to let me know it was the last time we would see each other. I picked her up just like she was my new pup and held her. I turned on the radio and Simon and Garfunkel's "Old Friends/Bookends" came on. In the morning she wasn't there. She is buried here, and I visit my old friend often.

This was a haunted house on my block growing up. No one wanted to go near it. The story was that if you went up to it at night and watched the windows long enough, a little ghost girl named Mabel would open the shades and watch you until you left and then follow you home and stand at the foot of your bed and wake you up by tickling your toes. Now I have passed the story on to you. Enjoy the repercussions. (This could be a perfect place to do the Three Kings ritual.)

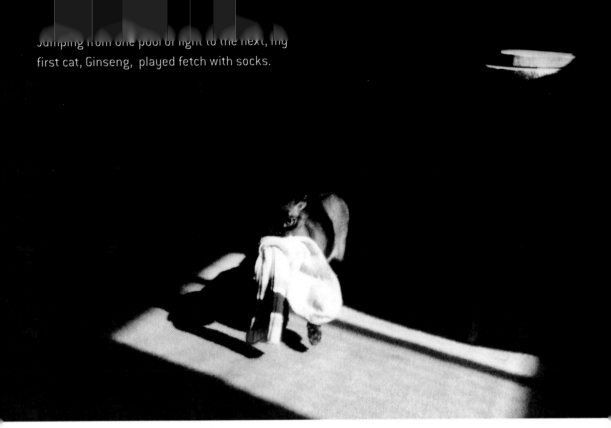

Jumping from one pool of light to the next, my first cat, Ginseng, played fetch with socks.

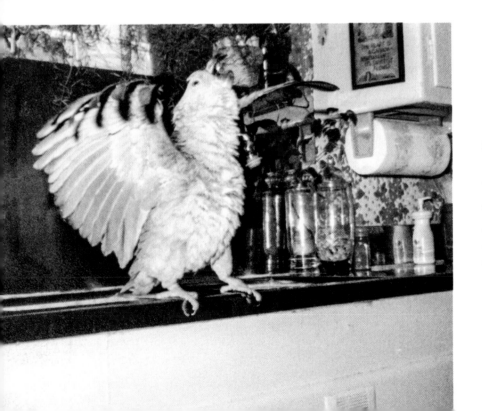

Godfrey

The bird I grew up with, a yellow-naped Amazon parrot, was a free-roaming animal. This is her in our kitchen singing a Van Morrison song.

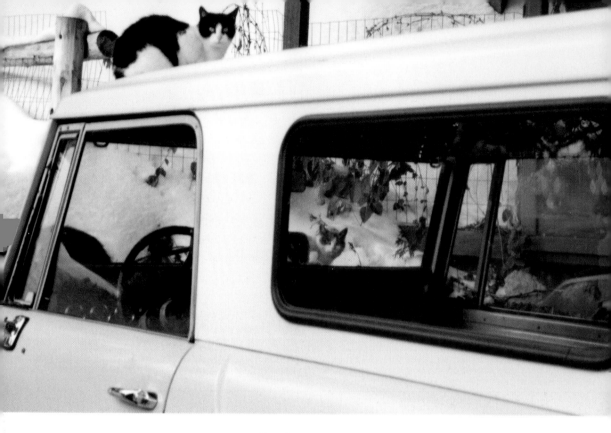

Cat Car House

The last bastion of hope: I would leave my parents' house on an errand or for leisure and walk by our neighbor's vintage Jeep Scout, usually spotting a family of cats that lived in and around it. I liked to believe that they were not all from the same mother but that they had banded together, as the lonely often do, to brave the cold winter. To experience independence away from the dreaded human environment and survive with moxie while upholding a fundamental nature—that all cats simply need no one. Maybe the feline posse would take turns getting food and then share it or hoard it in the wheel well. Maybe they had a secret language, like teenagers communicating above the frequency of adults. Perhaps many others around the territory feared the gang they had become and the fact that they didn't answer to a higher power. Another guess was that they were strays that would wait for the car to park with its engine still hot, digging themselves in at night, emerging during the day to warm their fur in the sun and discuss with judgmental eyes who the weakest link was. As I approached them they didn't seem concerned until I pulled out my camera, with its silent snap of the shutter opening and closing at 1/250 of a second. They all collectively tensed up and eyes widened, pupils dilated. Backs arched and with a graceful and premeditative spring in their hind legs, the troops scattered into the labyrinth of snow and trees. Never seen again, until now. The power of film.

Underwater Baggie

In the stream where I went fishing every summer, the fish were not always biting; they were hiding underneath the reeds and darting from riverbank to riverbank like small-business owners. If they weren't feeding, they would lay dormant, floating in the current. I wanted to capture them resting, so I put my camera in a sandwich Baggie to make a temporary waterproof case. I dipped my hand into the ice-cold water and snapped a photo. Since I couldn't review it, I tried again and again and again. I used an entire roll of film. When I finally got it developed, only two shots came out with fish in them. Turns out, I had spooked them with the first dunk and then was taking pictures of an abandoned underwater universe for thirty-five exposures without knowing. This was before the digital age of "chimping," where the photographer checks each photo immediately after it's taken.

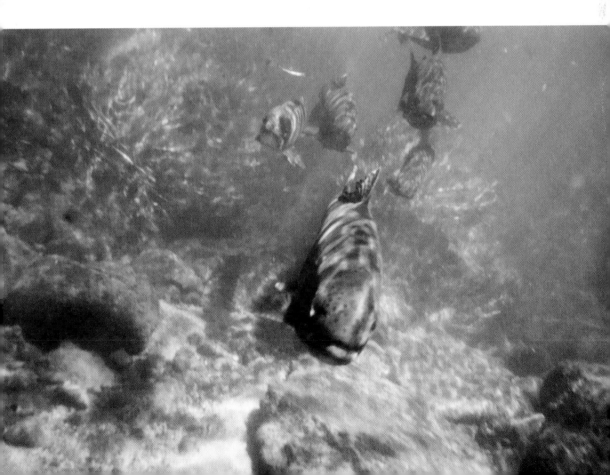

Self-Portrait with My Pet Praying Mantis, E.T.

She was pregnant, so for my middle school science project I accounted for her change in habitual eating and monitored her choice in resting positions before she laid her eggs. Several months went by, and then one hot day, while we were driving up to the fishing ranch, the eggs hatched in the car. In the middle of the desert, hundreds of transparent microscopic praying mantis babies popped out of the egg sack and all over everyone. At the time I also had a pet chicken, frog, turtles, cat, dog, parrot, parakeet, and a pet rat all in their respective travel cages. But my parents were used to my pets and dysfunctional habits and when we got back home I set up the camera, loaded some high-speed film, and captured her eating a fly with me watching . . . for science.

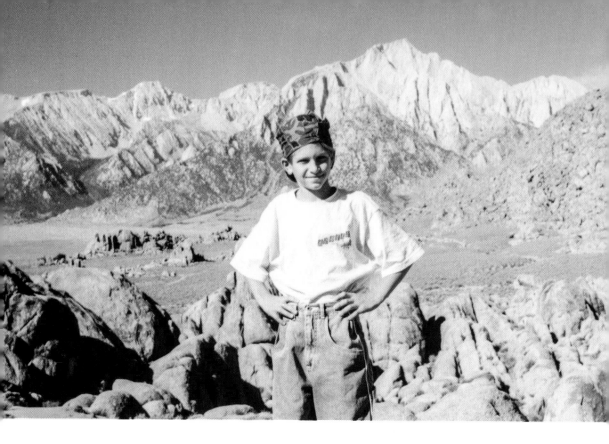

Alabama Hills, California. I went out there alone to take photos of myself to impress a girl in my class. I wasn't too focused on fashion; I was more concerned that my composition was strong. Looking back, it was about as strong as my style game.

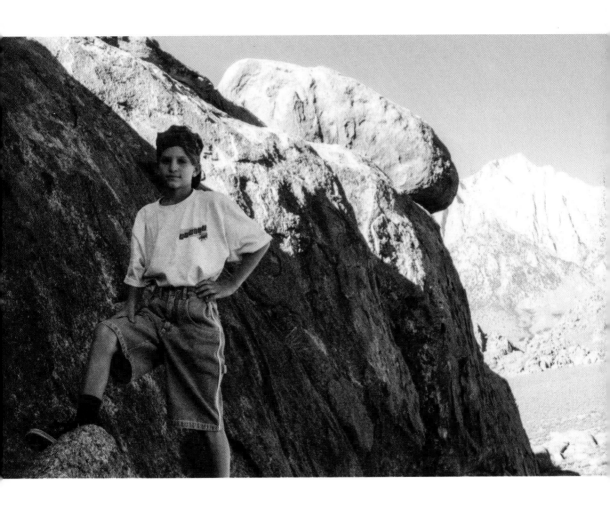

Broken Light Metering: A manual attempt at dynamic range. I had hiked to the base of Mt. Whitney at this point, lugging around my tripod and backpack. I had hoped to see a snake or tiger on the way, but all I had at the end was a hyperbolic story of my "self-portrait composition adventure." The girl liked my photos and story and she was my girlfriend for a whole week. So it turned out to be a great idea.

My final self-portrait was based on becoming the rocks. In between thinking up shots, I was busy finding bugs, writing my name in the sand, and yelling at the top of my lungs to ricochet my voice across the deserted plain. Spiraling my mightiest sounds and being as loud as I wanted out there often later resulted in utter silence and contemplating my navel at home or in school.

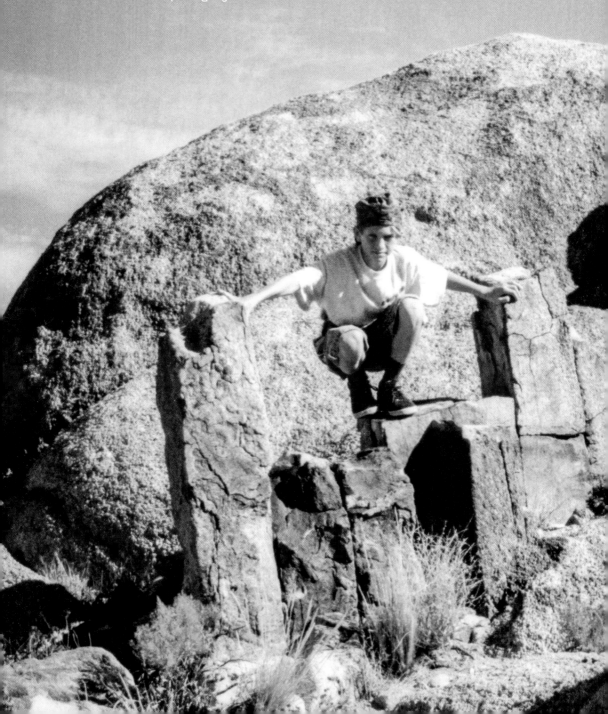

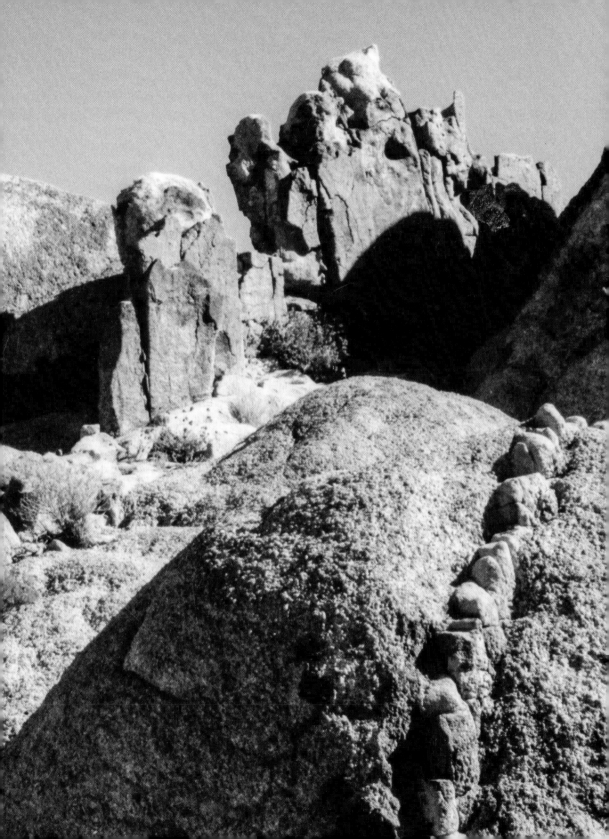

... fishbirds

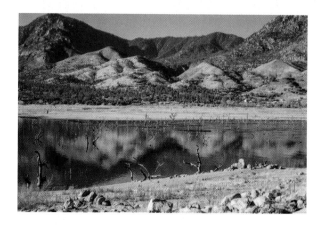

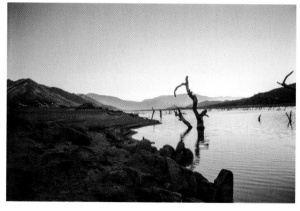

The lake was dangerously low that year and my mom told me it was going to evaporate and turn into a forest filled with "fishbirds." I told her *I didn't believe her* but grabbed my camera, a roll of film (labeled it *fishbirds*), my bike, and a tent . . . just in case. It was eerie seeing the lake get this low, the tips of trees poking out of the water's surface, indicating that there was in fact a whole forest in the murky depths. Wading out into the water with extreme apprehension, I went in to swim and try to touch the bottom, but it was still too deep. My mind went wild and churned my imagination with what this underwater forest was hiding and what these fishbirds looked like.

Racing into town for a milkshake, I quickly rallied all my friends and sounded off that I was going to capture the world's first fishbird on camera, make millions of dollars, and get the cover of *National Geographic*.

We all decided to camp on the shore and keep an eye out for these creatures as we roasted marshmallows and got bitten by mosquitoes. Every few minutes someone would say, "Shhhh . . . listen . . . did you hear that? You think that was them?" Then we'd go back to taking turns telling ghost stories until someone recited "The Man with the Golden Arm" and ended it with a loud scream. After that, everyone freaked out and we all ran home in a pack, screaming and laughing through the night with our flashlights and pieces of our tent, some cameras, half-eaten PBJs, and a thermos of pop. Too scared to return until morning, our parents assured us that there was no way the lake would drain over night and that there was no such thing as a fishbird. A huge rainstorm arrived the next week and the lake returned to normal. The fishbirds remained in hiding.

In a journey across America, most of the time I was too consumed with boredom to take a lot of pictures. This was pre–cell phones and pre-Internet, and I got carsick if I read my books while we were driving. I only brought one roll of film . . . so I had to choose my photos wisely. I took snapshots out of my parents' moving hatchback. It was only us on the road most of the time, with large dark clouds stoic in the background. When I opened the window, the smell of petrichor and the wind burst in with a rhythmic, thumping heat. *The stars hidden behind blue skies.* I was way too young to understand that the joy is in the journey. Are we there yet? We never seem to be.

An entry in my journal:

The snow is frigid and the blood has frozen under my fingernails as I write.
Waiting to get nowhere.
Glittering bundles of light dance to speeds I can't reach while I am awake.
The trail signs lie. We have been this way before.
The doors are shut.
The wind is soft inside with *Rubber Soul* rewinding in the tape deck, yet violent outside
 against the speeding metals breaking through the cascading gusts.
I can hear the rock columns reciting Shakespeare. I know all the parts.
I want to join in. We stop and
I (enter).
All fall silent.
The scenery has become a stage and I erupt and shout! The reverb gives me power. I am
 a king atop an elephant and this tan jungle is mine! I am unstoppable, and they have
 become obsessed.
Yet nothing moves.
These immortal towers of dirt loom with peaceful calm against my echoes for attention.
Am I listening or have the lines been far forgotten?
But now I realize
These grains of sand are now my audience of anonymous listeners forever gazing at me, a
 foreigner that stands among them.
How are they different from the people we will never meet throughout this life? These
 nameless spirits that flow in and out of the background in our stories and our
 memories. The faces blurred and the voices mumbled. And I am a grain of sand to
 someone else, right now. I am nameless and voiceless too. Someone will never know
 we exist(ed).
Drawing a line of separation makes me anxious to leave now.
Is this an existential tragedy?
Are we all terminally ill with this sickness that is humanity?
Is this an eventual result to become these pillars of sand in our expiration even if we live
 here and pretend that this dust and these rocks are our friends?
They will never change, and just like that, the play ends and these new friends fade away
 as well.
I can use this as a metaphor to comfort myself as I grow, or it can use us to explain the
 faults in our attachments.
The rocks have the right idea; staying put from time and changes around them, inanimately
 intimate with their surrounds harboring no emotional bonds.

I can leave them with no longing to return and they can let me go. No tears, just a breeze at my back and muted whistle when I return to the car and shut the door. Never calling me back to visit or checking up on my advancements.

These rocks can let us go because change and time are permanently racing each other towards infinity. Allowing us the freedom to return without judgment, as we are all temporary.

You can be what you want to be

And I can be you

While you are me

as I am you

Perpetually lost

Momentarily found

We are stopping at a fruit stand on the side of the road in the middle of nowhere . . .

Hopefully it will slow my mind down.

note to self

don't count the seeds in strawberries

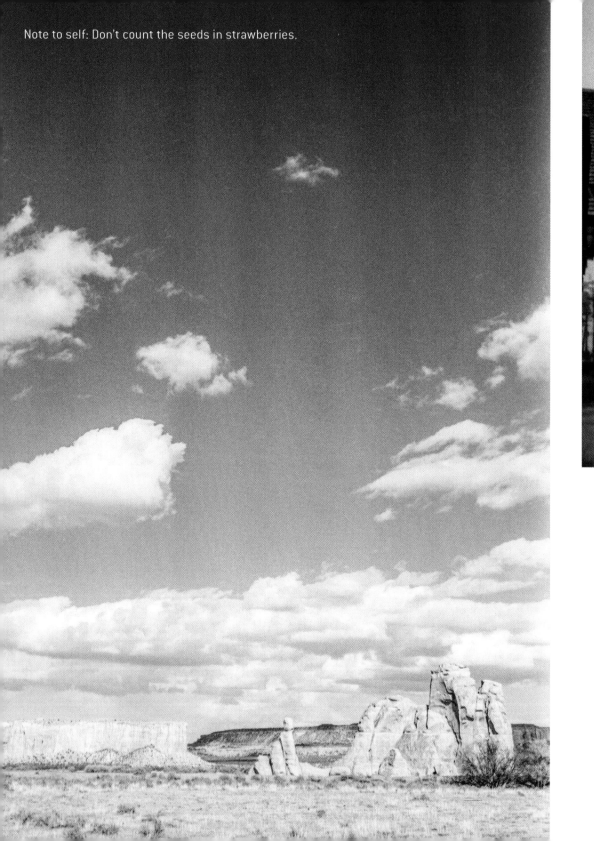

Note to self: Don't count the seeds in strawberries.

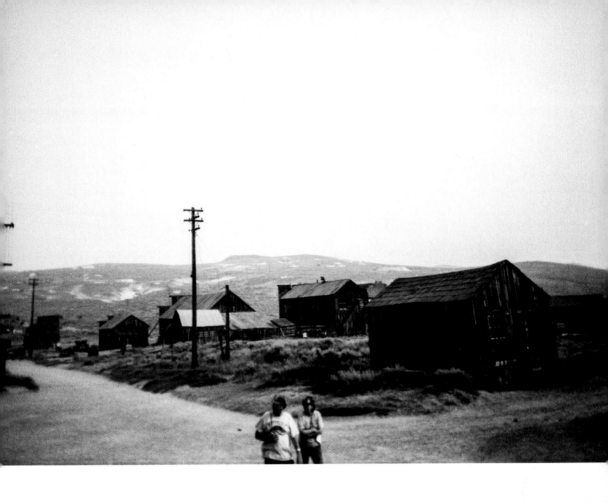

Bodie, California, is a ghost town that was discovered by a man named W. S. Bodey. He froze to death before he could profit on his discovery of gold mines, and the town (8,375 feet high) declined and was abandoned. I loved visiting it every chance I could get. So much went through my head when I explored it. Could it have been a bustling city as big as Los Angeles if the gold hadn't run out? There was a mine you could reach for a while, until it was shut down for being unstable. It was so deep you could throw a penny in and it took a full five seconds before it hit the ground. *That is deep.* The park rangers would replenish my ghost stories and warn me to *never take anything from there.* There is a Bodie curse. So if you visit, leave everything and only take *pictures.*

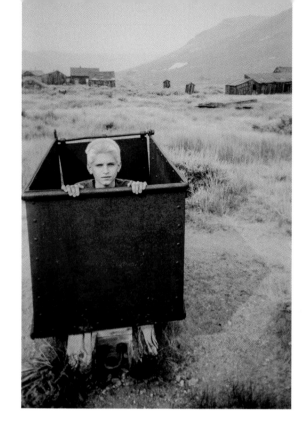

My Bodie self-portrait. I spent a lot of time alone here, listening to the silence of the mountains and waiting for the rangers to kick me out when the park closed. This was an "off-limits" shot. It wasn't that I wanted to be rebellious, but rather just wanted to take a photo of myself some place where no one had taken a self-portrait before.

This was the first time I mixed romance with photography. My first major crush was this girl named Jill. Our parents were on annual summer vacations at the same time every year. She was older than I was and urged me to hike and explore all the undiscovered areas of the land bravely and thoroughly, as there was always the possibility of treasure. While we were on an adventure to find some Native American grinding stones, we went out to this vast field and took pictures. I told her I would keep hers forever. (Told you, Jill.) I liked her so much I threw all her crayons over a barbed-wire fence so she would have to use mine and hang out with me all day. The plan backfired and she cried. Then I cried because I didn't like that I made her cry, so I gave her my crayons. It was the beginning of a wonderful friendship that has continued to this day.

This was the ranch where I spent most of my time learning to fly fish while experiencing everlasting family traditions:

"The Arc" near Mammoth Mountain. My parents would load up their old 1947 Dodge with a picnic basket and fishing rods. The instant camera framed up to my eye showed me what a perfect day looked like as I gently pressed the shutter with an audible pop and mechanical whining ejection. Laying the film in the grass as I saw it develop captivated me with the premonition that I'd be wishing to step inside this picture for many years to come.

We stayed out late and fished under the stars, sometimes believing we saw UFOs. (We would joke that these unknown lights were flying to Area 51.) My father instilled in me an open mind to endless possibilities of what was up there—a celestial accommodation for us to talk about after our crazy fish stories. "The mind is a wonderful thing to space."

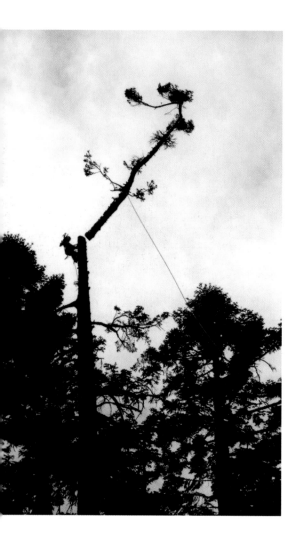

Timber

It is essential to take down a tree that has suffered from mountain pine beetles in order to save whole regions of forest. I took this when I was thirteen years old and got to witness a tree being felled prematurely.

A long moment of loud buzzing and then
the idle
of the saw
to pin-drop silence
as the bass in the air picked up
with the wind crushing beneath the falling
treetop.

It was so alarmingly muted by the canopy, as if I had plugged my ears from a greater disaster, but it still echoed through the mountain and silenced the wildlife for the brevity of an inhale like they were paying their respects before going about their continued survival business.

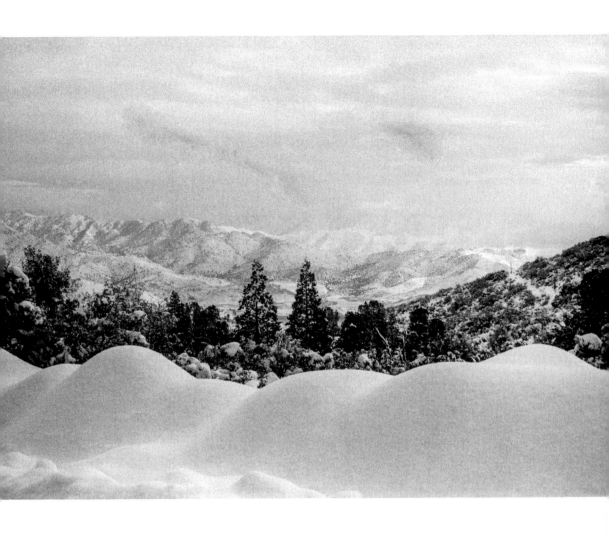

I was Ansel Adams when it snowed at my house. I would grab my camera and tripod and pretend I was in Group f/64. This was an important shot because I believed it would get me into the group. A fresh blanket of snow piled from the mountains behind it. Little did I know that 35mm was dramatically different from a large-format 8x10 or 16x20. But it never hurts to do your best. I believe falling in love with someone else's shooting style is a compliment to them and becomes a lesson for both parties. Ansel had already passed away, but I wonder what notes he would have given a thirteen-year-old out freezing in the snow.

These snow days were the best. If I didn't have to go to school because the roads were closed, we would pile into our Jeep and ride up the mountain to sled with the other kids. The tires on the Jeep had little metal nubs in them so it could drive on the ice and get us safely to the best secret spots for sledding. My mom was a master winter driver and would navigate through blizzards and ice storms in pursuit of the perfect untouched powder hills.

The camera would freeze up if it got too cold and I would have to shove it in my jacket (like thawing a huge metallic ice cube), only to pull it out and snap a picture of Captain Mom. She was the icebreaker.

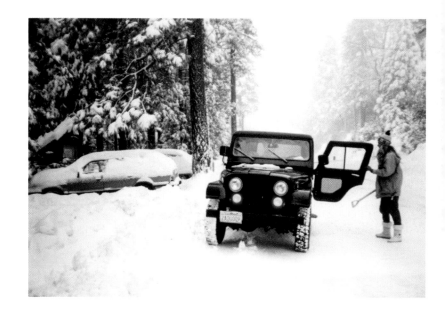

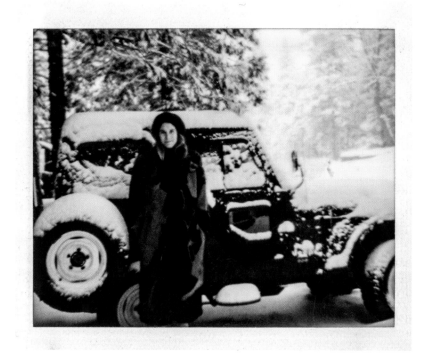

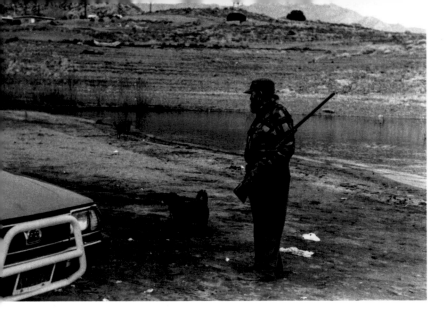

The front of my
dad's car interrupts
a random double-
barreled dog walker;
1998 meets 1898.

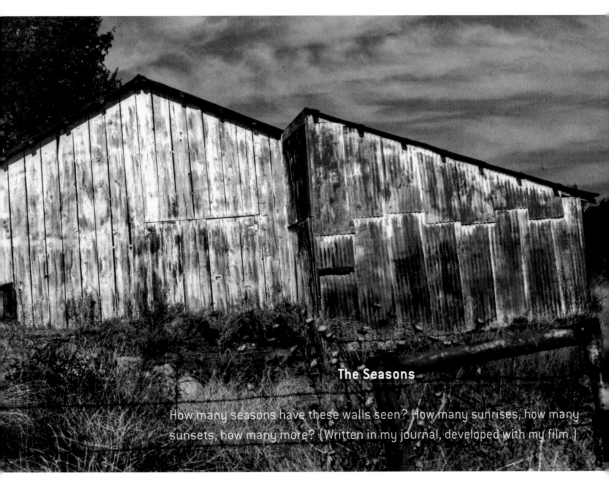

The Seasons

How many seasons have these walls seen? How many sunrises, how many sunsets, how many more? (Written in my journal, developed with my film.)

The train wreck was very loud and impossible to look away from. Nothing could be done once it derailed. The intimacy of danger prompted an inhale that felt so violent I thought for sure my lungs would pop.

Our breath held, achingly long.

The sudden smell of heated rust and disrupted dirt saturated my nostrils.

Screeching metals faded to a halt . . . The sounds transitioned to the distant and awkward hum of James Taylor's "Sweet Baby James" playing on an analog boom box where we were having a picnic moments before. No one was injured, the train only carrying freight. The sheriffs asked me to send them photos for investigation, as I was the only eyewitness with a camera.

This is beauty and disaster.

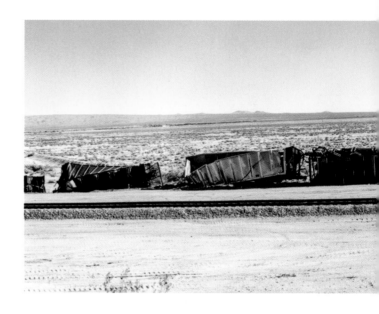

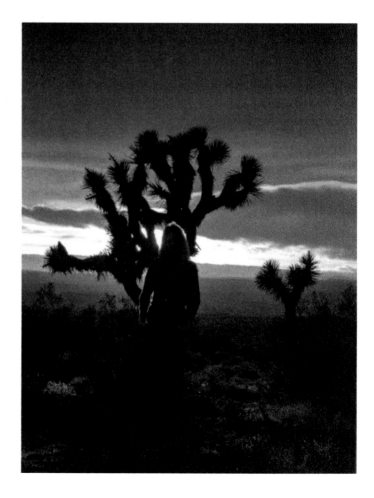

My beautiful mother in the shadows of a Joshua tree during a midsummer dusk. Taking a pit stop in Red Rock Canyon, California, I captured this moment with my Minox Spy camera. She is so stunning and shy as my light meter struggles to find her face silhouetted by a setting sun.

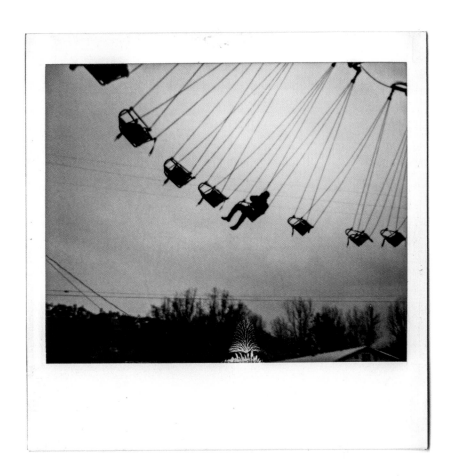

Dad on a carnival ride.

He was a paratrooper in the army, so he was used to more harsh realities but was fearless, heroic, and always went on any Ferris wheel or sky chair I pointed to.

Self-portrait of me selling my Pokémon cards at Venice Beach. I put the camera on a tripod to get the perspective I wanted by yelling back to my dad to click the shutter during certain parts of the day. I sold three cards. XPan 35mm—a panoramic film camera.

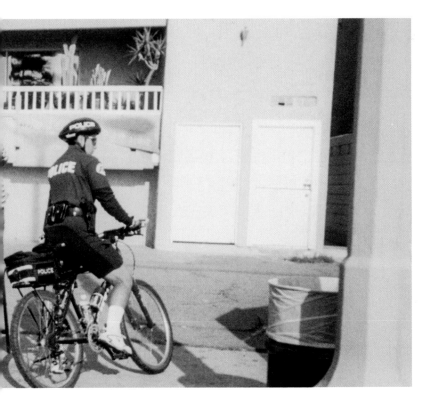

This image shows my vending operation getting shut down by the police. I negotiated a deal with the officer so I would not have to do hard time.

West Hollywood Self-Portrait

Post-parade skateboard bounty.

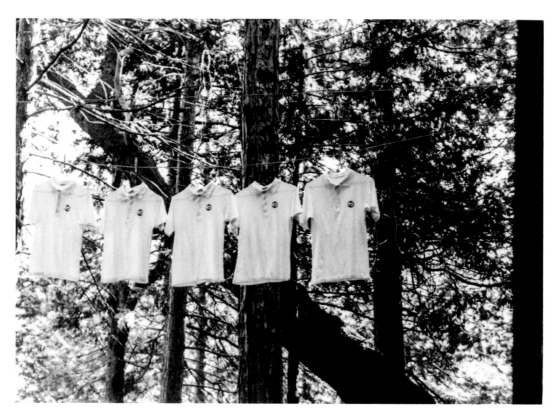

My uniform for middle school hanging out to dry in the middle of the forest.
Polar opposites: rough terrain versus spotless conformity.

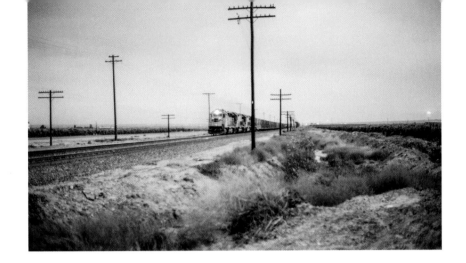

I would ride my bike more than ten miles out to the train to put pennies on the track, bringing a harmonica to pass the time, or a good adventure book. In the distance, the only way to tell if it was a train or the setting sun was the frantic whistle. It flattened the coins and I handed them out to girls I liked in class. I left them on their desks during recess since I was too shy to confront them.

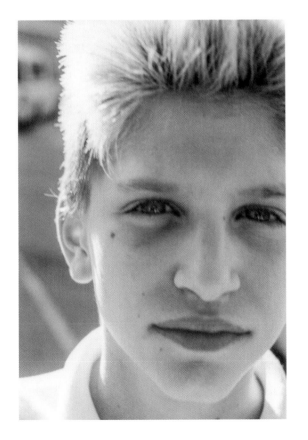

Back when a selfie took a couple of days to review, a bully in class gave me a black eye, so I grabbed a shot of it. I was, and still am, very into Radiohead and I wanted my hair to look like Thom Yorke's. The school made me cut it too short, so I would pour lemon juice on my head and stand in the sun with my headphones blasting. When that didn't work, I asked one of my classmates to bleach my hair at his house with his mom's hair product while we played videogames. We lost track of time and my hair turned out white.

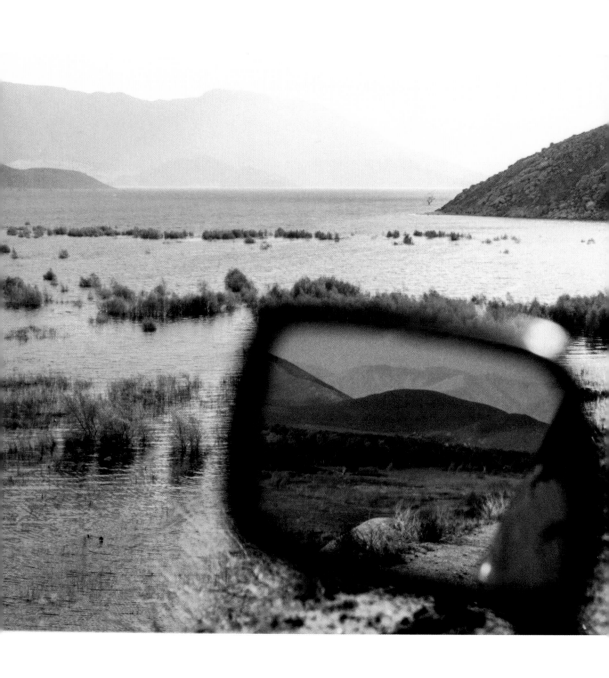

Sometimes I think back on this image I took when I was starting high school to remember that the dramas that consumed my life would soon be forgotten. Or replaced.

Leaving

You took it away
When you left home one summer's day,
 not a wrinkle in your dress
Left my town with no regrets
And you're leaving me again
And I can't stop you
While you're leaving
Because this time feels like the end
The sun comes out at night
There are star trails in the day
The bus stop's just a light
For you to write the words you can't say
because you're
leaving
me
tonight
And you won't turn back because you're
 leaving and whispering "it feels right"

You're here but you're gone
In your mind
You spend the time
On what lies beyond
She sits side by side
Disguised to be a bride
She's clinging to the age

Slit her wrist on the Bible's page
As she fell from the trees
And landed on her knees
In a creative way to scream
In silent misery
She's leaving out of sight
With my friends
In the evening
And sadly, I knew she might

A cup of coffee on the stove
is just sitting there getting cold
Someone let the breeze back in
Count the fire and oil the parts
Hit the bar and throw some darts
At what a waste we've been
Because
We're leaving this all
And the tears stream
Down our windowpanes
But we'll be back in the fall
You sit on the road
And listen to our song
While you're leaving
Yeah, you're leaving?
I'm gone

WHEN THINGS WORK OUT you'll SEE WHAT'S RIGHT AND GO ALONG
but WHAT'S RIGHT FOR YOU - OTHERS SEE ONLY WRONG
THEY TANGLE YOUR MIND IN A WEB OF PAIN
ONLY BECAUSE THEY KEEP LOSING AT THEIR OWN GAME
THEY BRING YOU DOWN BEFORE THEY FALL
THEY PUNCH YOU IN THE GUT WHEN YOU STAND UP TALL
THEY MAKE YOU FEEL LIKE YOU'RE MISSING OUT
WHEN NOTHING IS HAPPENING AT ALL

THEY PUT YOU DOWN BEHIND YOUR BACK
WHEN YOU'RE FREEZING COLD - THEY GIVE YOU AN ICE PACK
THEY SABOTAGE YOUR MIND CHILD THAT ONLY WANTS TO PLAY
THEY GRIT THEIR TEETH under THEIR FALSE SMILE AT EVERY WORD YOU SAY
YOU'RE JUST NOT GOOD enough to ever BE ON THEIR TEAM
BECAUSE EVERY PASSERBY SEES THEM living IN A DREAM
WHEN OTHERS SPEAK OF HOW YOU COULD WIN A PRIZE tOGETHER
ALL THEY DO IS KICK AND SCREAM

THE liberating FACTOR IS TO KNOW THAT YOU ARE TRUE
REAL AS THE DIRT IN YOUR NAILS, OR tIES THAT HOLD your SHOES
JEAlousy IS ENVY IS TERRIBLE AND WEAK
AND FOR those WHO LET IT CONTROL THEIR PERSON - the future looks mighty bleak
THEY PROMISE THEY WILL FIX THEMSELVES; THEY PROMISE YOU A CHANGE
BUT THE FRONT ONLY LASTS A WHILE AND IT FEELS APOCRYPHAL AND STRANGE
THEY WILL NEVER BE WHAT YOU WANT - THEY JUST REARRANGE THEIR BACKBITING
TILL THEY HAVE YOU FOOLED ONCE AGAIN blindfolded in their firing range with you in
PLAIN SIGHTING

THE ALLURE IS WHAT CALLS YOU BACK to SEE if it is WHAT YOU WANT
BUT BEHIND the foggy MIRRORS, EVERYTHING looks THE SAME AND ALL IS NONCHALANT
SO SMEAR your handprint, SEE THE TRUTH AND REALIZE YOUR PAST
TURN BACK AND MAKE A JUMP BECAUSE THIS SHIP IS LEAVING FAST
SAIL to new places AND LEARN ABOUT YOURSELF
WHEN PEOPLE TREAT YOU like garbage AND you WERE ALWAYS topshelf
SIT IN A GAZE AND STARE STRAIGHT INTO YOUR EYES
LET DOWN YOUR GUARD to YOURSELF GET READY FOR A SURPRISE
BEHIND YOUR STRONG disguise
ALL THE WHO WHAT WHERE WHEN'S AND WHYS
FROM FARMER JOHN, to INTERNATIONAL SPIES
ALL THE PLANS YOU DEVISE
THE LIVES YOU VANDALIZE
THOUGHTS YOU CRITICIZE
BANK notes YOU legalize
every TIME YOU'VE SAID HELLO after saying many goodbyes

THAT IS WHAT YOU'RE MISSING
THE LINE goes tight after YEARS OF FISHING
IT'S FINALLY HERE, YOU'LL NEVER LET GO
AS MUCH AS YOU try to FIGHT IT - it PULLS YOU ever SO SLOW
TILL YOU'RE RIGHT WHERE YOU HAVE ASKED to BE
YOUR SHACKLES TAKEN OFF ALLOWED to RUN FREE
BUT DO YOU RUN back to the DARKNESS because it looks bright from far away
DO YOU JUST STAND THERE SOBBING like A DOG lost OR A CAT gone ASTRAY
DO YOU RUN AIMLESSLY INTO the ARMS OF THE NEXT PERSON YOU MEET
WOULD YOU BE FINE WITH KEEPING distance AND FEELING INCOMPLETE

OR WOULD YOU JUST lISTEN to YOUR HEART AND TRUST IN YOUR FATE
HOW EARLY IS TOO SOON AND HOW LONG IS too late?
REALIZING THAT NOTHING IS PERFECT BUT IT SHOULDN'T BE SO HARD
WE LEARN to NOT GET CUT again WHERE OUR WOUNDS ARE HEALED
OR SCARRED
BUT SOMETIMES THE WORLD does FUNNY THINGS
IT OPENS THE CLOUDS, SHINES LIGHT AND IT BRINGS
YOU KEEP ASKING FOR IT TO BE REAL THE BIRDS AND BEES SING
YOU KEEP WANTING to PROVE IT WRONG AND JUST THEN the PHONE RINGS
HERE IT IS - YOUR chance to DRINK FROM THE KING'S CUP
IT'S DESTINY CALLING . . . are you ready to pick it up . . .

 life.

 - K.A.

life.

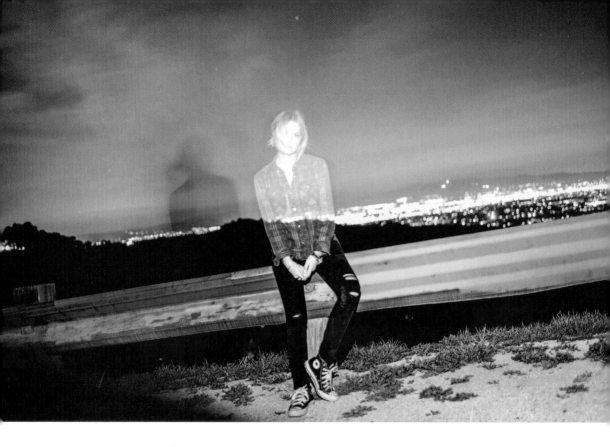

Sometimes after a long day of shooting *Pretty Little Liars* at Warner Bros., I love to go
driving and snap interesting pictures. Mulholland Drive is a well-known spot to go to
when you first get your license. It overlooks the Valley and Hollywood, an amber glow
that envelops the light into a cloud. When you make your way up the classic twisty road
and reach the summit, it feels like the 1950s carved your name in the dirt and dropped
you out of the Internet generation, mostly because there is limited wireless service at
the top. The timeless fragrance of the foliage lining the hills hasn't changed since I first
went up there when I was seven years old. The Valley ignites after dusk, creating an
awesome glittering backdrop for photographs. The night I took this picture, I had gone
up there with my friend Ashley Benson to shoot long-exposure flash. But we only got
one shot before the coyotes came out and we had to retreat into our cars. It feels as
though a little bit of your soul is always kept up there and you can revisit it anytime
you're looking for yourself.

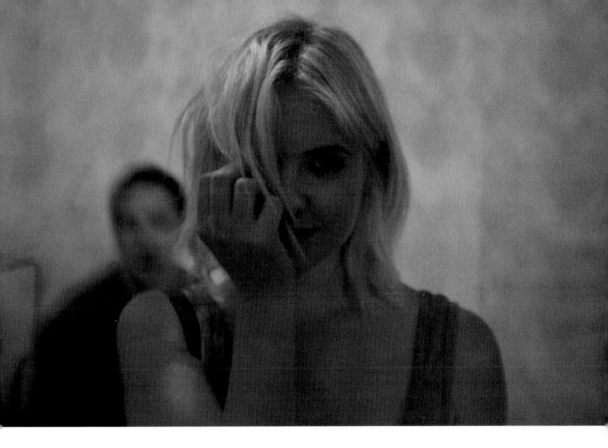

When I first met Ashley, she was very standoffish to me for about a year. We didn't even hang out off set until one day we chatted for a couple minutes and found we had so many common interests. We became fast close friends. That shy girl had transformed into my constant photographic companion. When I think about how much one job has changed my life, I am stunned and humbled by the huge amount of change I have experienced due to friends like Ashley. This is her at the Chateau Marmont.

There are nights we retreated to grab a bowl of french fries and run through the haunted halls until the a.m. It is a home away from home. To give you some background, the infamous Chateau Marmont has lived for generations off the Sunset Strip near where I grew up. As a child I played in its halls with no concern for who might be walking by me or sitting in the lounge. A surreal Hollywood hot spot, and the wee hours see many thirsty, interesting characters weaving their tales over dimly lit tables.

Sometimes I look into an image and just want to steal the thought of the subject. I still can't tell from this shot if she is approving, concerned, or inquisitive. I love that in life we can't always read people, even ones we know so well.

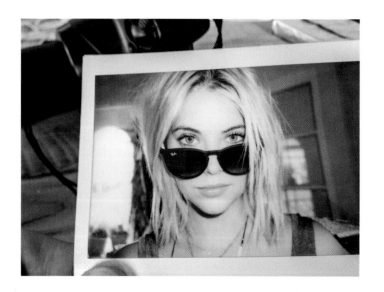

I call this "picture of a picture." Polaroids are the original analog picture-sharing application—an instant gratification now extinct in our digital age. Fashion has once again outlived technology, apparent in Ashley's Wayfarers.

This photo of Ashley is a living example of how we are really a work family. The baby is our coworker's newborn, Emma. I look at this picture and see how pop culture, from Ashley's hat to her fingernails, has so deeply crept into all of our lives. The baby has no idea what a wonderful ride is in her future.

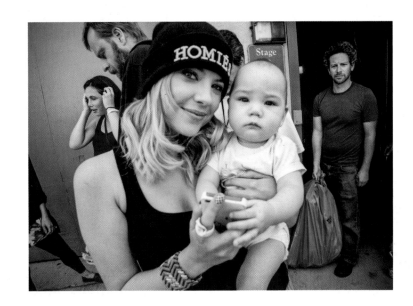

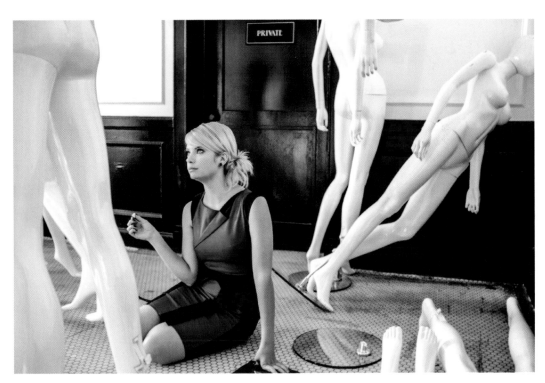

Modern get-together . . . Ashley surrounded by the immortal.

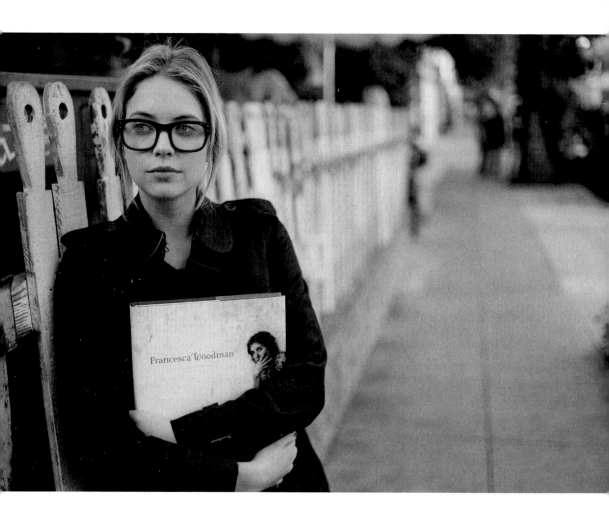

Just a kid on her way to class. Ashley and I both obsess over Francesca Woodman's work. We brought an art book of hers to lunch. Just another day in our life.

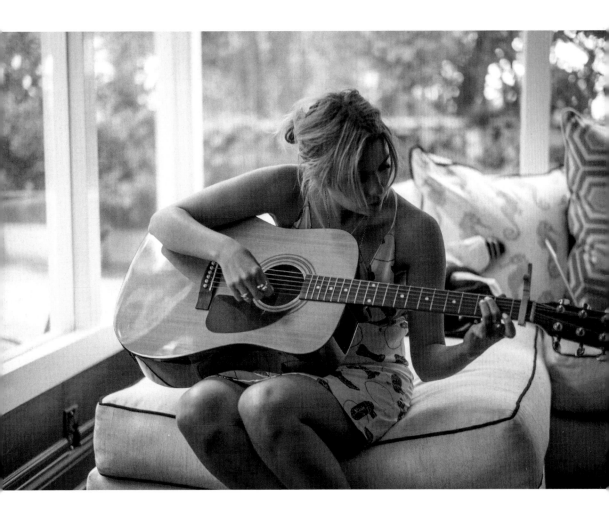

Ashley in her living room retreat. We share new music with each other.

Fireside

There's a look in your eyes like a fireside
As you let your guard back down
And I'll hold it in because once we begin
We'll both need to leave town

So hold back till you know
We can let it all go
Though one of us is going down
I hope it won't be you
That falls right through
As I see the floor opening up

So I fall
Fall
Down to my death
Punished by my love
And cigarettes
And I fall
Fall
Losing you all
But it's a love that keeps me alive

The feeling that you hide
I catch you by surprise
I know you catch me too
It's as permanent as smoke
It's our silly little joke
But I could be a love lost with you

So creep into my dreams
And make it all seem
Like I alone want to fall
And pin me with your hips
Up against the wall
And shut me up with your lips

So I fall

Fall down to my death
Banished by your words and my sweet
 regrets
And I fall
Fall I am losing you all
But it's the love that keeps her alive

We are coming home
And waiting all alone
To sit all night
By your fireside

So I fall
Fall down to my death
Holding on to lies and wasted breath
And I fall
Fall I am losing you all
But it's a love that keeps this alive

So as the train of thought
Comes around the bend
As we both near the end
And just with your eyes
Like a fire at my side
You kiss me once again

————

I'll leave the light on as the day starts to
 fade
And you'll keep your word on the promise
 you made
That you'll come home
Singing a song and laughing me wide
 awake

Troian Bellisario is filled with grace and talent. Her sharp wit is tempered by her beautiful heart. She makes everyone around her better at what they do. Having the pleasure of working with her is a gift in my career, and having her as a friend is a gift in my life. She has empowered me to take risks with my work and follow my dreams. When I think of Troian, I think of inspiration. Our work together started with a chemistry that the writers picked up on and that I enjoy in every interaction with her. She is a partner, a friend, a teacher, a rock, and a safe place to land.

Believe it or not, as glorious and free-flowing as this might look, Troian and I were actually working the night I captured this image. We were attending the Television Critics Association Awards on behalf of *Pretty Little Liars* and ABC Family. I look at this shot now and I still can't believe what my life has become and the incredibly talented artists who surround me. There is something about Troian's ease in this photo that is so beautiful to me. It is probably this very same quality in her personality that I love, too.

Troian and me, season one—young love. I actually see a younger me in this photo.

Soft, gentle, and strong: Troian becomes her character, Spencer, before a scene.

Tyler Blackburn is one of my most selfless coworkers. He approaches his work always trying to make everyone around him stronger. For us actors, that's a huge positive trait. I know how much he missed all of us when he went to New Orleans. We are all so glad he's back.

Tyler and me messing around on our media tour for season three:
a couple of hoodlums running around New York studios.

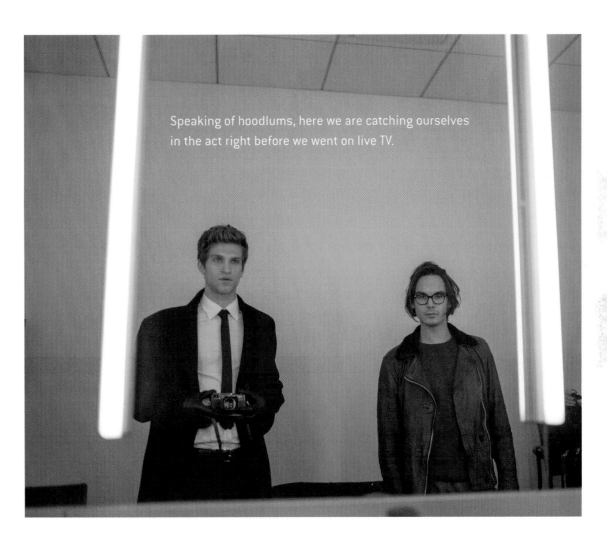

Speaking of hoodlums, here we are catching ourselves in the act right before we went on live TV.

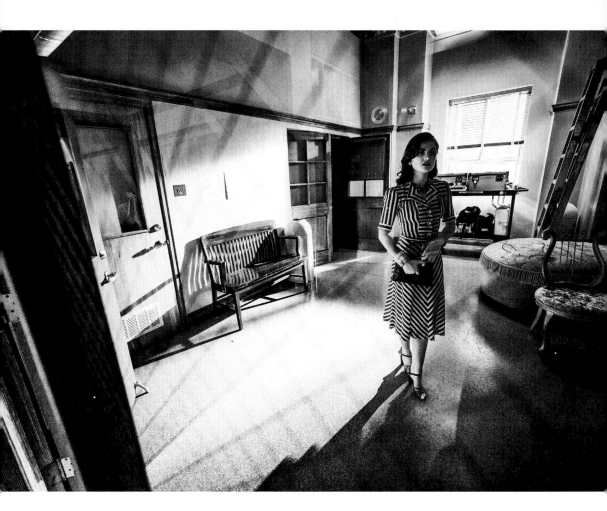

Lucy Hale is an angel. Her talent is unique because she has become famous for her acting, but she is also a gifted singer/songwriter. I remember when I first met Lucy and covered her song and sent her a video, immediately connecting us with music since we never have scenes together. Her charm and spirit never sleep.

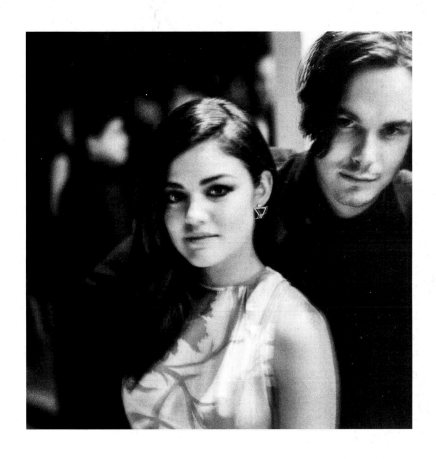

Lucy and Tyler at a Hollywood party.

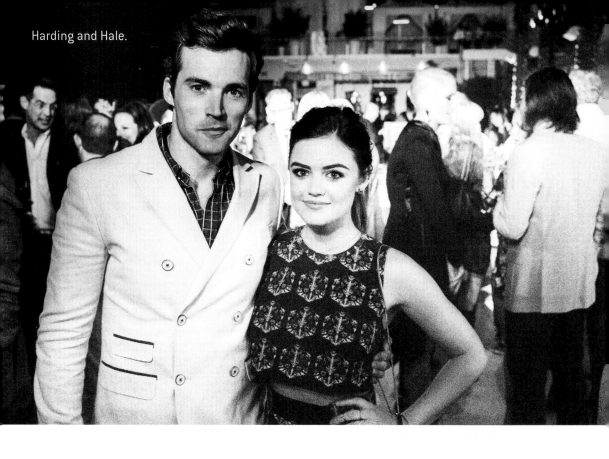

Harding and Hale.

Lucy memorizing lines. It's always impressive
how quickly the girls can memorize their
paragraphs of dialogue.

A china doll: my friend Janel on set with Drew shooting on a hot summer day.

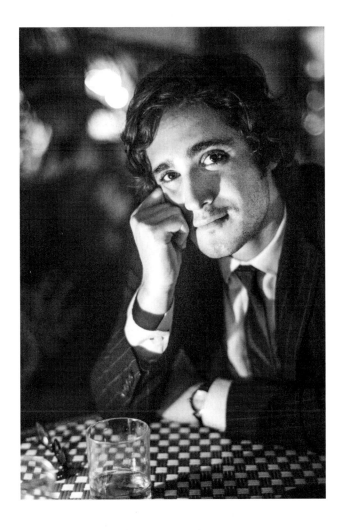

Diego Boneta staring into time for me. I lit this shot with a single candle at Chateau late one evening.

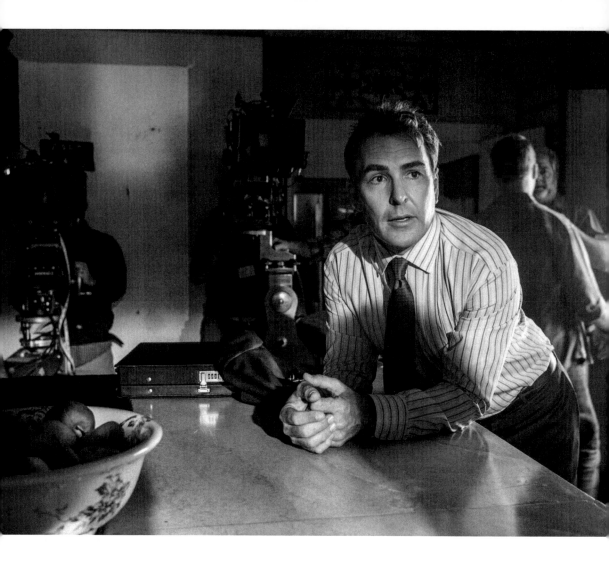

This is my friend and colleague Nolan North. I wish I could take a photograph of his voice rather than him. He voices all the Betty Crocker commercials. On *Pretty Little Liars*, he plays Peter Hastings, aka the show's fun-stopper. Doing scenes with him is always a pleasure because he has the cast and crew rolling on the floor laughing with his hundreds of character voices. He is a wildly talented voiceover artist for many of the famous video games we all play, and he can do a Christopher Walken impression so good that to keep composure we don't even look at him when the cameras are rolling.

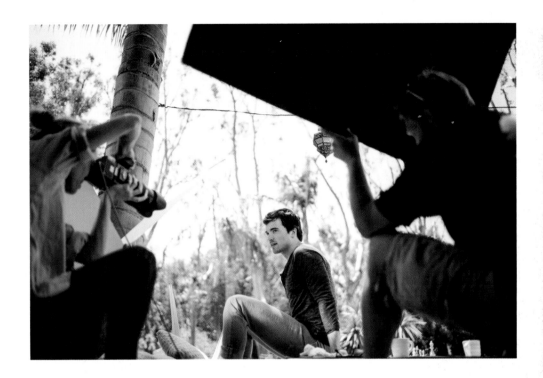

Ian Harding during a photo shoot. I somehow have become the photographer of photographers, carrying my camera with me everywhere I go, even into my own photo shoots.

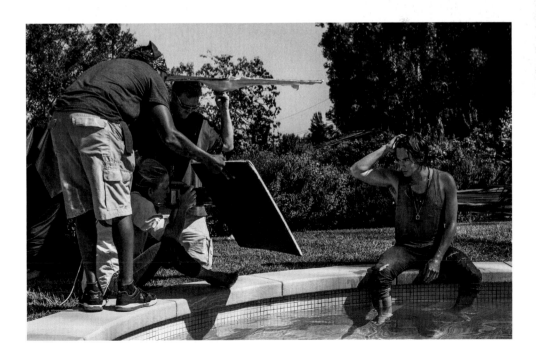

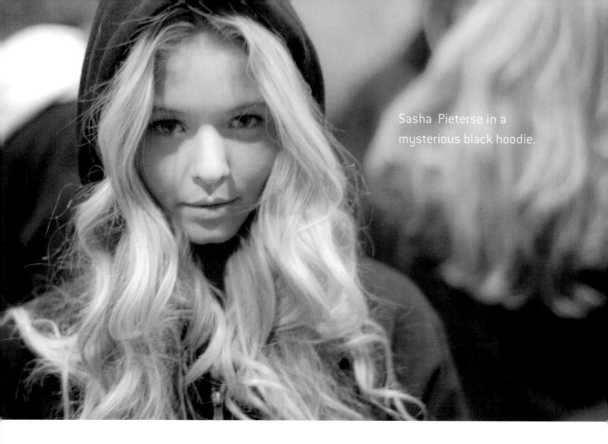

Sasha Pieterse in a mysterious black hoodie.

This was the first photo I took of Sasha. I remember thinking how she is the complete opposite of the character she plays on the show. It was a treat to see her switch from her sweet, kind, and nurturing personality to Alison's devilish and manipulative allure at the call of "action."

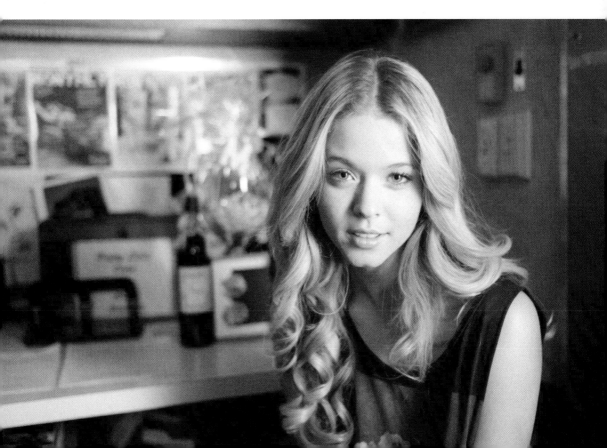

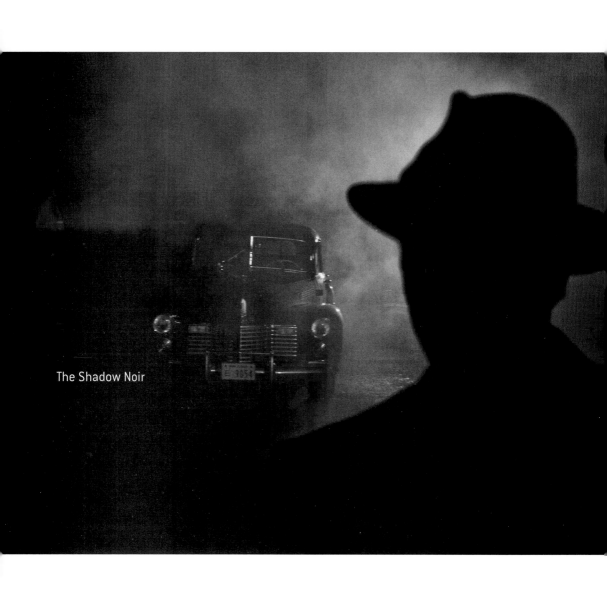

The Shadow Noir

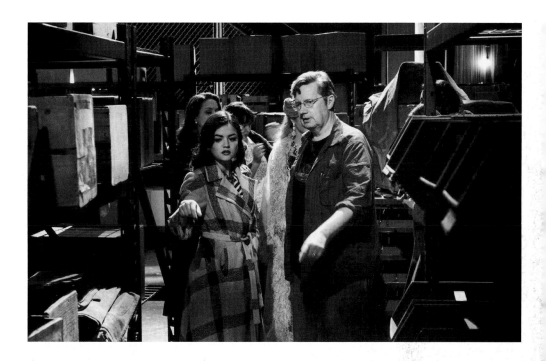

Joseph Dougherty directed and wrote "Shadow Play," the *Pretty Little Liars* black-and-white episode. You are watching a direct result of his reverence for this classic form of cinema. I recommend looking further into everything you see in the episode—every beautiful vignette, every subtle transition, every visual word in his writing, every article of clothing Mandi Line created to pull this off as a genuine and authentic homage to an art form that roots itself (still to this day) in film/TV. It will elevate your experience and hopefully send you on your own journey through classic filmmaking. Hats off to an amazing cast of writers, actors, and crew members.

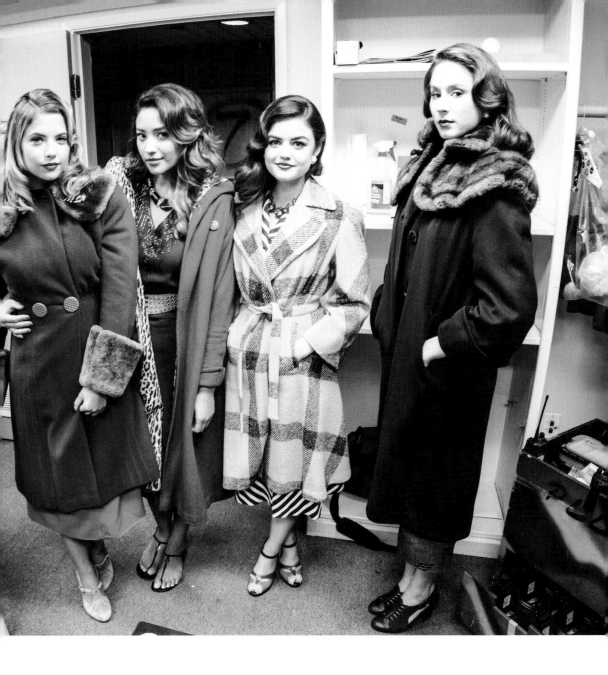

Before they went into monochrome, Mandi Line, our show wardrobe
designer and fashion guru, had to mix up different colors and patterns
to stand out in black and white. Once the color went away everything
made sense. . . . There is a lesson in that statement somewhere.

Troian becoming Spencer with a noir twist. I love the shoes.
Is it normal to love a woman in amazing shoes?

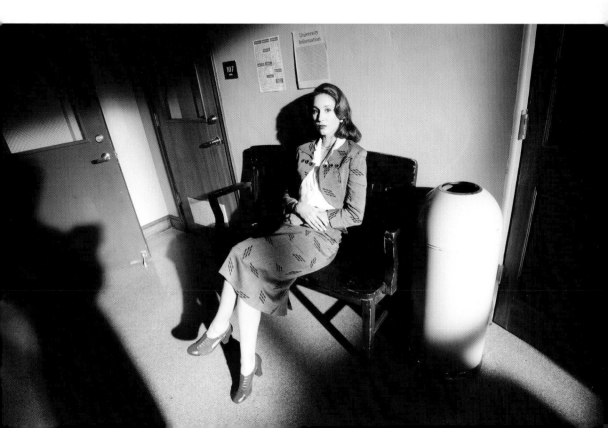

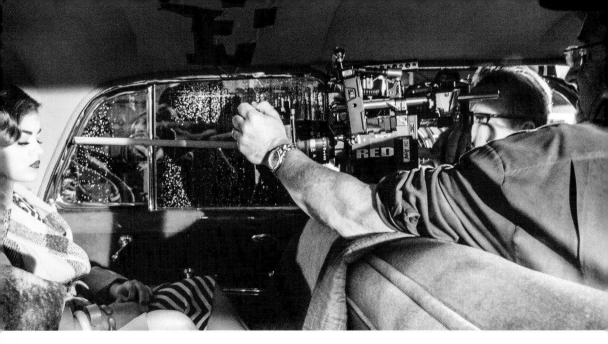

Shooting in the car for noir. This image still feels Old Hollywood to me, like we were all shooting and living in another time. On that very set, Humphrey Bogart and Lauren Bacall worked many times on many projects. So we were not only paying homage but also continuing production of a famous genre.

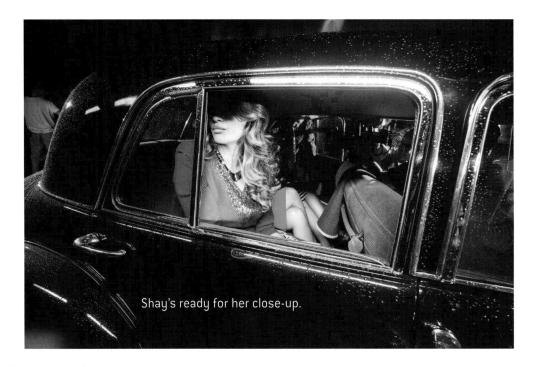

Shay's ready for her close-up.

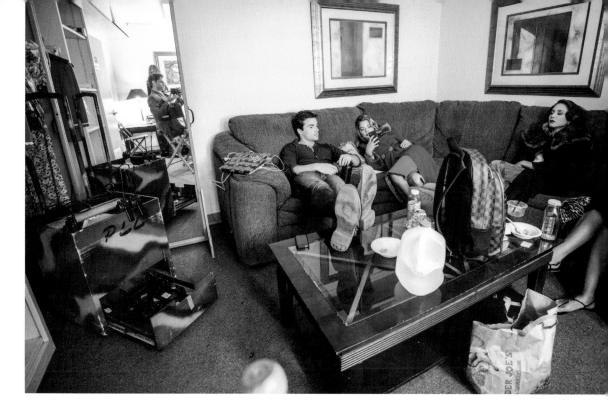

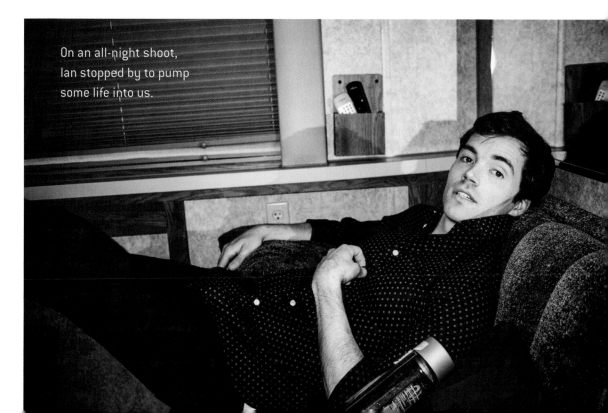

On an all-night shoot,
Ian stopped by to pump
some life into us.

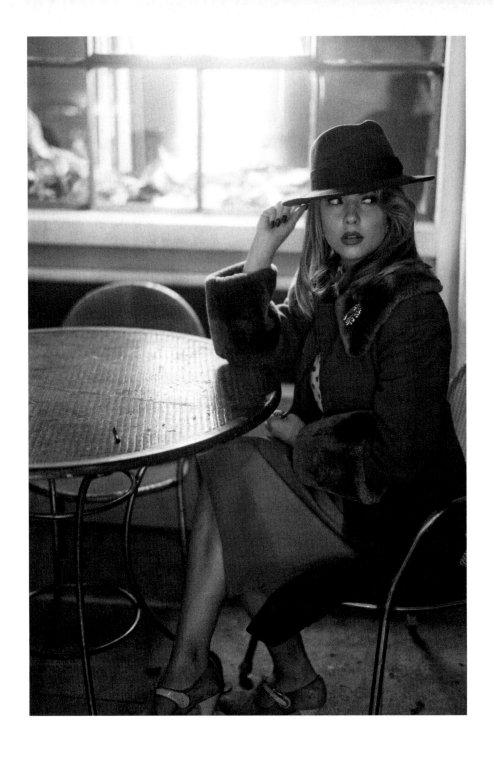

This shot of Ashley makes me want to go to Paris every time I look at it.

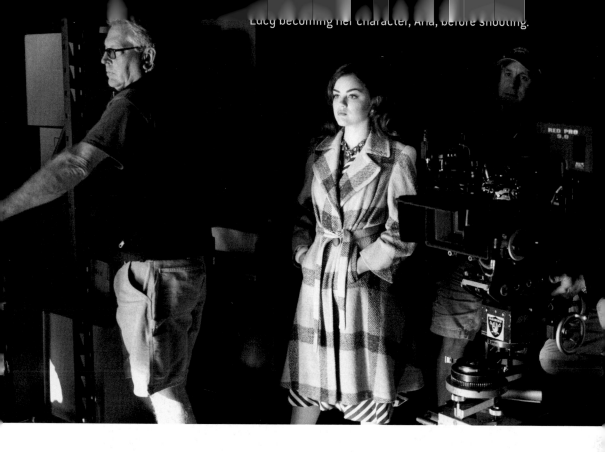

Lucy becoming her character, Aria, before shooting.

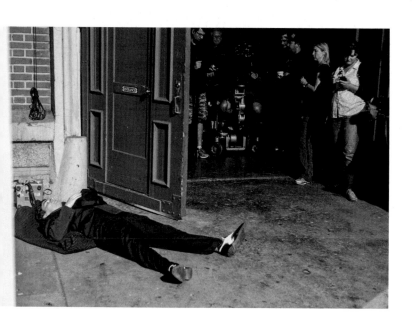

After Toby punched Ezra, Ian got in a little nap as he played up the knockout.

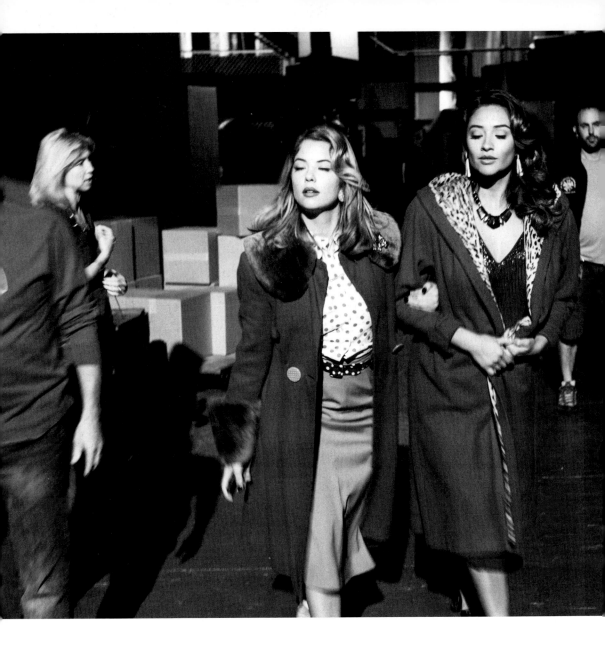

The Walking Dead-Tired

Ashley and Shay exit the stage after they finally finish one of their scenes. It was a long day and long night of shooting and everyone was exhausted. Still, they left the stage with the same strong, absolute glamour that they had when they arrived . . . they just could barely keep their eyes open with all the bright stage lights still glaring.

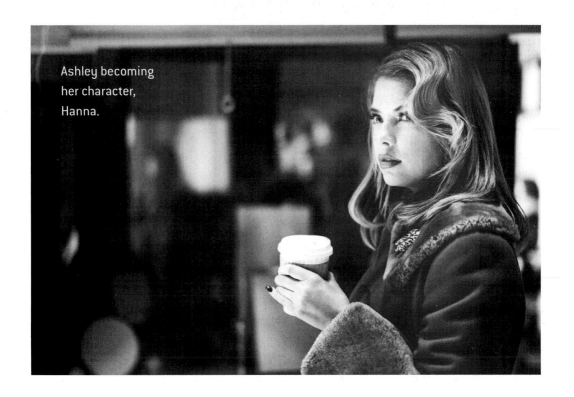

Ashley becoming her character, Hanna.

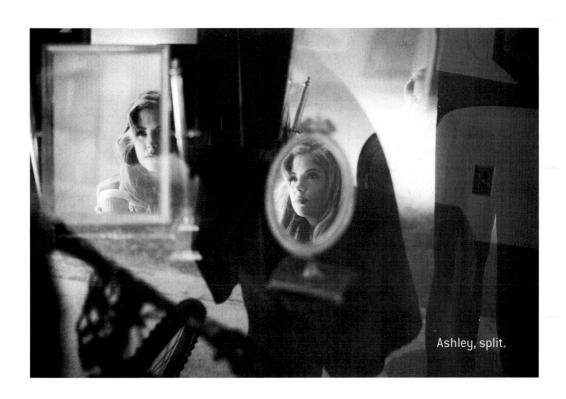

Ashley, split.

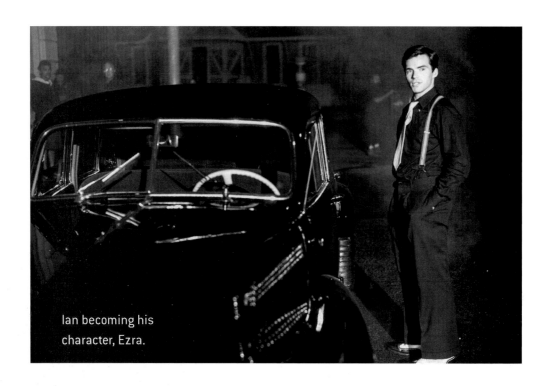

Ian becoming his character, Ezra.

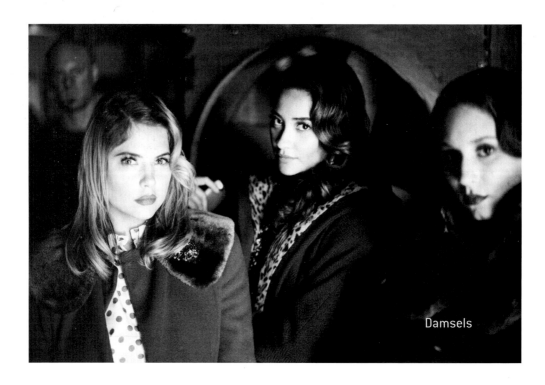

Damsels

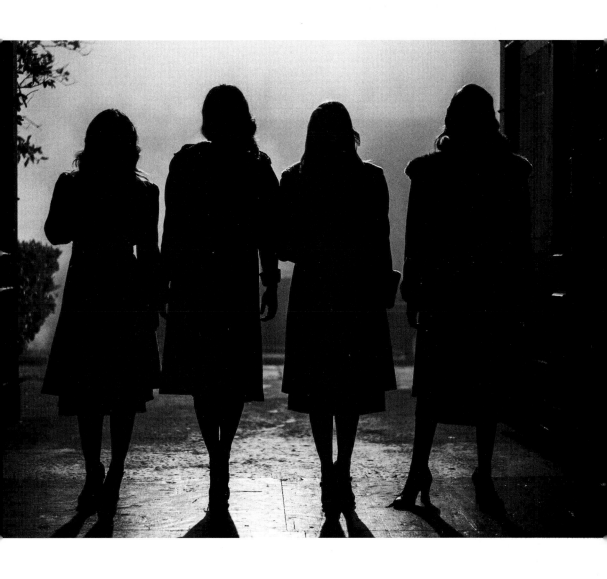

Shadow play

Ashley and Tyler rehearse a kissing scene.

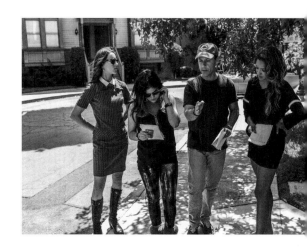

Chad Lowe directs the girls.

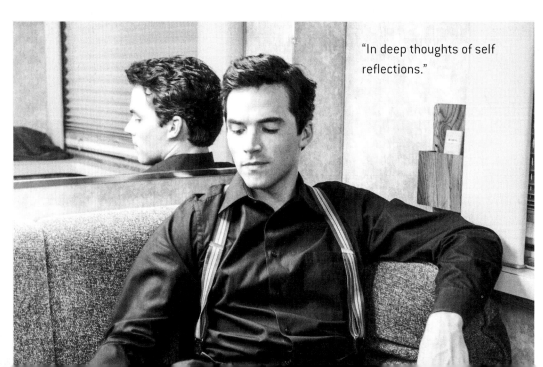

"In deep thoughts of self reflections."

The question everyone asks is: "Who is '−A'?" Well, I can answer it right here and right now. It is Marlene King, the program creator of *Pretty Little Lairs* and the Queen Bee of all the secret storylines.

The "−A" lair is one of the most mysterious places in the Rosewood universe. It was truly a visual creation coming to form for all of us to enjoy. In so many ways, Marlene is the mother of my career . . . she has crafted Toby in a tremendous way for me to bring to life. Sometimes when I am with her and her family, I think about all of us together many years from now and it fills me with happiness that someone as smart, caring, and thoughtful as Marlene believed in me first.

Marlene King and Kyle Bown in one of the "−A" lairs.

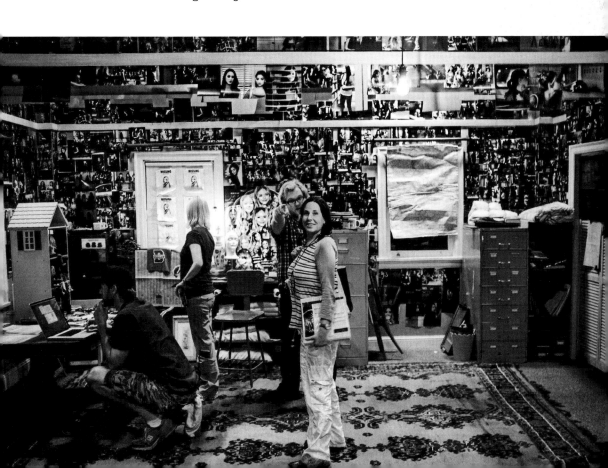

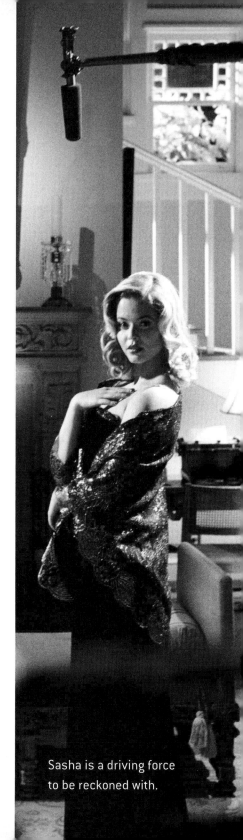

Tri-X 400 film always looks better; it adds to this already classic lighting and wardrobe.

Sasha is a driving force to be reckoned with.

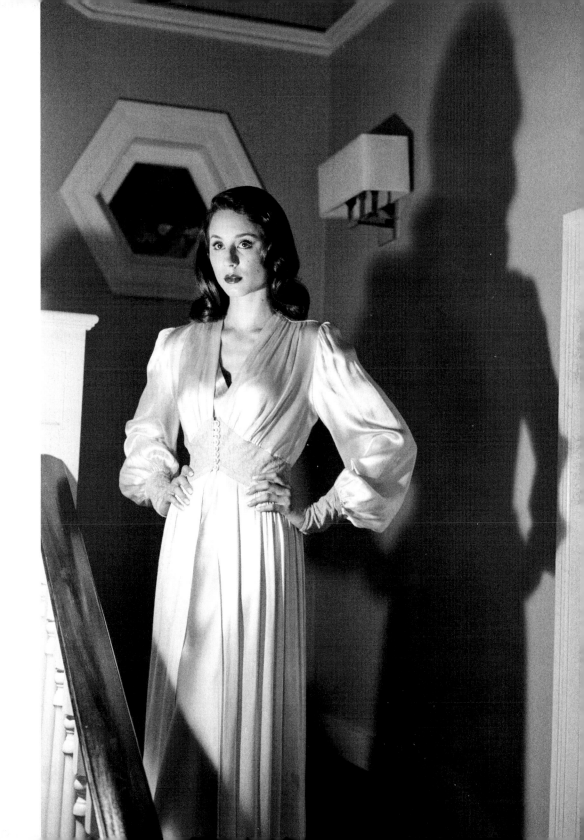

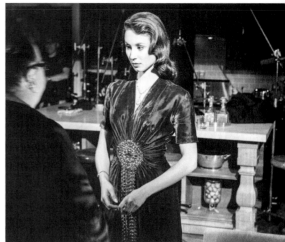

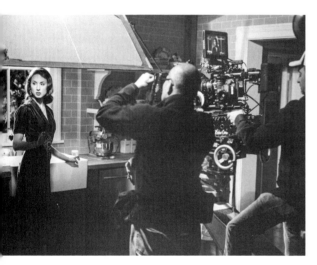

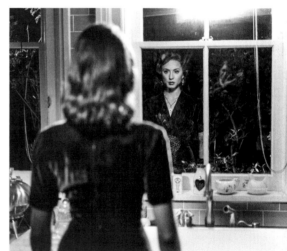

Table Read

For each episode, we read the script out loud for the writers, so they can hear what works while going on a wild ride of twists and spoilers before the cutting room floor.

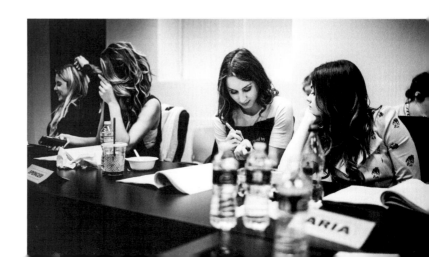

Troian as "—A"

I always have my camera on me, so I snapped a quick photo of Troian in her evil garb with her evil phone . . . and evil coffee. . . .

This was an interesting day of shooting. The network hadn't yet revealed the story lines to the public, and everyone in our cast and production team had to stay very tight-lipped. Since the fans are so ravenous for answers and spoilers, I knew I couldn't even develop this photo for a while, let alone publish it.

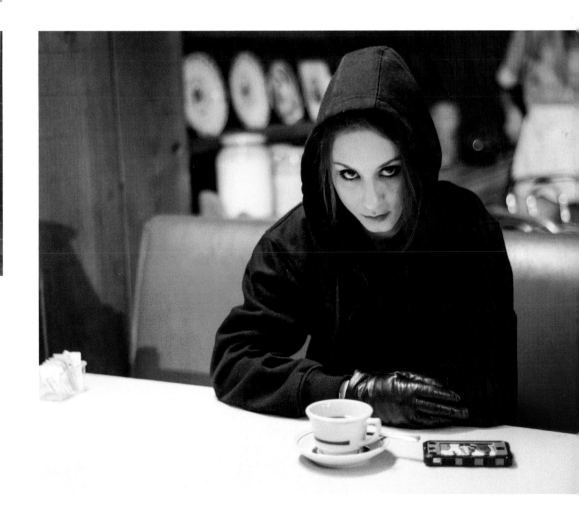

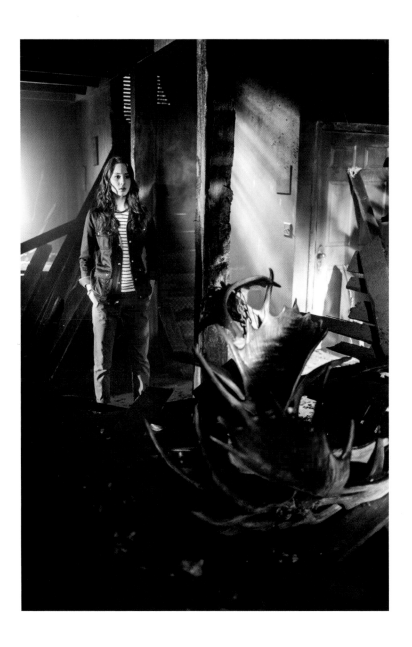

In this scene we explored the burned-down lodge.

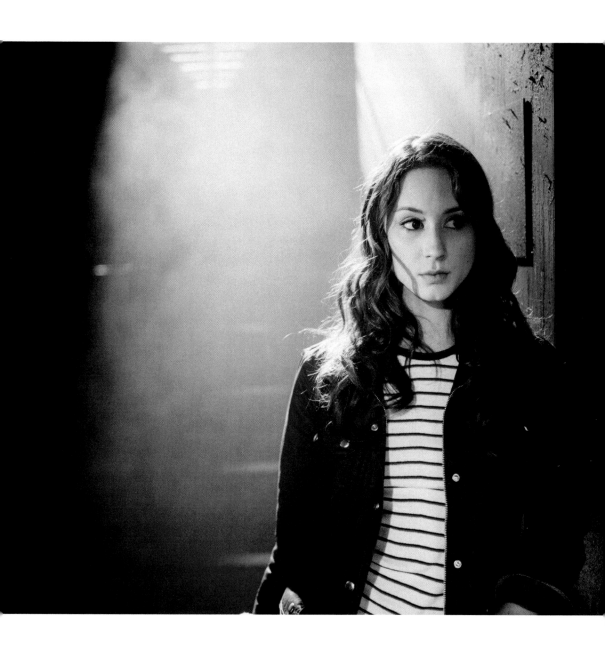

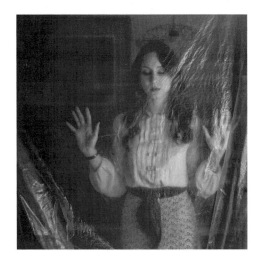

Troian hermetically sealed in time.

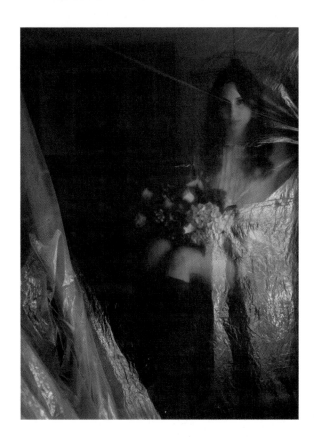

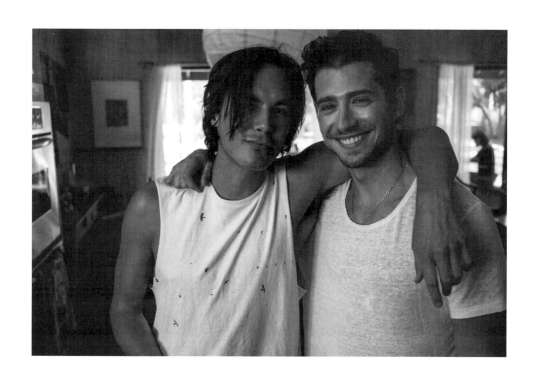

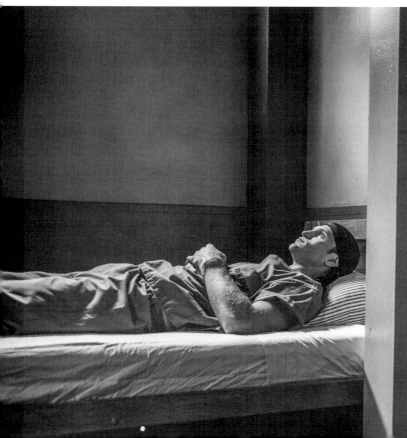

PLL Prison

I put the camera on a small table beside the bed while shooting a flashback scene of when my character on *Pretty Little Liars* was in juvenile hall for crimes he was innocent of. He had to come across with a hardened attitude, and he also had on a doo-rag. This wasn't intentional, since it was only to keep my hair down, but it stayed in the scene. I captured my contemplation of what Toby was really going through—being punished for something he never did, and too Mr. Milquetoast to speak out against his incarceration.

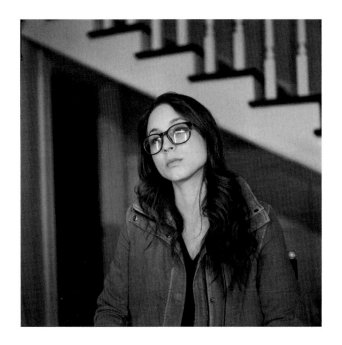

Troian on 120 film, sans Spencer.

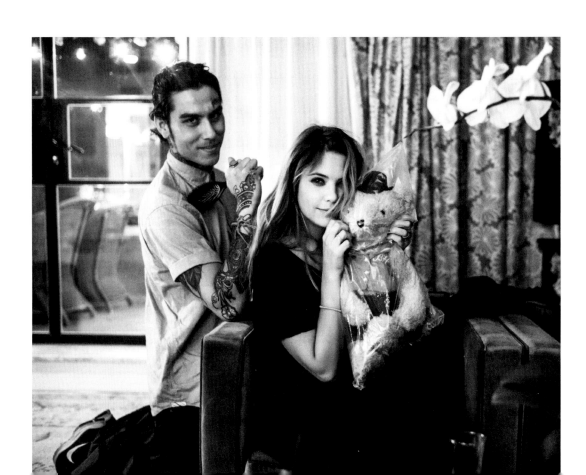

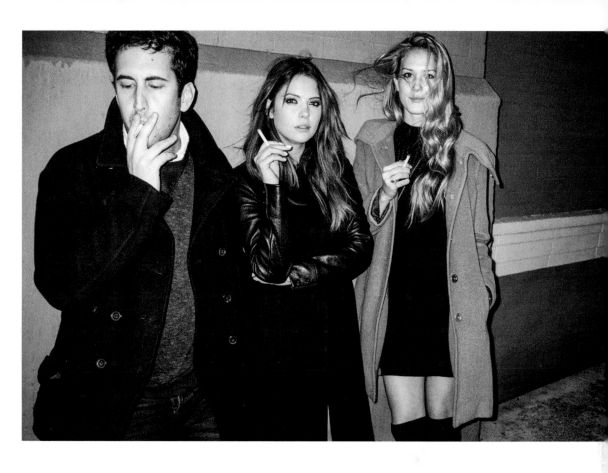

A break from the crowd inside. "Chelsea Ave.," New York City.

Ashley and Castillo

Ashley was getting her hair done in the suite of the Bowery Hotel by her talented friend Castillo. This hotel is the "Chateau Marmont" of New York with candlelit halls and ghostly comforts. Standing out on that huge terrace can make anyone feel like they own the town along with a sidekick teddy bear, included in the interest of never sleeping alone.

After this image was taken, Ashley went on to attend the Kiss for the Troops event in Times Square, and I proceeded to perform in *Small Engine Repair*.

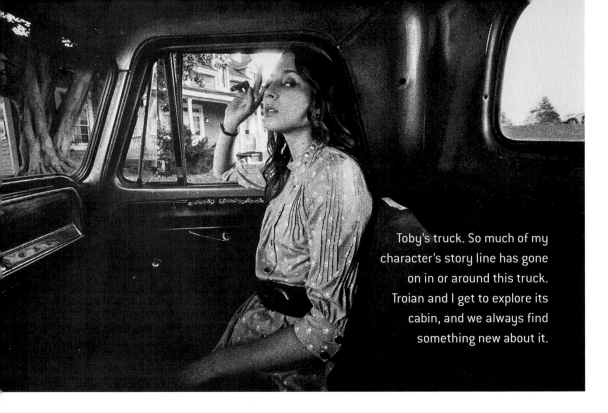

Toby's truck. So much of my character's story line has gone on in or around this truck. Troian and I get to explore its cabin, and we always find something new about it.

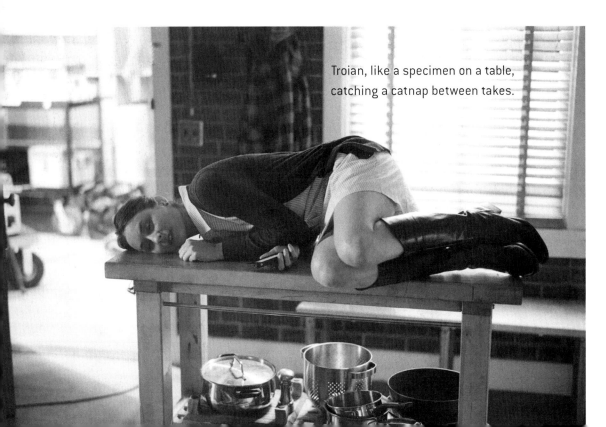

Troian, like a specimen on a table, catching a catnap between takes.

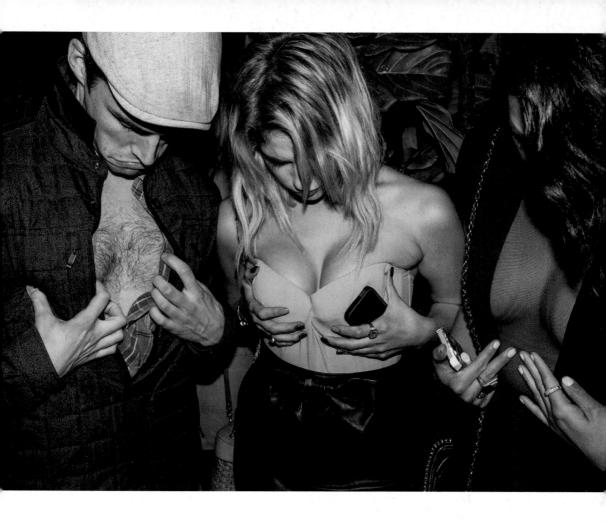

"It's a Wrap!"

This was our wrap party for season three of *Pretty Little Liars*. Got breasts?

James Franco directing *Bukowski*.
Sometimes I am a fan, too. I think it's so
interesting how we are all fans of someone.
James Franco is a great friend who is so
unbelievably multitalented. He is an actor,
director, author, and artist as well. He has
energy and passion for so many different
kinds of art. I look at all the things he does
with a constant stamina and they inspire
me to believe in my own art even that much
more. James is both a beacon and a brother.
A northbound express train with no stops.

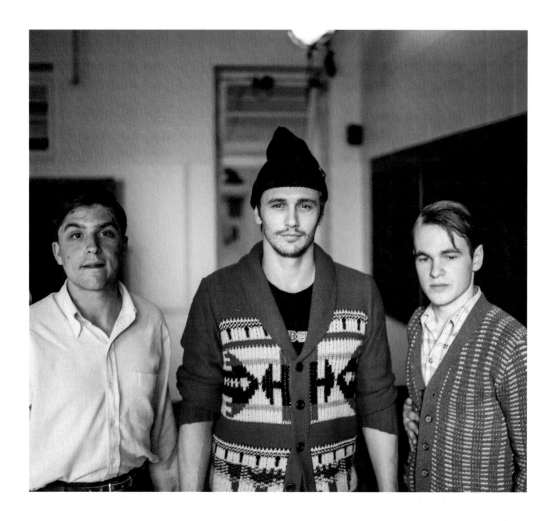

The director with his actors—pictured here with Jacob Loeb
and Graham Martin after we all shot a heated scene.

This image is haunting. I guess you could call it the nonglamorous side of my work. I took this on the set of the James Franco–directed independent film *Bukowski*. Jacob Loeb had to undergo four hours of makeup to accurately depict Hank Bukowski, who, like so many teens, suffered horrible acne.

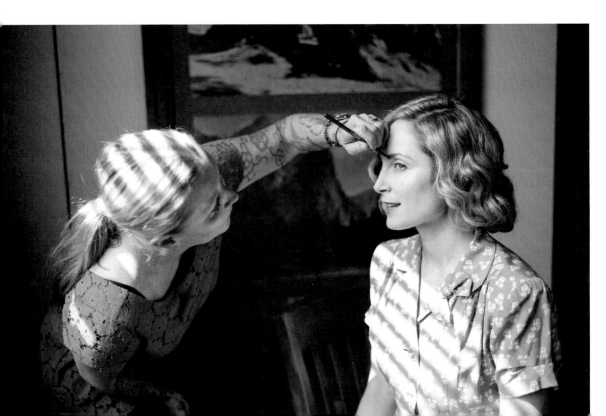

Bukowski

Working on this project with James Franco and Jacob Loeb was another moment in my life that validated a lot of hard work and sacrifice. Long live the poet and artist.

Clarity, Purity, and Beauty

This image juxtaposes the actress and the tatted makeup artist.

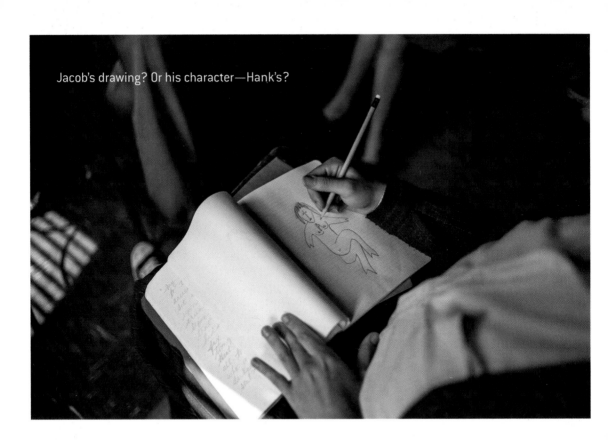

Jacob's drawing? Or his character—Hank's?

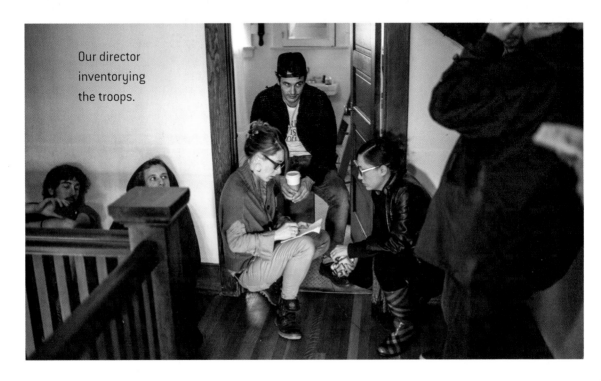

Our director inventorying the troops.

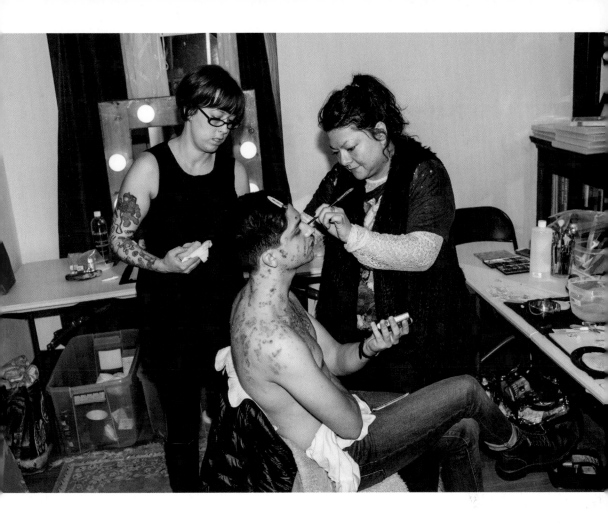

Four long hours of makeup to add acne. . . . And to think
what all of us do *to get rid of* our acne.

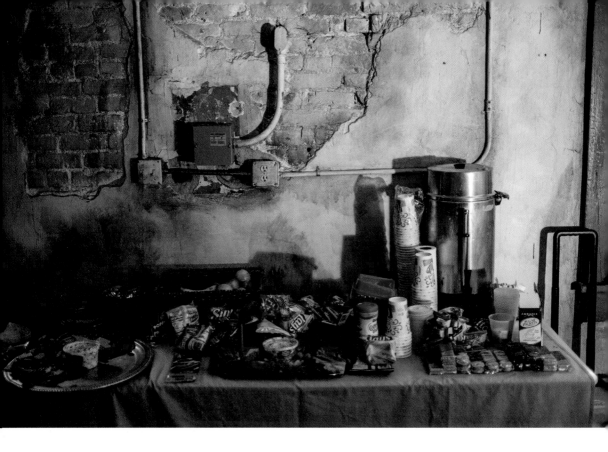

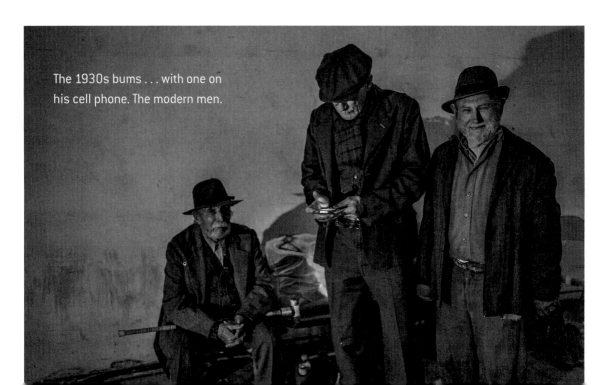

The 1930s bums . . . with one on his cell phone. The modern men.

Industrial Craft Services

Craft services is the table all of us eat from while we're shooting.
This was on the set of *Bukowski*, once again revealing the lack
of grand service away from the cameras.

Figure 8 Wall in Silver Lake

Elliott Smith is one of my favorite singer/songwriters and was a huge influence on my generation.
This wall was for his album *Figure 8*, which happens to be next to a great taco place. So after filming
Bukowski with these kooks, we grabbed a bite to catch up and paid our respects to Mr. Smith.

James directing *The Sound and the Fury*, the third film I have worked with him on. He directed and starred in it as Benjy.

Jacob Loeb lost twenty-five pounds to play Quentin in *The Sound and the Fury*. We transformed from our *Bukowski* days to step into the shoes of early 1900s southern culture.

I gave Joey King her first kiss in her life on set, on a swing in front of James Franco as he acted and directed in the scene with us. He was joking all morning about how we had to make it "good." In hindsight, James was taking the tension out of what could have been an awkward moment.

Joey King in *The Sound and the Fury*.

Kylen Davis as Luster.

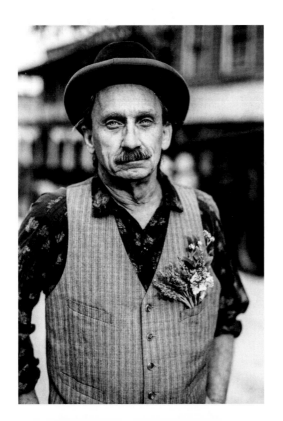

Sage and lavender.

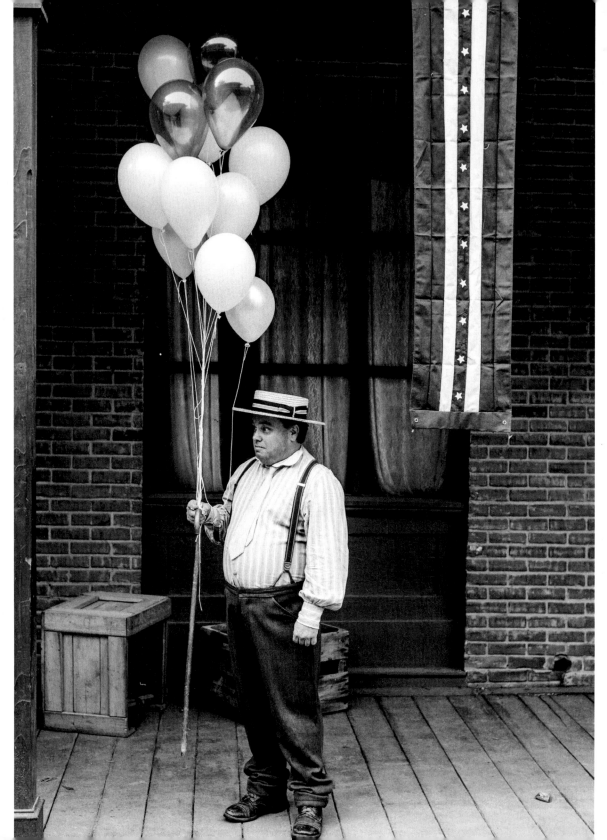

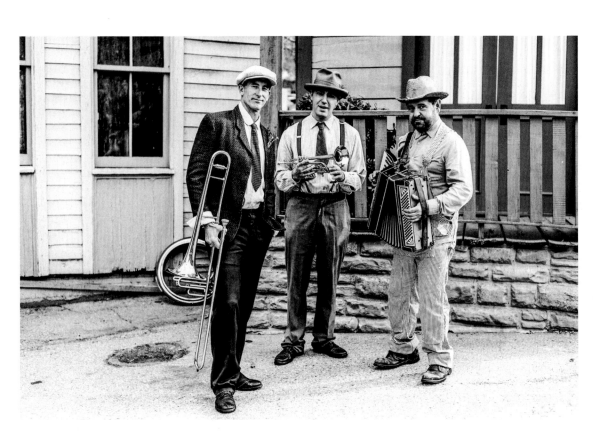

Playing in the band.

Bow tie

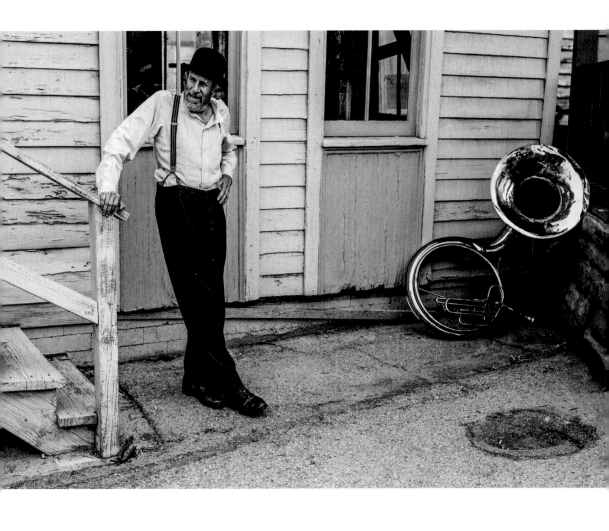

Tuba man

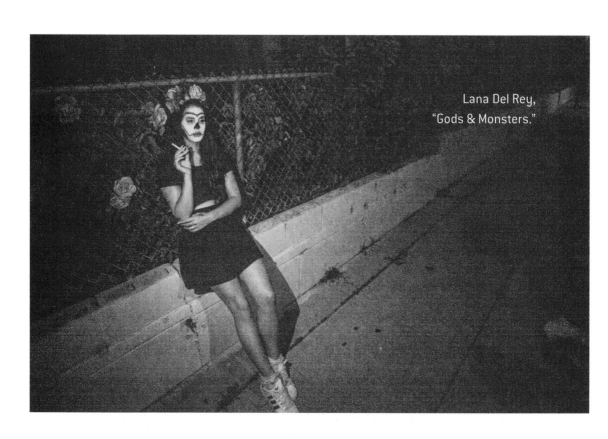

Lana Del Rey,
"Gods & Monsters."

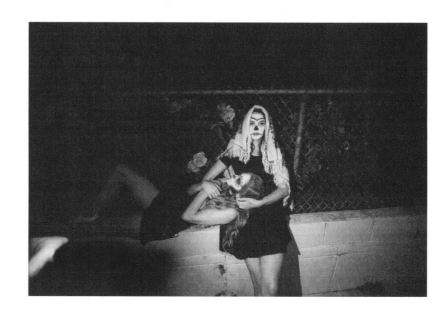

Chuck Grant (fine art photographer) and Lana Del Rey (singer/songwriter) taking a moment after filming *Tropico*.

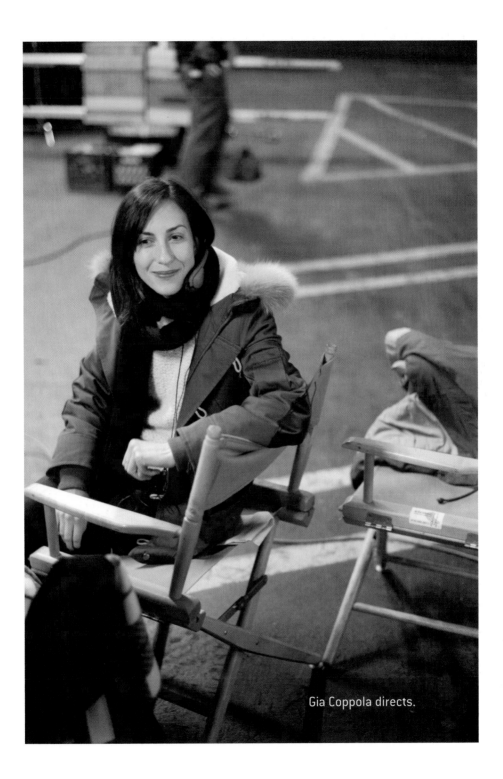

Gia Coppola directs.

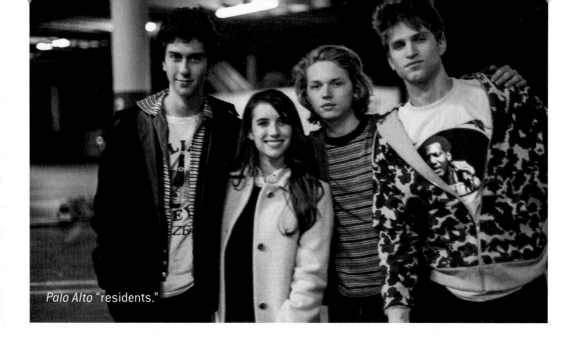

Palo Alto "residents."

Tricks for days.

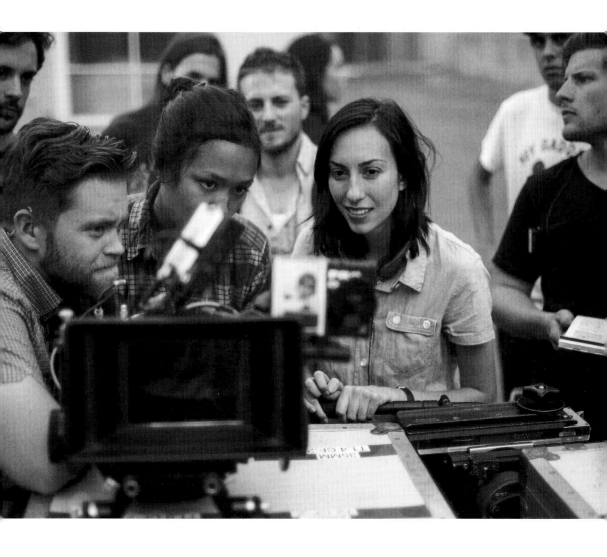

Gia watches playback and directs.

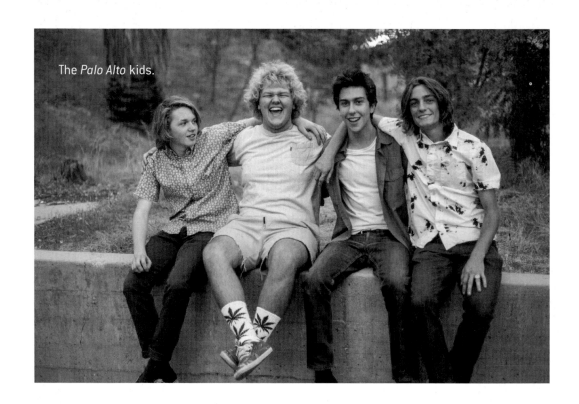

The *Palo Alto* kids.

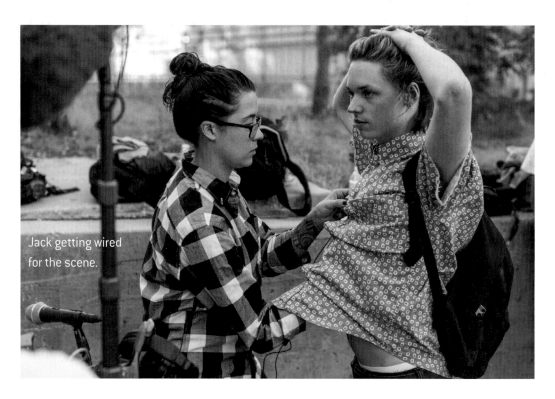

Jack getting wired
for the scene.

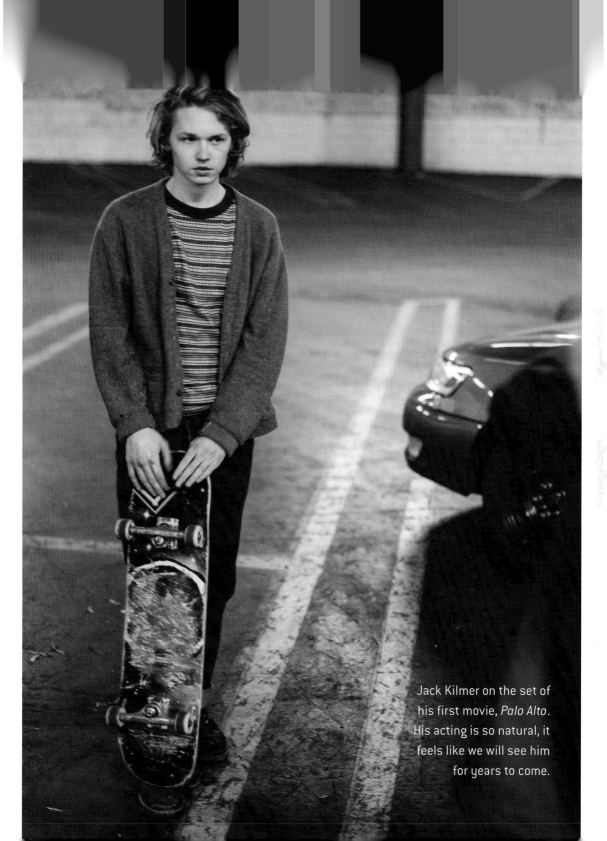

Jack Kilmer on the set of his first movie, *Palo Alto*. His acting is so natural, it feels like we will see him for years to come.

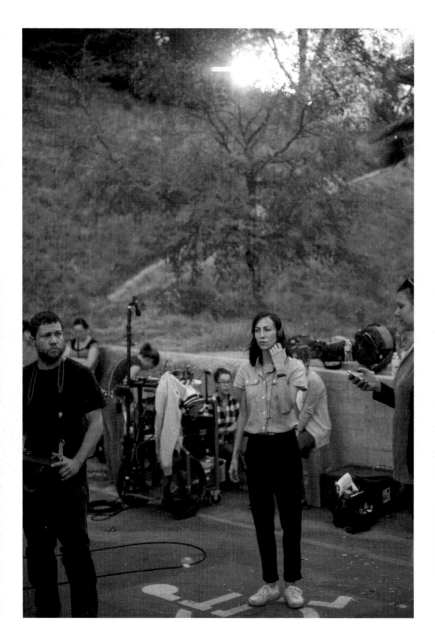

This image is Gia taking her characteristic thoughtful approach to every detail on set. Working with her was such a gift because she cares about art and beauty so much.

This is at the Chateau Marmont's infamous bungalow number 1. A lot of living and dying has gone on in that bungalow. This night, however, it was a celebration of Salvatore Ferragamo. Some friends pictured here are Evan Peters, Emma Roberts, Gia Coppola (the next morning we shot my scene in *Palo Alto*, her directorial debut), and Linda Ramone.

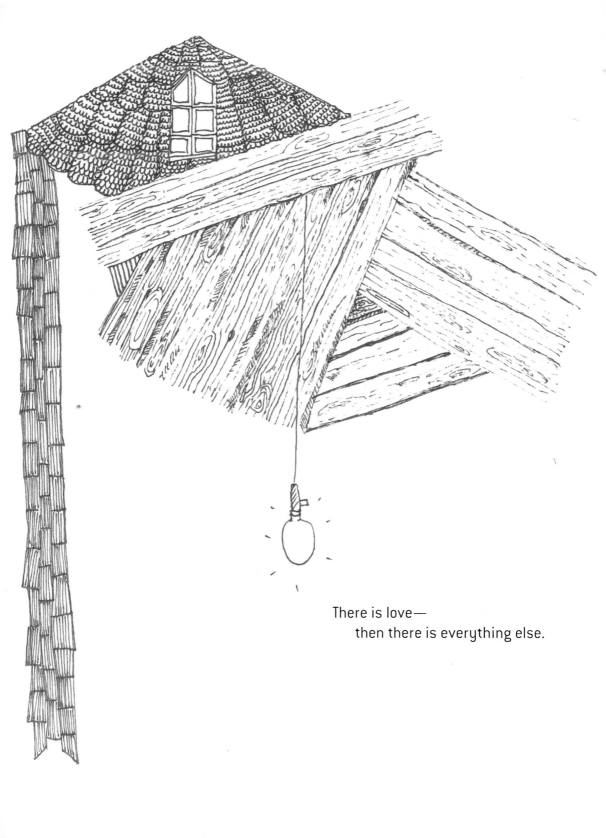

There is love—
 then there is everything else.

love.

In a discussion recently, I stumbled again upon a question I ask myself daily (hourly). There is no right or wrong answer to it. No matter how hard I try to build the answer into a keepsake, it always ends up deserted like a child's Lego city after the discovery of video games. When I ask someone else this question (which is rare), I am searching for their personal understanding to try to put my own uncertainty to rest for a while. I am hoping to push pause on my cynical cycle, to stop and gaze into a box of glowing romantic slides.

When anyone brings up this heady topic, even among friends, it sucks the air out of the room. I have no idea what could be said or done to answer it—and I find that fascinating. Whenever I've asked other people this question, I've gained a solid layout showing how that person feels about himself or herself around me. The topography of the conversation seems to reach a mountain or deep canyon, and I enjoy seeing how we make it over or across. So when it is asked . . . "What is love?" (Sometimes followed by "Baby, don't hurt me") . . . it splits an atom. It means something different for everyone. A love for a smell, parent, sibling, pet, charity, spouse, lover, friend, book, song, place, time, feeling, food, movie . . . it goes on and on . . . and on.

But when I ask it I know my answer, right or wrong. It is an image. I have had it since I was six years old. It was my birthday and I was in the woods. I had a girlfriend at the time and she was seven years old. It was the first time I remember asking someone that question.

She kissed me on the cheek and told me love was something that made people sick and the only way to cure it was to kiss on the lips. I wasn't that interested in her answer because I knew she was baiting me to kiss her . . . on the lips (that was serious business back then, by the way). She asked me rapid-fire right back . . . and I had no answer. Simply because I didn't know in the first place how to define it with words. I had only felt it as a primal need to survive.

I looked up and I saw a red balloon trapped in a thorny tree. It stood out over the greens and browns of the forest canopy. Trying to free it from the tree would guarantee its demise. And a simple gust of wind could possibly blow it out of harm's way, but it would never see that same tree again. It would float away, lost forever. Swallowed by the sky. I studied this for a moment and then told my eager listener: "Love is a balloon perfectly trapped in a tree."

Yes, six years old, waxing poetic, and on my way to bending my mind around the metaphoric works of romance. Her reaction was both inspiration and misunderstanding. In one motion, she grabbed a chair, secured it to the base of the trunk, and grabbed the balloon out of the tree. She walked back and handed me a perfect balloon, kissed me, and went on back to the party. I stood there and pondered. It made more sense now. I let the balloon go and made a wish (probably for cake or toys) and it sailed through the air. It turned into a small speck and vanished . . . forever. This scenario has played out many times again and I still see that balloon, and it speaks for itself: fragile and unpredictable.

Venice sunset at the court. Fistfights and free throws. Freak shows and groms. Tourists and locals. Palm trees and snow cones. Shadows and drum circles. Run-on salesmen and street performers. This is Venice soup.

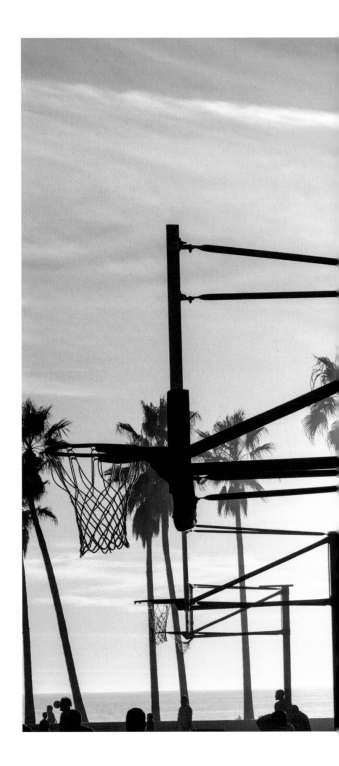

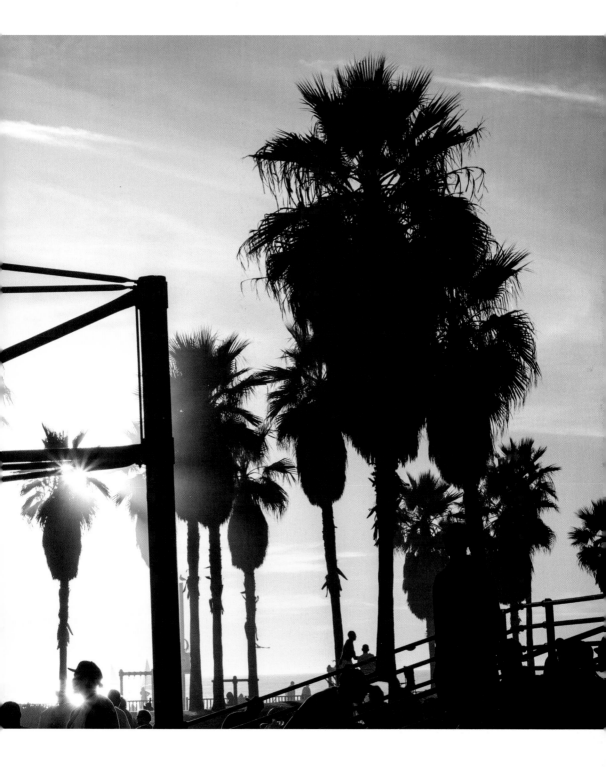

Star-Studded Rapture

Abalone oils stir around her ankles in the tide.
Her voice is exactly the way I imagined it from when we never
 knew each other
I had dreamt her up

We ran out to the desert
And screamed it in the sea
And we climbed up that mountain
Where our breath could be seen
And I drew it on a letter
And I mailed it in the post

But unless I was there in person, girl
Well, I might as well have been a ghost
Boo

I just can't wrap my head around
Why you left me there
Standing in that vanilla sun
At the hotel Deuce bel air
Was it just a dream—
Or a pattern on the rise—
Or was I just your star hidden behind blue
Blue skies?

The note on her foot lightly informs me "In the wake of
 perfection swims beautiful imperfections"
(a passage from a book she loved by Matthew Good called *At
 Last There Is Nothing Left to Say*)
and then walks away into a stunning void of future and past.
No interest to return to the present and explain.

Yet there is no need,
The moment is perfect and we are its imperfections.

She is used to being followed, but she follows me.
This happened so fast. The sand still caught between our toes,
 our fingers inserted into each other's pockets looking for
 change to buy more smokes.
We return to her front door, her flying saucer eyes keep focus on
 my lips trying to finish this cigarette before your big sister
 found out it was missing.
Am I under a spell?
This is not us falling in love. It is us following the footsteps into
 the boned graveyards of those who have fallen in love with
 ideas before
I burn my lips when I kiss her as she steals the cigarette out of
 my mouth with no hands.
She tells me "Happiness is one hell of a drug" of which I've been
 sober for years and pulls the dregs of the chemicals out of
 the fire, filling the ashtrays inside her chest.

I feel a sickness coming on. I am paralyzed with doubt that I will
 never escape her grasp but these sweet joys of sun-kissed
 decks and sandy oceanfronts lure me into her mandibles.
Devour me.

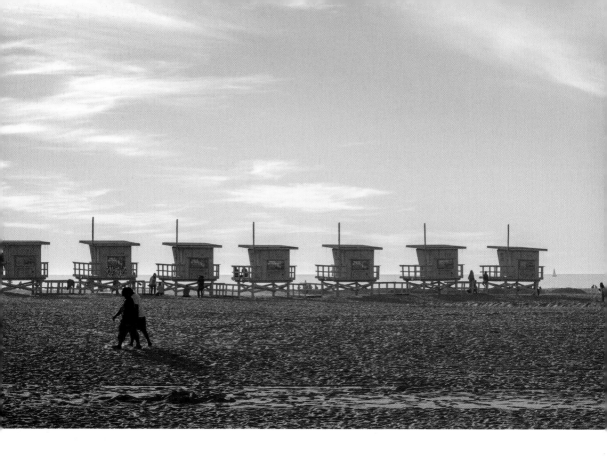

Southern California. Wow. Sometimes I can't even believe I live here.
I captured this shot in the fall when all the lifeguard towers are
pulled together. It's a sadness that overcomes my friends and me
when we arrive and see it, because it means that summer is over
and the winter has begun. Many people say that California doesn't
have any seasons—but this is proof that we do. I still get sad
driving by the beach and realizing another summer has passed.

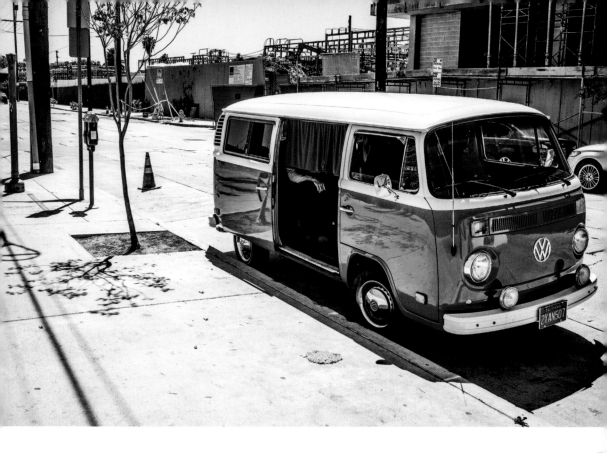

California hotel. I actually own a VW bus,
but this is not it. Mine is a faded relic
compared to this shiny street oasis.

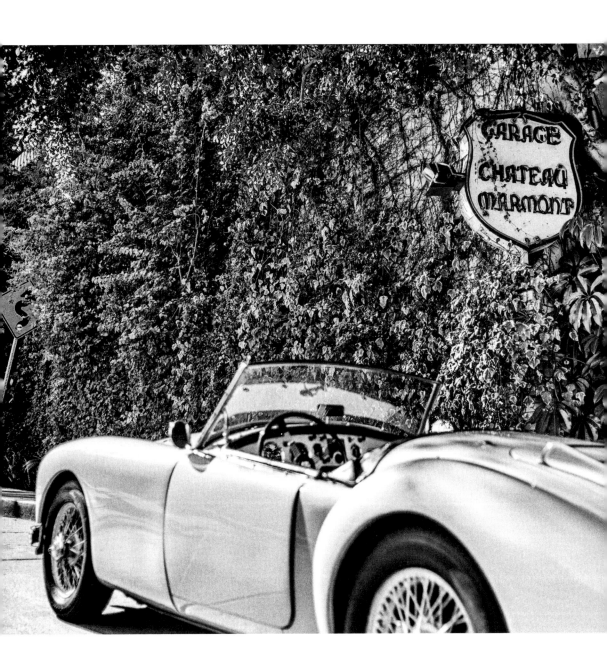

Chateau Roadster, 2010

Growing up in Hollywood made me feel normal. I felt right at home skating down the well-known Walk of Fame over dried champagne from movie premieres that might have happened decades ago, or maybe just yesterday. Or lounging on a bus stop bench reading my favorite book as a Hummer stretch limo blazes by with a group of loud tourists living the Hollywood moment, yet stuck in traffic behind an A-list celebrity's electric car.

Everyone wants to fit in and be noticed. Everyone is searching for something, every day, every hour. There are echoes of dreams once made on these very streets, and subtle reminders of nightmares. This was my degenerate suburban playground, the Sunset Strip, the mother ship of catwalks and train wrecks. I walk it with my camera and notebook constantly in hand. The city is sweet and close to its beach roots.

Luminescent shadows danced, and I watched people in alleyways light their cigarettes as they spoke of their hopes and dreams. My time was filled with daytime skating and adventures through the heart of the hills. There was always big noise up on the Strip, and the fabled Chateau Marmont was calling my name, a siren in the night. At a very early age I found retreat there to read and play piano. Everyone in the lobby was lost and the guests were all searching for attention, so I made a lot of friends. This photo is my 1959 MGA Roadster idling in front of the Chateau garage. Inside that very garage is a vintage Morgan that is permanently parked. I still owe Alessandra Balazs a lesson in driving a manual transmission so that we can take the car out together. The Chateau is my favorite place for late-night meals and immersive Hollywood conversations.

There is love, and then there is everything else. You won't find what you're looking for in there, and maybe that's exactly as it should be.

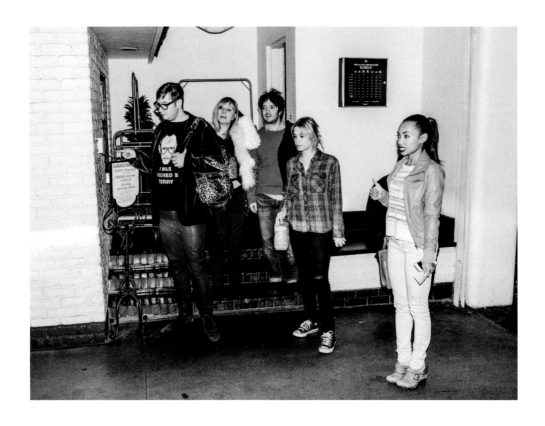

This is a moment in time at the Chateau valet: waiting for
their chariots to whisk them home.

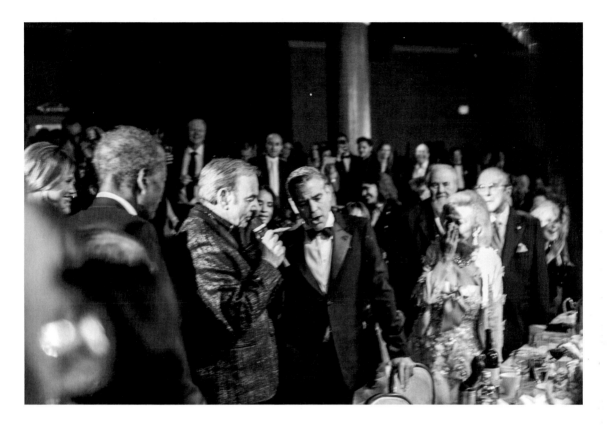

Hollywood royalty using their celebrity for good. Barbara Davis, the grande dame in this image, has called on her celebrity friends—in this case, George Clooney, Sidney Poitier, and Neil Diamond, photographed here at the famed Carousel Ball of Hope. Barbara has raised hundreds of millions of dollars to find a cure and help those with juvenile diabetes.

Nowadays, I spend a lot of time on airplanes. Whether it is for work or play, I really enjoy flying. A lot of people say they hate it or find it annoying. But I feel so comfortable with the idea of flying, being up in the clouds, above all the chaos and the noise. I love getting from point A to point B while sitting on an airplane reading a good book or writing down my own thoughts, feelings, and impressions. I write poetry and songs, and I created parts of this book, *in the air.*

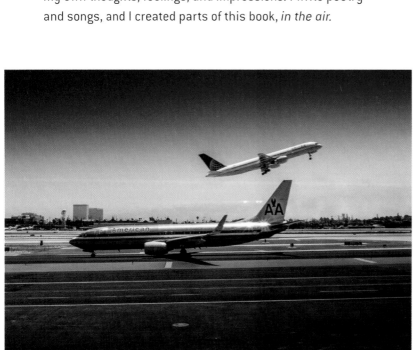

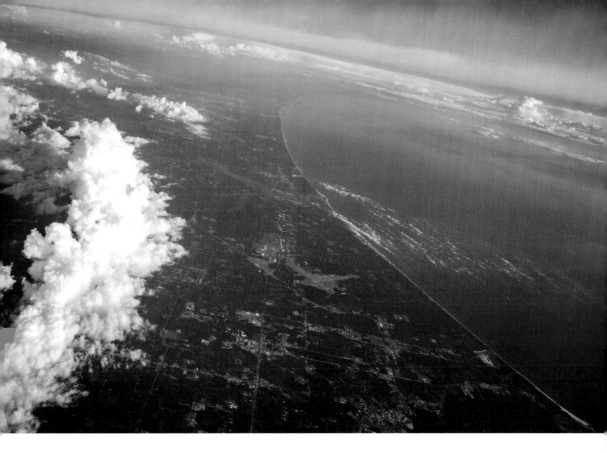

I really miss you.
So as you are slowly disappearing,
The sun is the only place I can put you.
The only place I can find you when I wake up.
The only place I can say good-bye before it's dark.
The only place where all my mistakes are burned away
Where I can rejoice.
I can't see directly but can feel you.
I know you won't leave.
Because even on a rainy day, you are above the weather.
And even at night, I am spinning on Earth's merry-go-
 round while you wait for me on the other side.
I love you and can't wait to see you beaming again.

The first place I ever traveled to was New York City. I was just a few weeks old, and my senses were still very new. Now as an adult walking around Manhattan, I sometimes daydream about when I was there as an infant. But seeing new lands has put things into perspective over the years. It has sparked a wanderlust inside of me, a longing to venture and to share. It is a vital part of life to travel and try to grow from the experience.

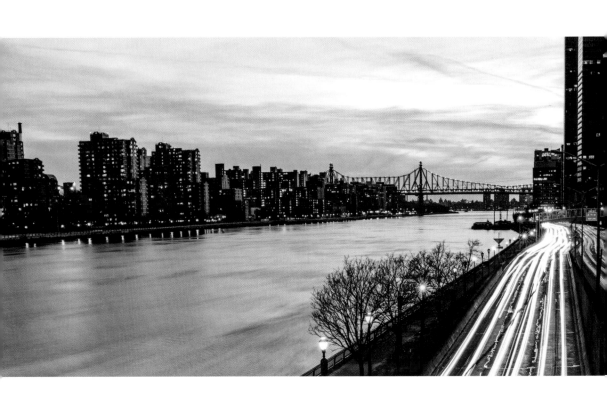

East-Side Shuffle

Manhattan, 2013. . . . Where are they all going?

Phantasmagoric Girl

Love so strong, it's heavy like the sun.
I'm mildly obsessed.
Rather it me than you.
Get behind me, Satan.
All I've longed for before is obsolete, it's not familiar.
This fragile bird calls me at night with the softest voice
Too dull to hear
As if it was a knife to stay away from.
Still vibrating from butter fingers
I try to listen till morning, when I can no longer hear her.
You tell me of your adventures. These thoughts hammer my brain.

A slow necrosis of my excitement fuels sleepovers with no rest.
Yelling on double-A batteries.
Visiting an old burned-down house I used to live in.
Dead Christmas trees at every corner,
A reminder that Christmas spirit has died.
Traumatic arts.

I want to experience the walls of this place. Run my hands over the
 sweating wallpaper.
Stay up late with candlelight poetry
As she enlightens me for the first time.

But I am not ready for her.
She is two moons wiser and trained in trickery of the soul.
My inner child's hand lingers at my throat while I express my feelings to her.
We are the same.
We are soul children, mates of this life, if only for a time.

We feed on our passion. The concept is convincing. My lungs are dry with
 sighs and troubled whimpers as she makes me believe I am spoiled from
 too much of everything.
Will she come around? It's only magic for a short while and I want to be
 spoiled by everything that is her.

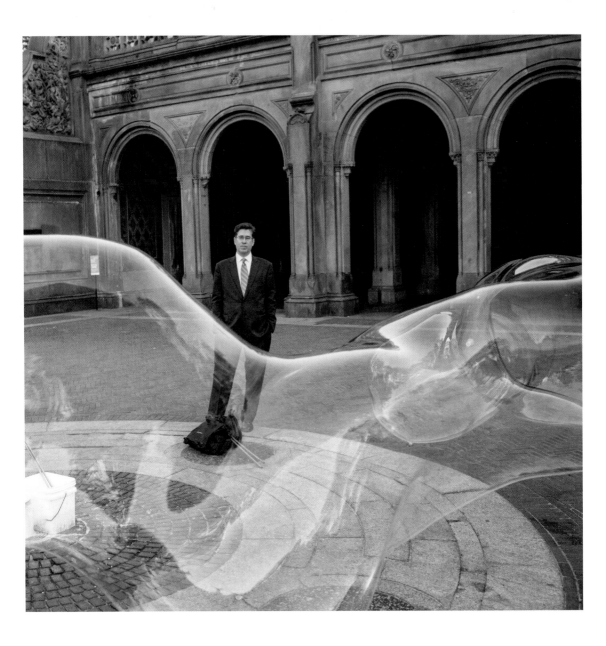

Art, architecture, and humanity—New York has so much of each.
This fluid bubble floats next to the heritage of the architecture
with a man somehow stuck in the middle of it all.

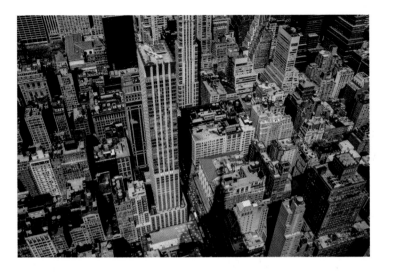

I figured we have all seen the Empire State Building; why not photograph its shadow from the top? New York City, 2013.

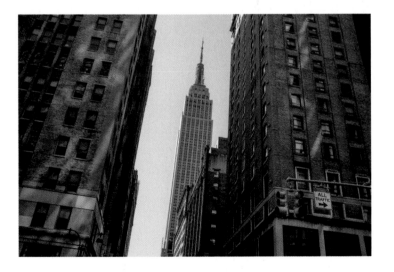

The first time I set foot out on the streets of New York I felt I had discovered a whole new playground compared to my familiar Sunset Strip. Somehow New York City's skyline is like a great mountain range that continues to strike awe when you look at it.

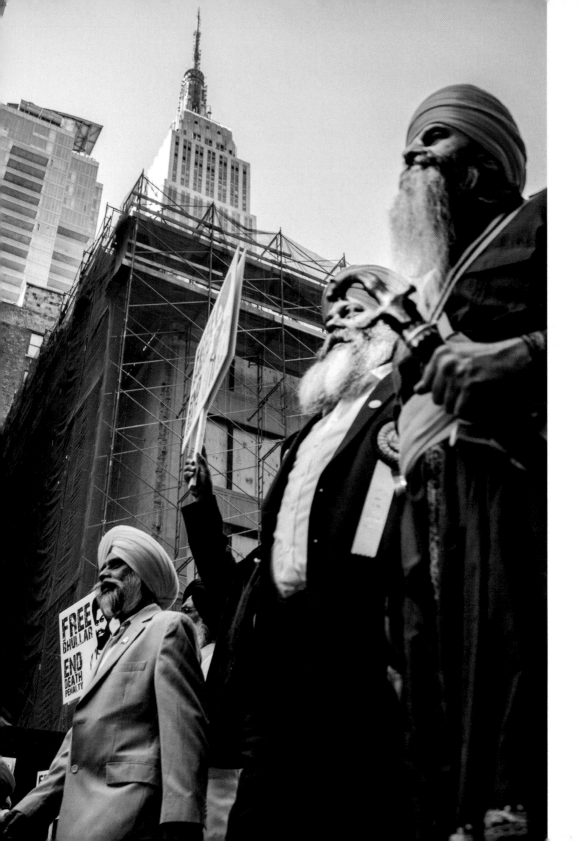

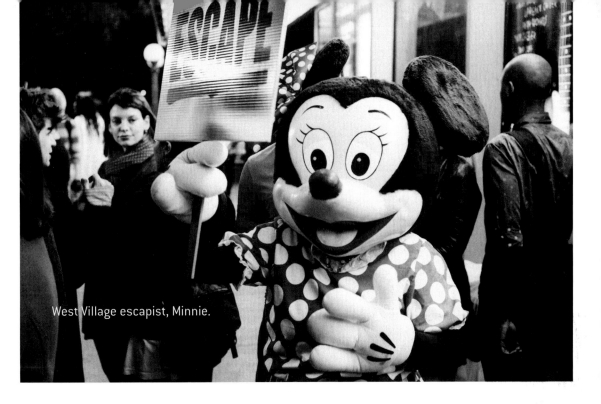

West Village escapist, Minnie.

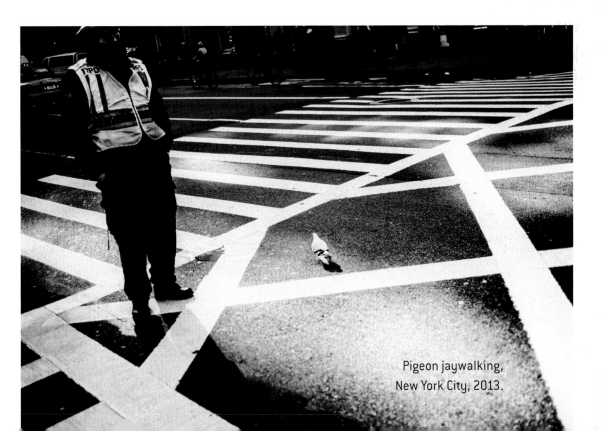

Pigeon jaywalking,
New York City, 2013.

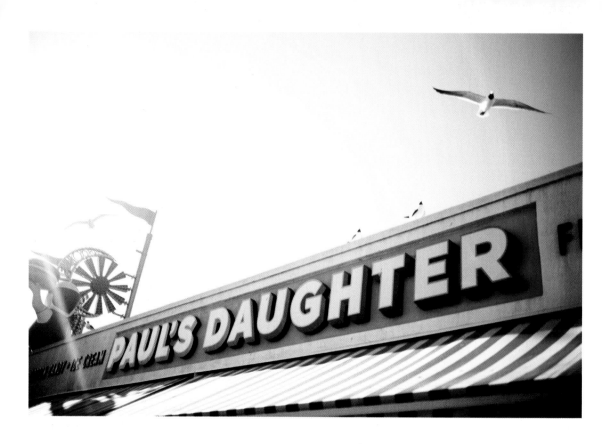

Coney Island. Some say the best soft serve to be found is at Paul's Daughter; just ask the seagull.

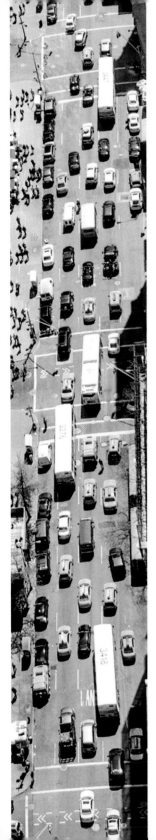

Chelsea Ave.

One more time
Can you look me in the eye
Before you go
Or would that kill all your pride
You said you found
Another place to be
Can it be here
Can it be
One more time
One more time
Can you straighten up this tie
When you're gone
Dressing up's a chore
I'm getting high on
Undeveloped photographs
Unsaid words in paragraphs
Burned at the edge
No room to dream anymore
What we got can't be taken away
I just want to hear you say
That I'm still on your mind
'Cause I am still on your side
And I'll see you again one day
On Chelsea Ave.
Where does time go now
When you're no longer around
Had a dream last night
That you'd wake me in the night
Taxi lights
They're all off except for one

Take me back
This side of town's too heavy, it
 weighs a ton
But are you even in the state
Or did you give your heart away
To run to something you want but
 want to go away
What we got can't be taken away
I just want to hear you say
That I'm still on your mind
'Cause I'm spending all my dimes
As I'll see you again one day
On Chelsea Ave.
I saw you running rain
Trying to catch that uptown train
As I called out half of your name
I was thinking the same
But
You faded into the mist
4, 5 and 6
What's been done
An image on some film that
 touched the sun
What we got has been taken away
I just need to hear you say
That I'm not on your mind and I'm
 wasting my time and I
Won't see you again one day
No Chelsea Ave.
"There is no Chelsea Ave."

Orbit, eclipse

A bomb gone off in slow motion
Burned
To fly too close to
And silence a sonic kaleidoscope
Of synesthetic dreams

Mercy; made in the dark

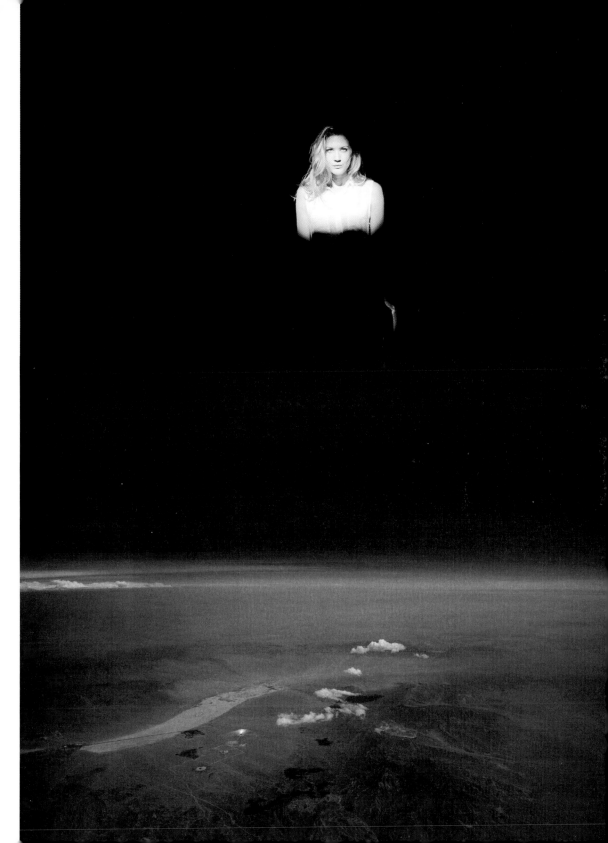

Ships in the night

Ships in the night
Gives us a fright
That I won't be here
When you land in the sand
Arrival unplanned

I've got nothing to write
No love songs to sing
I haven't known you long enough for
 my heart to sting
But I'm here
And you're there
But you're everywhere
And I can't get you off of my mind

In an old New York bar
At closing time
You might think you see me
But your eyes will be lying
Because I'm here and you're there
But I'm everywhere
And you can't get me off of your mind

I'm telling you
That I might hop on that plane
Because you're all I've ever needed
Everything here just feels the same
I'm fearing that
You might hop on that plane

And I'll pass you in the air
While you're here and I'm there
And I'll miss you
All over
Again

So while I'm here, my dear
I might tell you that I love you so
And while you're here, my dear
I don't want to let you go

Ships in the night
Fog flashing lights
I won't be there if you land on the shore
I'm across the world at your door

But I promise to write
I promise to bring
Myself to recognize
It's heaven that we're in
When you're here and we're there
We'll go everywhere
And you'll always be right on my mind

Ships in the night
Passing the light
I will wait by the edge
Of the earth again and again
Come back when you can

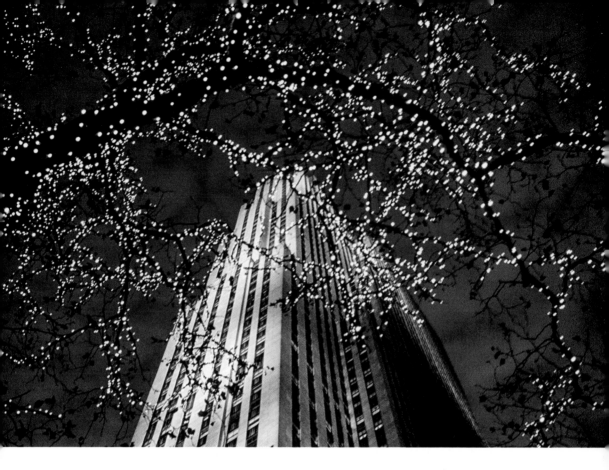

Rockefeller Center, New York City, on E6 chrome film.

New York City during the holidays is enchanted but
Rockefeller Center is somehow the magical *center* of the New York City commercial universe.
A touristic needle weaving over upon itself,
Attracting beautiful moments
And burning memories into the minds of all of those close enough to indulge in why
it stands there. It is a sovereign tower holding ground above the twinkles and
constant light emitting below. And looking up at it, it seems to know itself better
than anyone could explain. A subtle idol.

Infrared film on the XPan

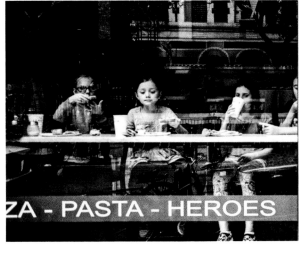

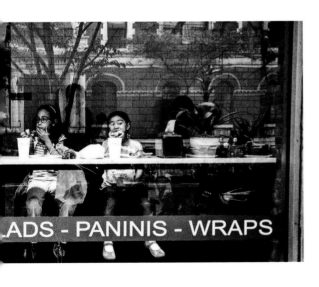

ADS - PANINIS - WRAPS

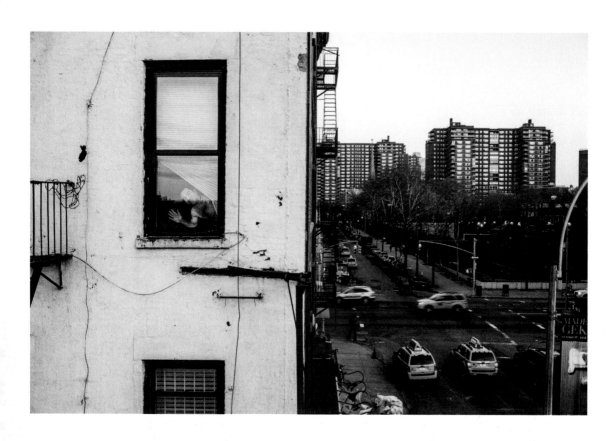

Urban Lair

The High Line in New York.

Dare to look into puddles. Find the other worlds in there.

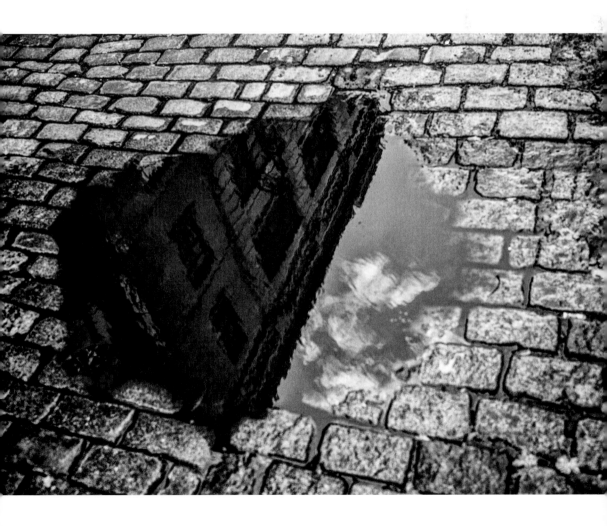

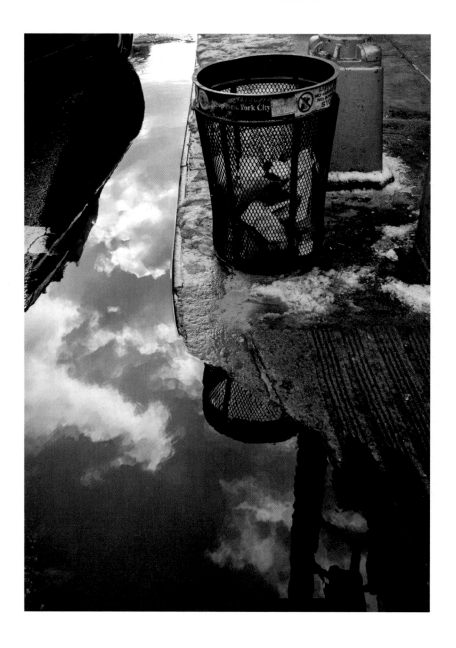

Beauty and trash: how quickly we forget the things we take for granted and how long they wait for us to notice.

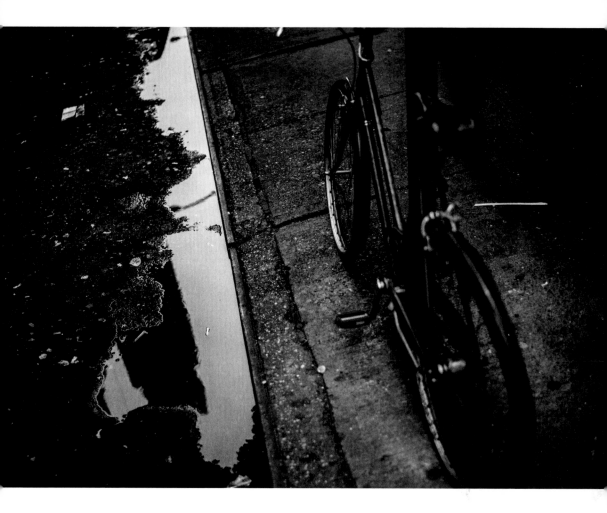

How does one explain it?

It was not a fond farewell. It felt as if it was being pried out of aching fingers. A final dire breath in the last sentence uttered to be remembered as a whole. Hanging off the ledge and the air crunching under your feet. The eternity of this free fall, after the stumbled step echoes through a reverberating oblivion, forcefully floats one towards a mundane and uninteresting landing. Wondering how hard the ground below will feel, and if you can take off running with broken limbs to scale the peak again. Left cold, alone, and in the dark with the warmth of a memory. The only light there is now is a reflection on the pavement from the rain that fell while we jousted upon the summit.

And to know it took months to climb and seconds to fall.

These seconds turn into months again with no escape as the unbreakable mirrors in the concrete are constant reminders of what was before.

Before you break someone's heart, make sure you're not in it.

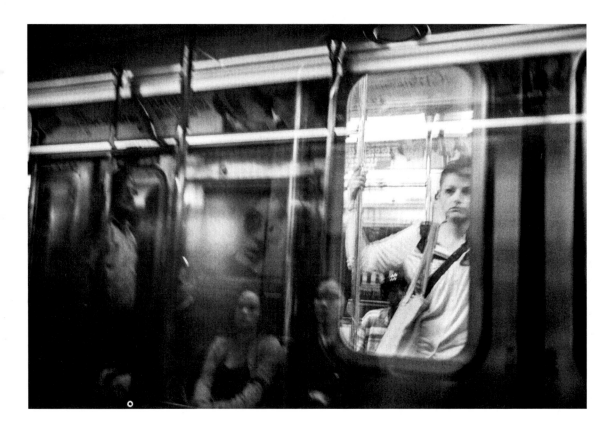

The subway reflects. It forces interaction with others. It nudges you, like a parent, to observe. As an actor, I love to people-watch in the subways, feeling like a human-behavior scientist. I soaked up mannerisms like a sponge to use later as I was on my way to work in the theater.

Down on these streets
I see our life
It's played out by people we don't know
You've changed so much
But I'm back to being me
So I think you might like me
More now.

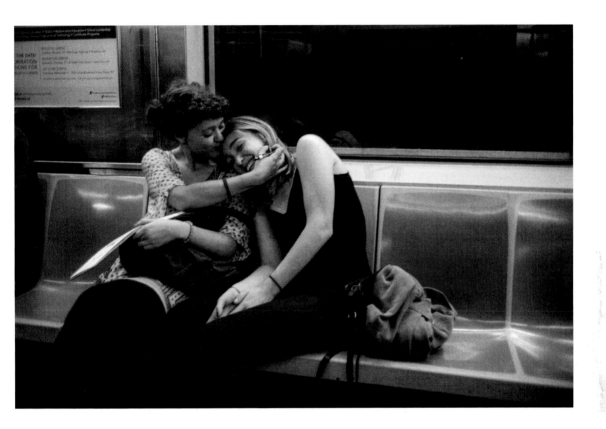

One night, I took the number 1 subway in New York with no destination. I was about to start performing in my first play and I was all alone in a big city. I felt really down since I didn't know anyone out there.

I wanted to see where the night would take me—maybe I could kick these big-city blues by observing happiness somewhere else. In came these two girls. They were such close friends that it seemed they were sisters. It was as if they were talking without speaking any words. I sat across from them and tried to mind my own business but they were so damn interesting that I asked if I could photograph them. They smiled and posed. I told them not to pose but to act natural, and so one of them grabbed the other and kissed her forehead.

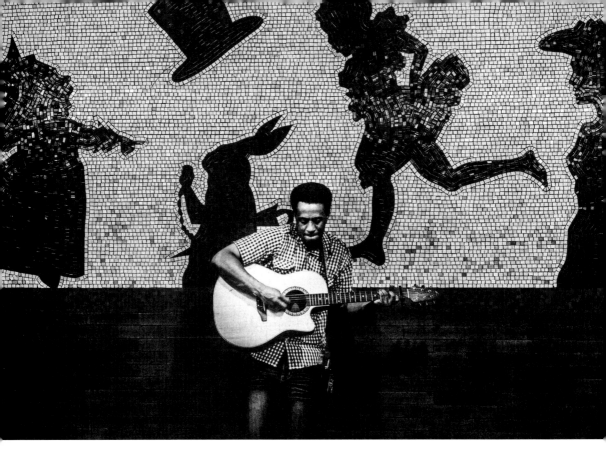

Some musicians down here sound better live than what you might hear on the radio or what you are listening to in your headphones. They will make you stop and forget where you need to go, and I needed to get to the theater.

My first love in the craft of acting is bringing characters to life, live on stage. For these performers, anywhere is a stage with a revolving, sold-out audience.

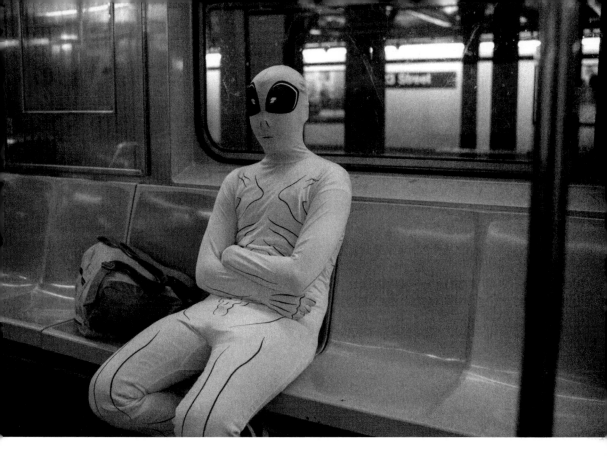

For some, it is not their way home, but simply their home.

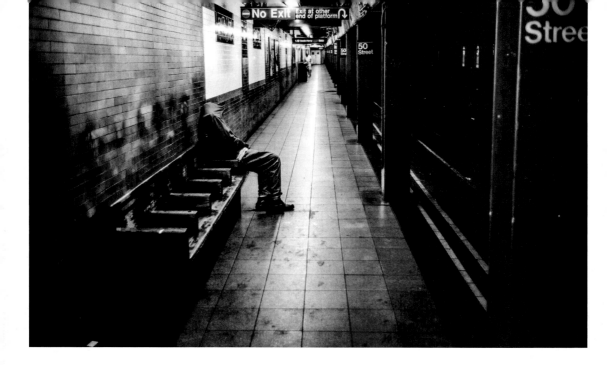

Desolation

A place to get lost, and still feel like you are on your way home.

No matter what time of day or night, you are thrown into a social encounter with groups of friends, families, or lone travelers. There is always a story, whether of great happiness or sadness. On every stranger's face a novel is being written behind their eyes or whispered on their lips.

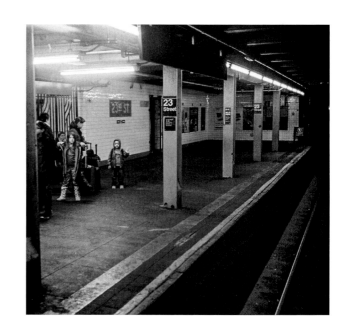

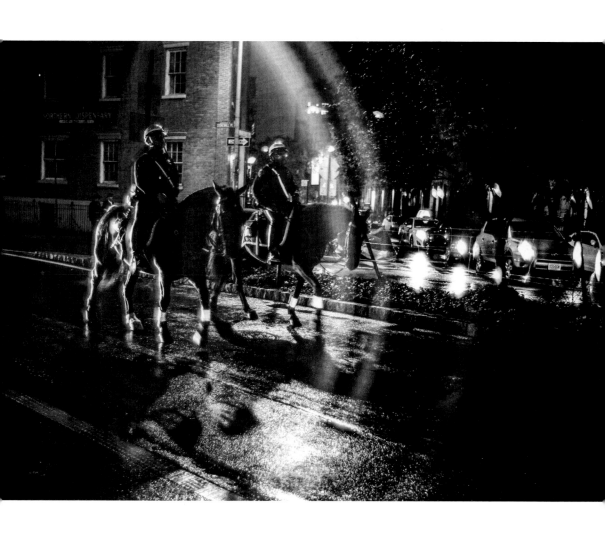

Police on horseback in the West Village.

Fabrizio Goldstein (The Fat Jewish)

Another New York character, a laugh-out-loud funny guy,
walking around in his New York camo.

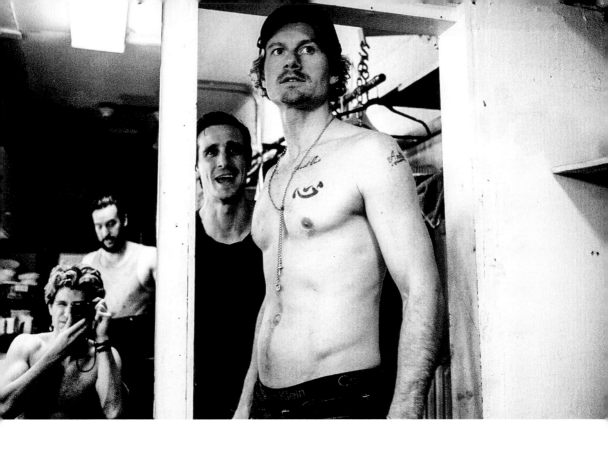

This was taken backstage on one of the most exciting
nights of my career, opening night of *Small Engine Repair*
at the Lucille Lortel Theatre—my New York stage debut.

I did my own hair and makeup nightly for *Small Engine Repair* as I transformed into Chad Walker.

John and PJ backstage after opening night of *Small Engine Repair*.

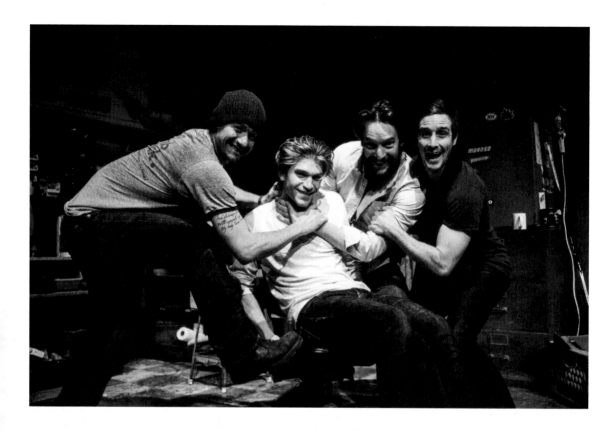

Here is the cast of *Small Engine Repair*. Every day before the show, we would do a fight call, meaning that we would run through all the physical, simulated fight scenes so no one would get hurt during the actual performance. Every night in the play, I was punched and strangled (among other things). This was our last fight call before we performed the final show to a sold-out audience. I miss being together with these guys every day.

Our journey together on stage had come to a close. The theater is a strange family where you live and breathe together for a production, then part company and go on to your next project. There's definitely a period of loss and sadness in the transition. This was taken on closing night of *Small Engine Repair*.

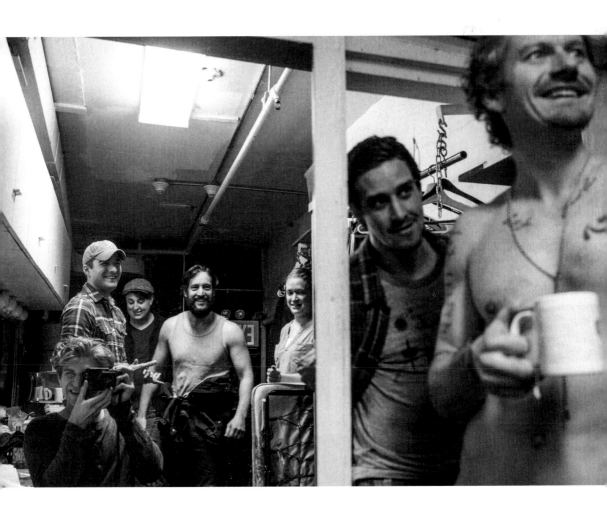

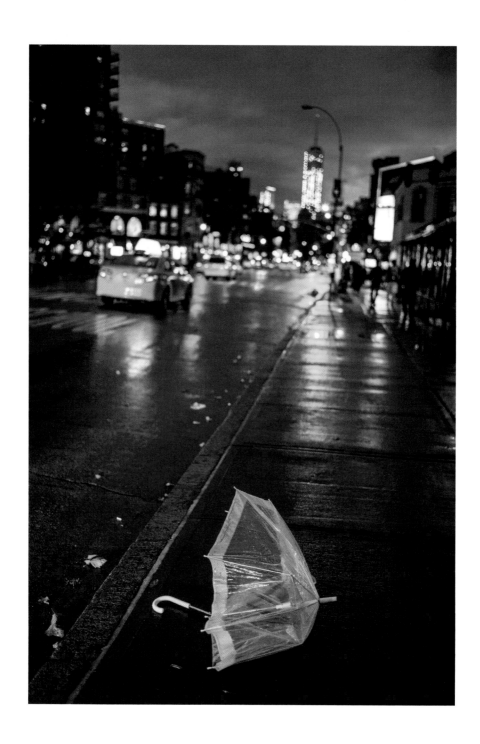

That's life. I enjoy the rainy days.

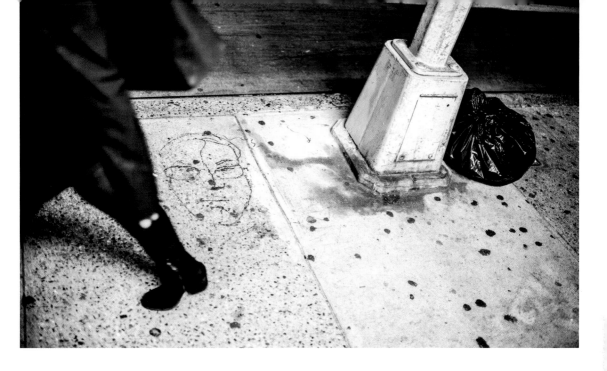

New York City streets have seen so many faces pass by.

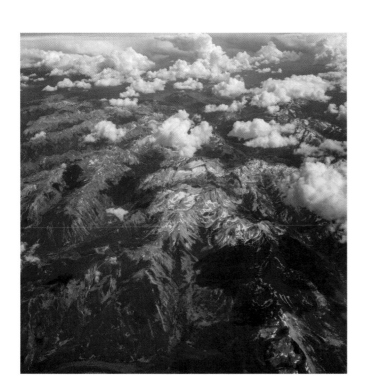

Up in the air.

Being up in the air, in a vacuum high above the ground, my mind goes to the ones I love. I imagine them thinking of me on my travels, wondering when I will see them again. Great distances bring me closer to them up in the air; I look down below and see a circuit board of others chained to others.

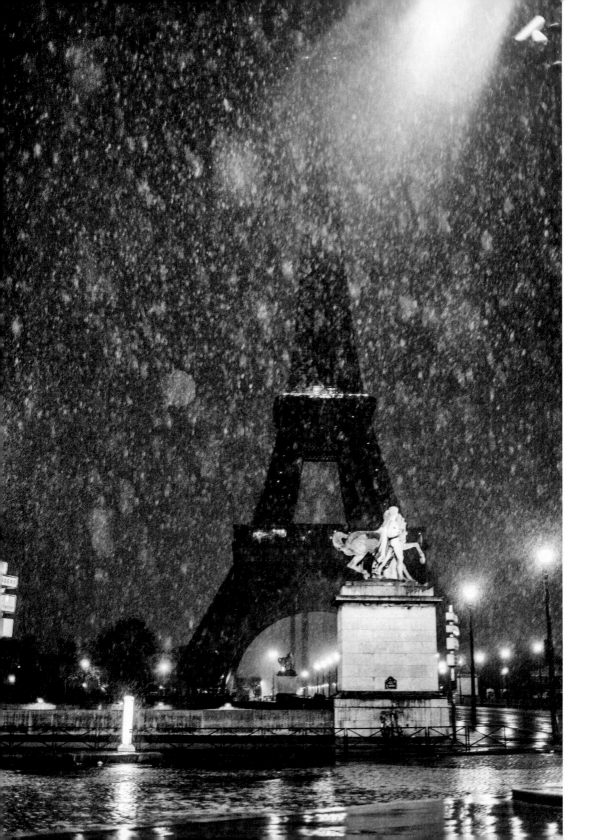

Boarding a plane for Europe, my head was filled with so many dreams of art and architecture. I looked out the window of my calm flight at nothing but the blackness of the Atlantic. When I landed, I was excited to see what my lens might capture. I was traveling there for a show convention, but it felt like a dream I have imagined for so many years. Dreams do come true for each of us if we work toward them each day. I'm sure that's how the builders of the Eiffel Tower felt. When I arrived in Paris for the first time, it was already ten p.m. Since I was still on West Coast time, I decided to stay up all night and explore the city. When I arrived at the incredible Eiffel Tower it began to snow. It was the first snow of the year, and the tower loomed in the distance like a dreadnought. Since it was so late, the lights were off on the tower and no one was around. I spent my very own *Midnight in Paris.*

Ian in Paris.

This was taken on the streets of Nîmes, France. I was there with Ian and Holly Marie Combs. Poor Ian had broken his leg Rollerblading and had to travel to France with us while complaining about his swelling on the plane. . . .

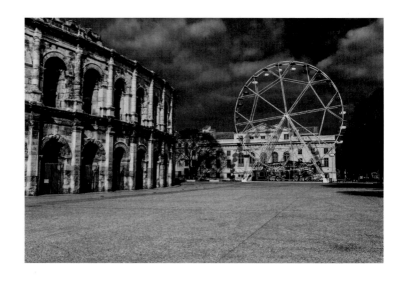

Modern Colosseum, Nîmes, France. Clearly our modern games are slightly more civilized than in the days of the gladiators.

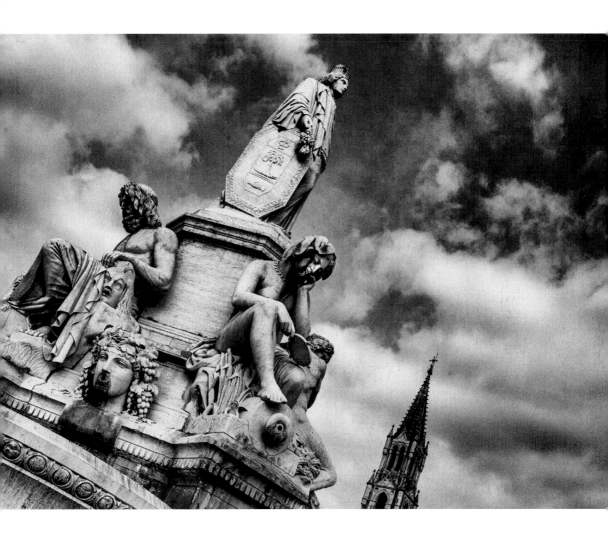

Outside of the convention hall was a frozen fountain: a dramatic scene with the clouds hovering above and a Gothic steeple in the background. During one of our coffee breaks we explored Nîmes and enjoyed the timeless stonework and architecture.

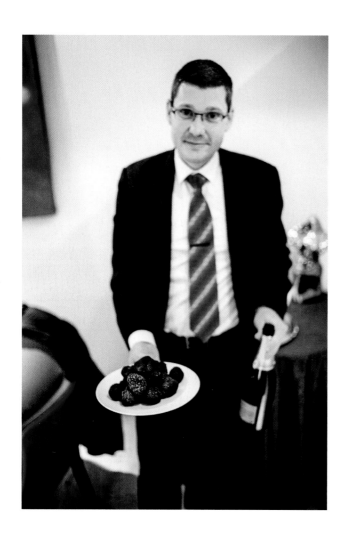

This is insane! This is a restaurateur in Nîmes proudly showing off his 100,000 euros' worth of black truffles. Hopefully he wasn't about to drink out of the bottle too!

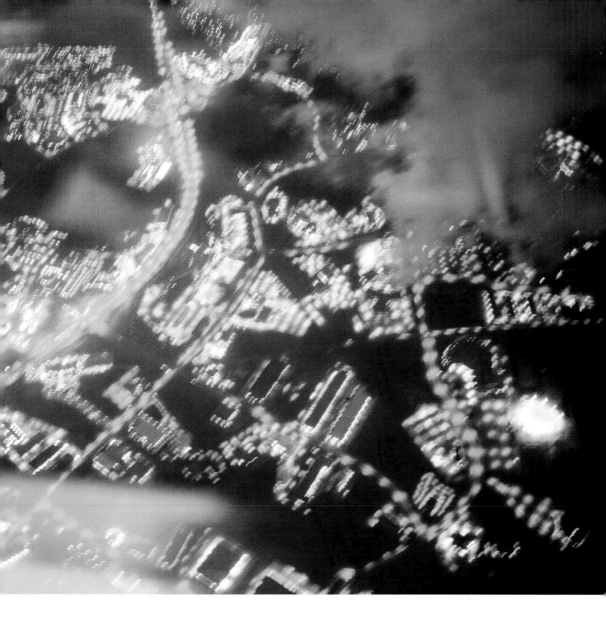

A colorful diagram of people wishing for our safe returns. Traveling upward, we hold on to the last words we spoke or text we sent before being held in limbo. So far from the ground and so close to the nothingness above. Hovering above our homes and land, seeing these things as we may have never seen them before. It all looks different from up here. Quiet.

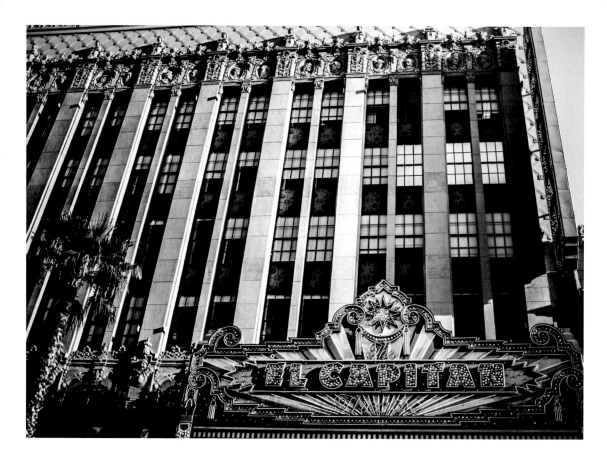

El Capitan Theater—Hollywood Boulevard

When you are down to earth—you are real. And reality is boring? Or so I've been told.

Hollywood is a snake pit. One must either become a snake or learn to handle them—and learning how to handle them will get you bitten, but hopefully you learn from each bite.

The sounds of the street on Hollywood Boulevard at 3:30 in the morning are pretty calming—every bum is asleep on their stairs or favorite sidewalk. The people of the night, all cuddling in their buyers' bed. The bad guys are, by this time, very lost in downtown and all the police are dealing with Northridge.

I walk with myself and ponder the use of trust—the reliance on integrity, strength, ability, and surety of this town.

Everyone Lies to Everyone

That's why people die and wars are waged
That's why marriages fail and money is lost
That's why buildings are erected and people fall
That's why babies are in Dumpsters
Animals on the highway
Beer in the toilet
And it goes on . . .

Think the truth is good to say because when you tell the truth—
 we don't need to think about it anymore—There it is
No more to be said.
When you LIE
It is ALWAYS found out over time
By accident or on purpose
And it turns into a disease
You keep doing it—until you can't control it . . .
You begin to lie more to cover up the original lie
And then
You lose track . . .

"Sooner or later God will cut you down," as Johnny would say
And I think I walked on his star (a public Hollywood
 gravestone) a couple hours ago.

We are young
Stupid is not an excuse—
Time is not an excuse and
You can no longer lie
Even to yourself.
Tell the truth and tell me it all, little Tinseltown.

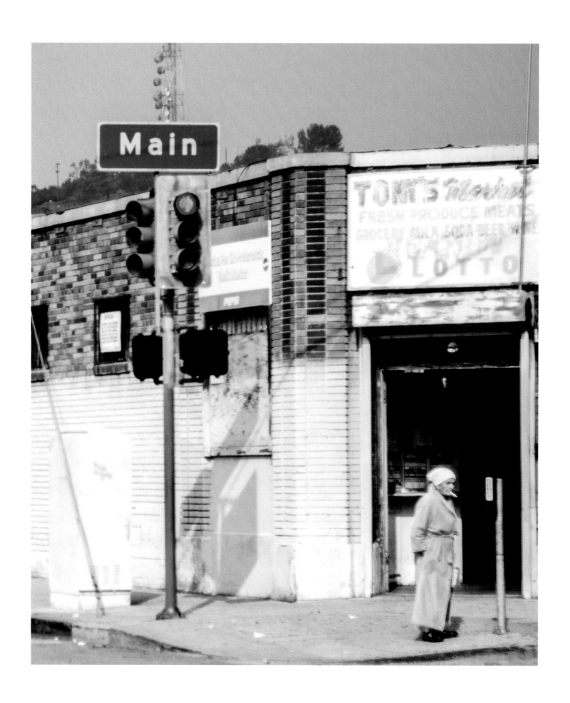

Hopefully Main Street has seen better days.

Los Angeles is a playground.
A hell to feel safe in.

Undercover Gun/Joker, Santa Monica Boulevard, 2011

Hollywood Halloween offers a view into the imagination of all the people who pump the lifeblood into the stories we enjoy on our televisions and in theaters. But among the cacophony of sex, drugs, and mania, the peacekeepers hide silently in the crowd and are always at the ready. I took this picture during a Halloween parade in West Hollywood in the dead of night. It felt like millions of people were in the street, with Santa Monica Boulevard completely shut down to cars. I rarely go out into this mess anymore, but I wanted to capture it, to show the sharp reality of boundaries that exist if someone steps out of line.

Someone had started a knife fight and threatened another guy with a gun. Suddenly, the street filled with LAPD and undercover cops. Can you spot him?

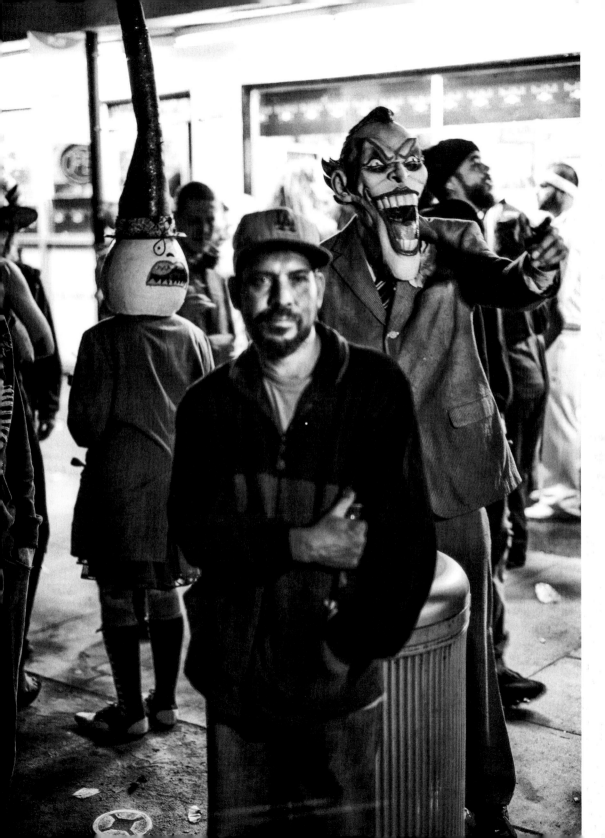

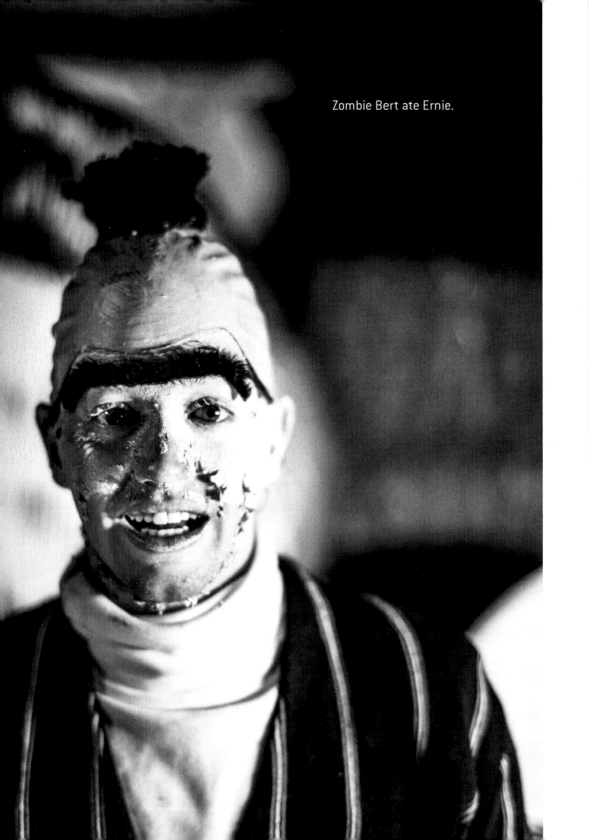

Zombie Bert ate Ernie.

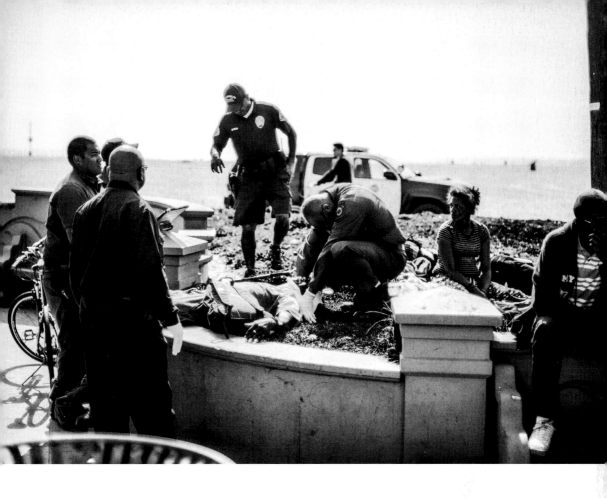

Venice Beach drama. I remember the first time I snuck down to Venice Beach with my friends. I was fourteen and it was not a place my parents wanted me hanging out. Venice Beach has become so symbolic of the quintessential urban Southern California beach from its famous glory days of muscle-building and sunbathing. It's "a see and be seen" cement boardwalk. It has always been a bohemian hot spot in the Los Angeles landscape, a multicultural tapestry giving way to its rougher edges. . . . Life goes on around drama in Venice Beach.

Even Prada needs a face-lift every so often: the alley behind Rodeo Drive, Beverly Hills.

The Beverly Hills Ice Cream Man

This image takes me way back to my childhood. My parents would dress me up and take me to Beverly Hills. It was always a big to-do.

One of my earliest memories is of my father buying me a fudge bar after playing in Roxbury Park. My old man was not so old then. The ice cream man offered the most thrilling array of trinkets and sweets in that beat-up wagon. He wore shirts that looked like ice cream. On windy days his hair would look like a whipped-cream topping. He was from another time, from another life, chained to that van in my memory. I still see him to this day. For some reason he fits right in next to the designer stores and their front window installations. He seems to just melt and belong.

One day when I was out roving around with my camera, I noticed these kids at a bus stop and immediately imagined their desolation and the starkness of their lives. Yet, I knew nothing about them and my judgment could have been wildly misplaced. They could have been doctors or scientists, parents or caregivers to someone in need, or brilliant artists in pursuit of all the questions we ask. It was somehow both compelling and scary to me how quickly we judge lives we don't live. I guess in some ways all of our lives reflect the choices we make and where we decide to put our energy. Considering I grew up on a street not far from where this photograph was taken, I am grateful for my good fortune, choices, and my work.

Beverly Boulevard Hope

I was working at a photo shoot above Swingers restaurant in this classic
motel. I was asking myself who would stay here and why. As the sun was
setting, a woman was checking in, and then she went to the window of her
room. Her contemplation and silent gaze struck me in the most thought-
provoking way. She looked hopelessly hopeful and longing for something she
may need or already have. A picture is worth a thousand words.

Santa Cruz, California: A Lost Family?

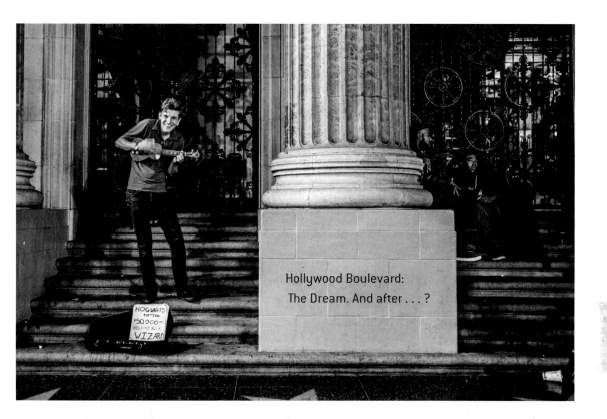

Hollywood Boulevard:
The Dream. And after . . . ?

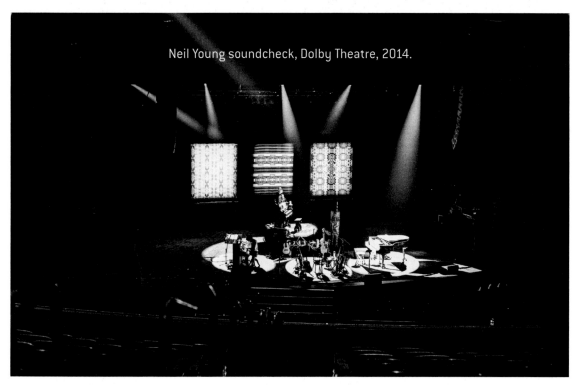

Neil Young soundcheck, Dolby Theatre, 2014.

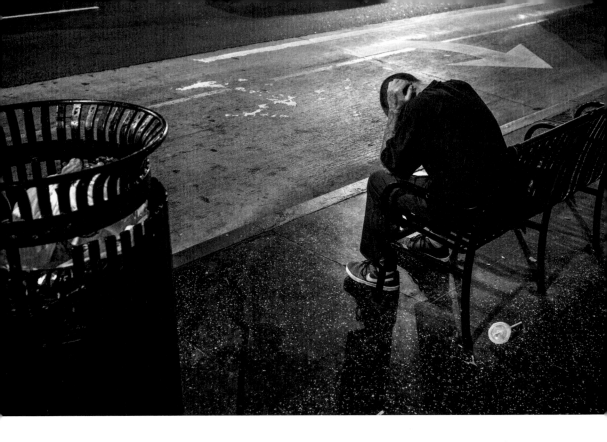

Hollywood Boulevard: they call it the City of Broken Dreams for good reason.

The Excuse

'Cause I am too stupid, immature, selfish, and immoral to truly appreciate someone else's love. I know what to do and don't want to do it because it involves too much work or it is not worth the outcome. I don't have the time or patience. I am too expensive. I am always "wrong." I don't care about feelings. I am a workaholic. I am allergic to your commitment. My words are all lies. I come on too strong. I don't come on strong enough. I need my space. I believe in ghosts. I don't eat red meat. I don't want you on my bed. I love you. I like you. I hate you. I want you. I ignore you. I call you. I can't talk to you. I am with someone else. I am with you and you are with someone else. I am still in love. I can't fall in love again too quickly. Love is for people who like to get hurt. Love is a waste of time. We don't connect. We connect but we can't make love. I write songs you can never hear. I make you cry. I make you think. I make myself hurt.

I thought you liked me. I need some time. You need some space. We need each other.

Talking in the Wind

When you walk outside
Does everything around you start to die?
When you look past your eyes—
Behind the mask
Do you start to cry?

We keep on talking in the wind
Because no one can listen to us now
Just keep on talking in the wind
Since it won't matter anyhow.

Standing still and everything is moving
moving
moving on
Mama, you should have told your boy
That these kings and queens
were once all pawns.

We're looking for someone who belongs here
We can't make it on our own
And baby, they should have told you
That you can't
make it all alone.

So, they tell us to be strong
And *everything* will be OK
"It's just I've never waited this long—
And I can't
wait another day."

Just keep on talking in the wind
Because no one wants to hear you now
We keep on talking in the wind
No one listens anyhow.

So let's all sing along inside
The words of these songs are all the same
We all live each other's lives
But we go by different names.

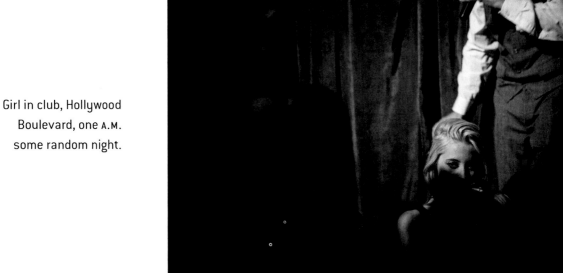

Girl in club, Hollywood
Boulevard, one A.M.
some random night.

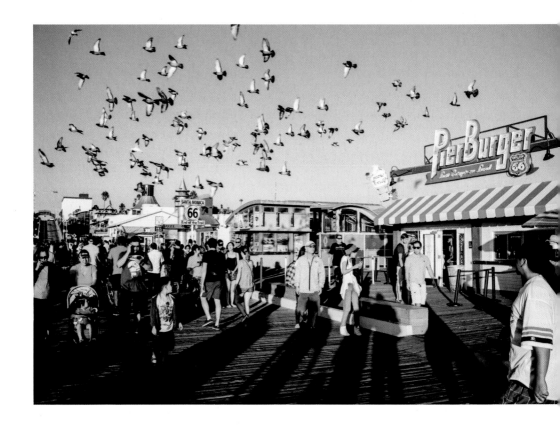

One More Night

Tonight we will be the ruler of all the families.
The Capetians and the Rothschilds will bow to
 kiss our feet.
Will we dine amongst the gods?
Or may we fly to where they could never
 reach?
Seven away. Home at our back.
I feel the fabric of our previous life tearing
 slowly, burning away under my coat.
 Flicking your lighter inside my sleeve to
 keep my fingers warm.
Burning them through the numbness.

They told us we could never make it here, to
 our world.
But we ran through Beverly Hills and kicked
 over its fake plastic watering cans.
(Thom, you were right.)

The Apple store has nice robots in it to fuel the
 grand machine. The flux de trésorerie.
We applaud them fondly and connect without
 talking.
Alone, it could win this robot war, but it
 recruits us;
The heart of its personal army, the voice of a
 generation muted under binary chimes.
We all gladly hold the monolith and peer into
 the window of tomorrow.

Onward to the blast zone of Venice—a
 scramble of my transient brothers and
 sisters, made to watch each other fight
 and steal at the sparkle of sunlight.

We will find a spot to
Take a nap and then
 report back to you, my trusty paper goblet.
Our travels will continue further.
It is illegal to live in my mother's nature and to
 be sixteen, out
 skating past ten p.m.—
It's a crime against everyone who has ever
 loved us
 to leave where we feel unwanted.
They choose to stay.
We run.
Criminals.

The beach is our home
We love it without possession.

We hitchhike down the coast and inland to the
 wintery divide.
Tiny homes covered in snow that smell like
 burning bread.
All of them lit with yellow buzzing bulbs,
 and strewn with trinkets on the porch
 inviting strangers to knock.
We climb up on the roof of a winter bird's
 summer nesting duplex overlooking the
 lake.
We've been up all night and we don't want to
 go back.
No one wants to ruin this moment of freedom.

We have talked throughout this journey but
 only now she speaks with conviction.
The words are heavy in her mouth as she

lowers her jaw while searching the sky
Time stops when you have no interest in
 finding it

"What's out there?" she asked.

He looked out over the rows of houses . . .
 quiet and covered in snow. His breath
 hovered in the air like a lazy balloon
 as his eyes spotted a point beyond the
 clouds.

"Whatever you want," he said defiantly. "What
 they told you was only what they could
 believe."

Stars are out in the night sky,
 and they will never come down.
If this night lasts forever then we are
 forgiven.

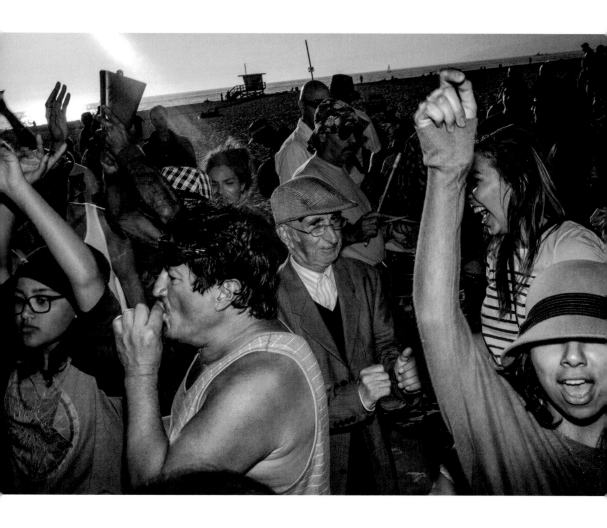

Venice drum circle.

Even man's best friend loves Venice Beach.

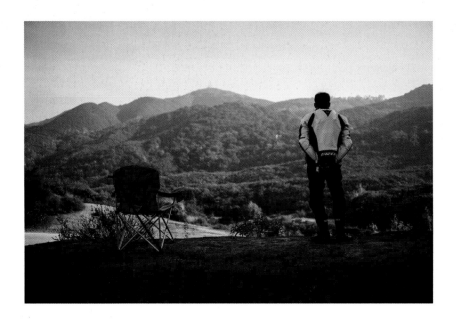

The famous Mulholland Snake.

The Rock Store photographer. He has seen more crashes than he cares to admit. The Rock Store is a famous motorcyclist gathering spot on the way up Mulholland. The Snake is very well-known among road enthusiasts. My Harley Davidson loves it.

The beach in California has long been a stronghold
for those inclined to push new directions in their
workouts. Just ask Arnold. . . .

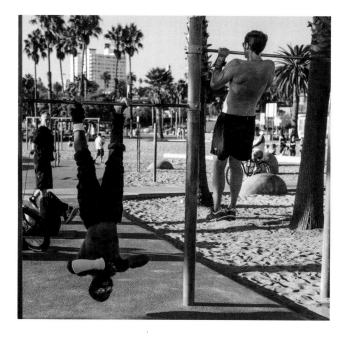

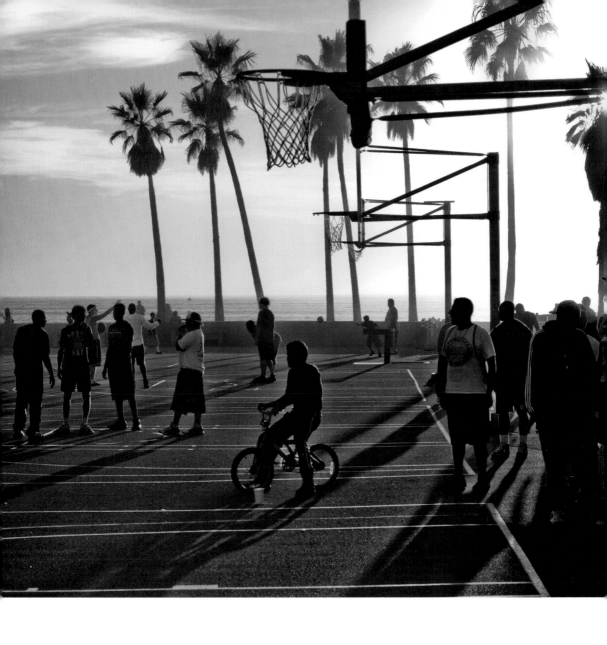

The courts at dawn on a hot summer day.

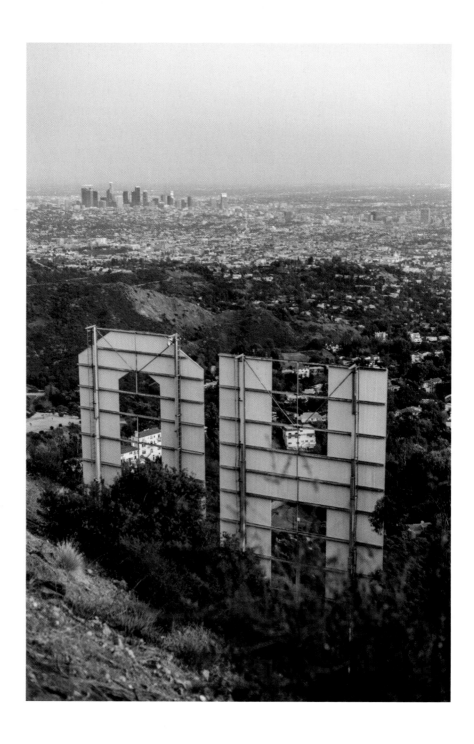

It's very illegal to go up to the sign. I got chased down one time by a helicopter for coming through the wrong gate and getting near the letters.

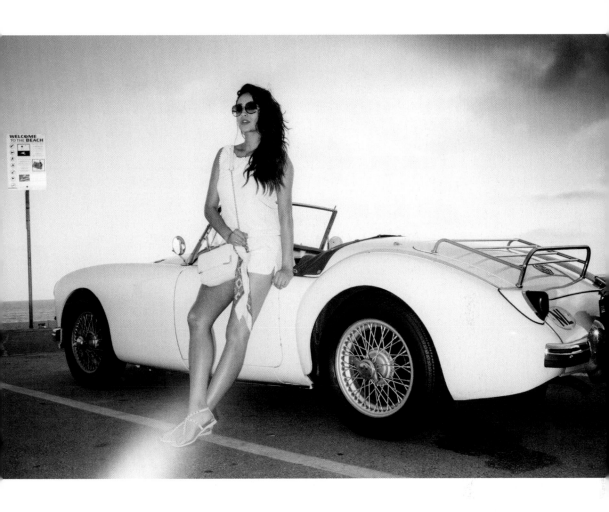

A thing of beauty.

Its lines, its curves, its natural grace moving everything it touches . . . ride on, ride on.

I am a Southern Californian, born and raised, and I just love the ocean. I am lucky enough to live in a place where I can visit the beach year round, so when my friend Shay wanted to take a drive in my roadster, I thought of no better place than the coast. Shay is from Canada—she is no stranger to cold weather—so you can imagine how much she loves California. We spent the afternoon taking photos of each other on the lifeguard tower posts and enjoying the afternoon. We even met some fans on the beach. If you ever need to reboot your mind, sometimes an afternoon in the sand is all it takes.

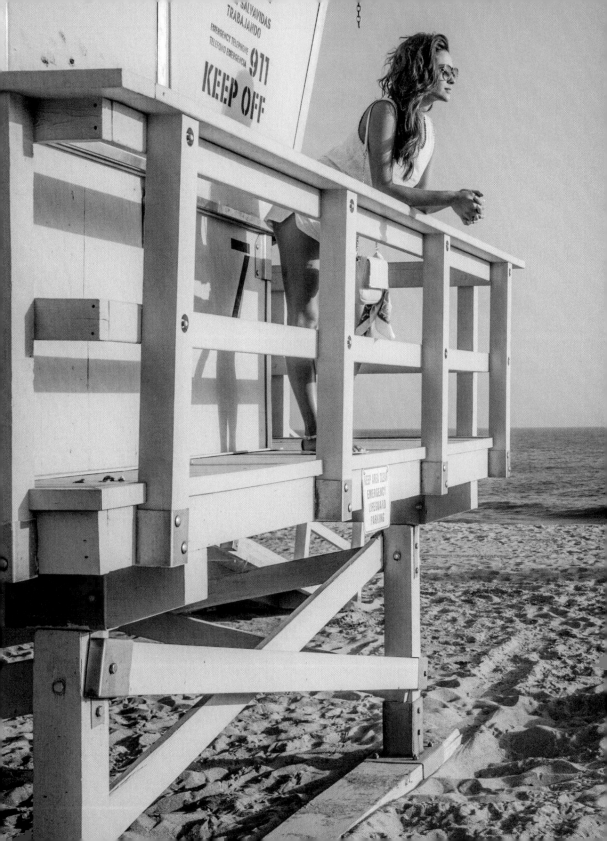

The *SuperFan* Nation

In this part of the book, I share images reflecting the tremendous outpouring of love and affection I have received from fans of my work as an actor. I am moved by the intensity of feelings that they share with me when I interact with them every day through Instagram, Twitter, Vine, Keek, and Tumblr. When I post a new photo, I instantly get tens of thousands of "likes"—and when I "like" a fan's photo or comment, they seem so thrilled and immediately receive lots of attention from their friends and followers. But it is especially uplifting for me to meet them in person, and to surprise them by taking pictures of them even as they vie to snap photos of me!

The fans, the love, the tears of joy in meeting a stranger who knows me.

I still have a hard time with some of the emotion
that our show brings out in our fans. I can't believe
that the sight of me can cause a reaction like this.

Happy campers

It's an understatement that if it weren't for all of you, I would never have the opportunity to take a photo like this. Someone early in my career kindly said to me that having fans was a by-product of the good work I was doing. The response from all of you to Toby and *Pretty Little Liars* has humbled me as an artist in so many ways. I enjoy looking at images of all of you, because it reminds me how lucky I truly am.

I love to photograph fans. They are thrilled, and the photos always feel electric and anxious. The line above was for my first solo acoustic performance, in Binghamton, New York. The support of the crowd was something I had never experienced before. Here was a group of strangers who hung onto every lyric of songs they had never even heard before. People had been waiting for a whole day to get in. They had separate lines for a meet-and-greet and for the concert itself. One girl came all the way from Canada, videotaped her journey, and then months later traveled to New York City to meet me following a performance of the Off-Broadway play I was appearing in, *Small Engine Repair*. There, just outside the Lucille Lortel Theatre in Manhattan, this sweet girl gave me a DVD capturing her journey as my fan. It brought me to tears how authentic and eager she was to express the level of support she shared with her peers. Thank you, Jenn!

True fan love

Niagara Falls Fans

These girls hunted me down through a social media post that I was at the Falls for the day and actually found me. The power of social media is unmatched in this generation and it might be cool to share the story of why I took their picture.

Within minutes of posting online that I was in Niagara Falls (Canada side) for the day (taking a break from shooting *The Hazing Secret*), reading my book and completely distracted by the overwhelming roar and beauty of the falls before me, two teenage girls approached. I told them they were welcome to join me, so they did. Both of them couldn't believe that they found me through my Instagram post, and we talked about everything from maple syrup tourist traps to Clifton being a disguise. We also talked about the show and they asked me about my photography and the book that I was working on. I examined the scenery and told them to act natural and I might take a photo of them out in public to put in the book.

So here it is, a very surreal glance at the urban Niagara girls who were savvy enough to find me and kind enough to let me photograph them— I moved from the spot promptly as word got out quick that I was at the bench and pretty soon small groups of bottled lightning were chasing me down. The power of social media.

Traveling from town to town, I am so moved by the warmth, affection, and tremendous creativity of my fans. I love you all so much.

This day at the Teen Choice Awards celebration was really fun for many different reasons. Shortly after I finished doing interviews, meeting some of you, and taking photographs, I went to my seat, which was pretty close to the stage, and saw a great opportunity to take a photo of all of you. It seemed like a good idea to me, but I got screamed at and chased off the stage by security. I didn't really mind it too much, because I got this terrific shot and happened to win my award that day, too.

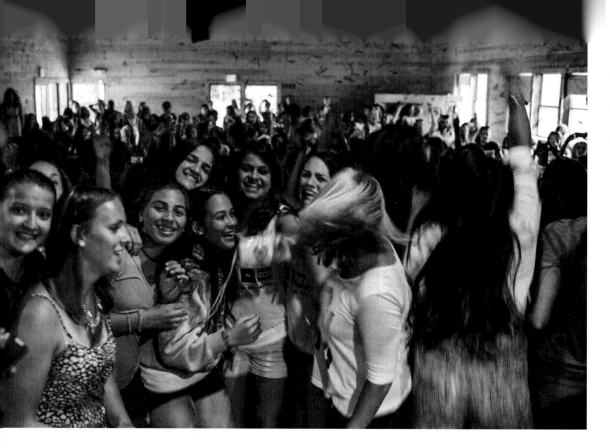

I traveled to Camp Danbee, an all-girls summer camp in the Berkshire Mountains in rural Massachusetts. Thanks to all of you, I got served up as the celebrity surprise.

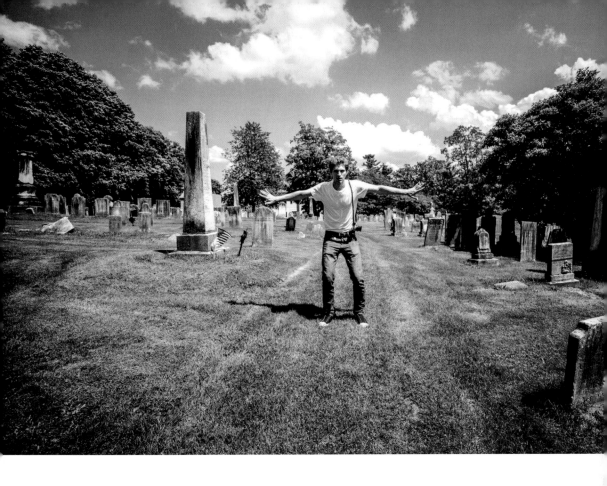

The great thing about visiting Camp Danbee was that after I went to my hotel in Lenox, Massachusetts, I found a graveyard close by. There are a lot of lost children from the 1700s buried in this cemetery located just next to the Church on the Hill in Lenox. Walking among these tombstones after hours definitely gave me my eerie fix!

My interest in the paranormal had my friends and me hanging out in graveyards, enchanted forests, and gravity hills throughout my adolescence. Every night we would try to find a new place to explore. Research online all day and sleuth all night was our motto. When I did a guest role on *CSI*, I had to fall asleep against a stranger's grave, which of course I loved. And when I first started working on *Pretty Little Liars*, I found myself right at home on the show's creepy cemetery sets.

The sound of a million people breathing. Tyler Blackburn and I went to the middle of Times Square to do the ball drop show with MTV. I never thought my first Times Square New Year's Eve experience would be appearing on a TV show, live in front of a sea of people.

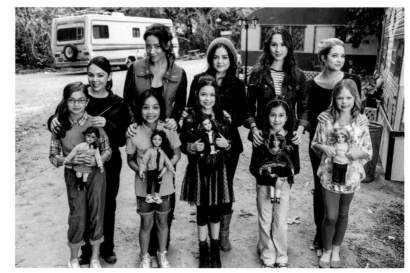

Generations of Pretty Little Liars.

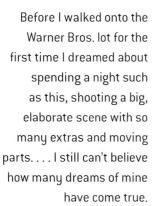

Before I walked onto the Warner Bros. lot for the first time I dreamed about spending a night such as this, shooting a big, elaborate scene with so many extras and moving parts. . . . I still can't believe how many dreams of mine have come true.

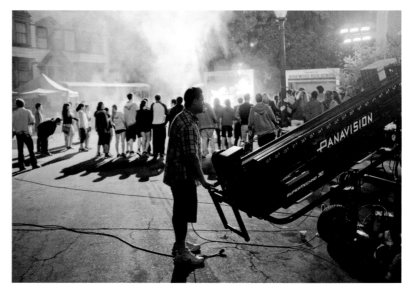

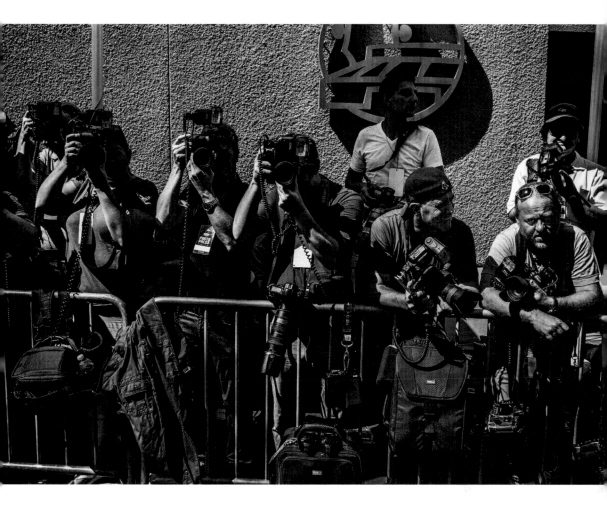

The paparazzi and Hollywood are forever connected. Sometimes they're demonized for snapping pictures of us during private moments, while other times we stand and preen for them on the red carpet. When I think about paparazzi and their lives, I always remember that they are photographers fortunate enough to be working and I try to show them the professional respect they deserve.

At press events, sometimes I sneak away from my red carpet interviews to spend a bit of time talking with them about photography gear before I get roped in by an overzealous publicist escorting me to my next interview.

Here you are seeing the reverse side, me being a vulture with my own camera.

beauty

Ask if these are palm trees or flowers
Ask if I miss you more everyday
Neither answer matters
when we are not around to experience
the beauty
of
the truth

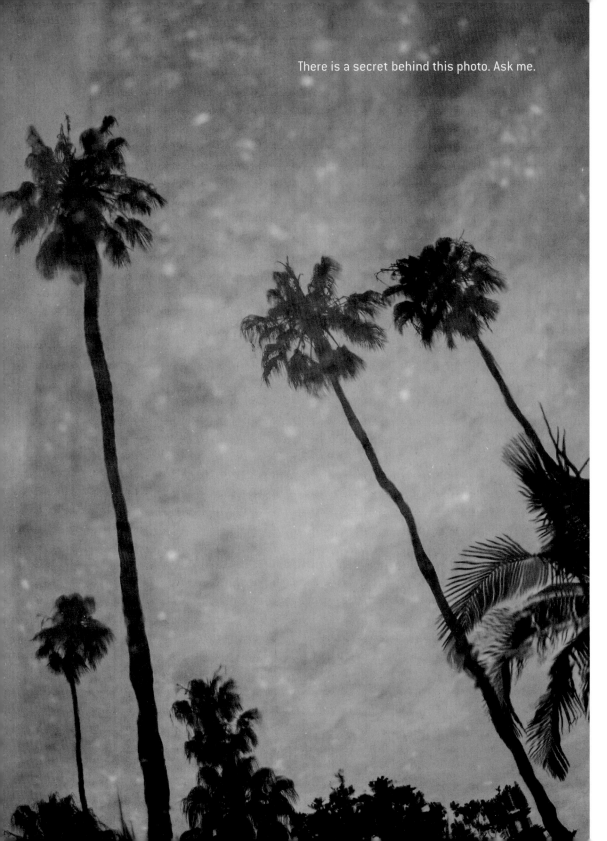

There is a secret behind this photo. Ask me.

The rain to stay.

Half a life is all I need
It's all we've ever had
Until the day we realize
It's half of what we'll ever have
Ever have
Ever have

Clouds that won't go away
The moon is dipped in paint
The sound of silence on the waves
And the still awkward state
That we're in
That we're in

The sun is silent
Burning down the trees
And you're still standing
Waiting for me to leave
I want to hold you
Like you want me to
But I'm so lost, my dear
Lost on this trip that I've started here

Never wanted it before
Never want it again
It's just another inside day
Where I want the rain to stay
Rain to stay

It's been such a long, long time
Since I've seen the rain
So I would let you drench my skin
I'd catch you like a cold
I'd let you in
I'd let you in

I come from a time
Where it's cool to fall in love
Sub sublyrical in the words
I'm so sublime
You'll find me
Here

Life without you
Is just wasted time
Missing stories
Between the lines
When will I see you again

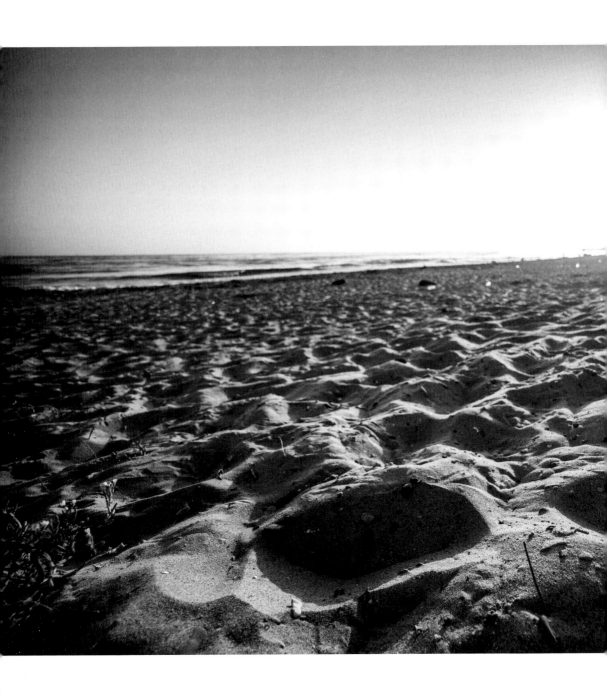

Footprints in the sand are still as fascinating as when I first saw them as a child. Each one has their own story of why they came to the shore. What is it about the ocean's shore that causes us to make the pilgrimage time and time again? Does it ground us? Does it elevate us? Or does it simply drown out the noise in our minds of everyday struggles as the waves slowly erase the troubles that litter our thoughts?

———————————

I still see you in the health of the sun, the quench of the water, and the relief of the breeze. I still hear you in the words of a lullaby, the ring of the telephone, and the song of the jam band. I still smell you in the sting of amber, the frost of winter, and the keen citrus of summer. I still feel you in the clouds of bedsheets, the kiss of cotton shirts, and empty shoes. We can pretend. We can get good at pretending. We can master pretending but it will still be pretend.

It's only when we look back on the flame so bright that we realize it was an inferno. Don't look back but let the heat warm your spine. Your next fire will leave you cold and dreaming of what once was. Wanting more but getting less. Risks that are not worth fueling. Reason or rationale but put into the trash.

You will search for me forever.
Find me a while I am still here
In front of you.
Hold me and never let me go.

A spiritual reset button pushed around the world as the gravitational pull begins to emulsify into the stratosphere.

There is a great love story between the sun and the moon:

Dear sun,

You're my burning fire
Up above the rain
A dark side of desire
I can feel your flames
In me
It's love
I feel
And I just can't believe
You exist
This is real
And I don't trust opinions
Like "the sky is blue" (is this true?)
 I'm in love with you

I know you're far away
Never visit, we stay away
But I know I'll see you soon
Even if it feels like
You're the sun
And I'm the moon
And we miss
Each other by the light
We create
Or dismiss
And I don't trust logistics
But I know this
 I'm in love with you

I'm burning up for you

Love, moon.

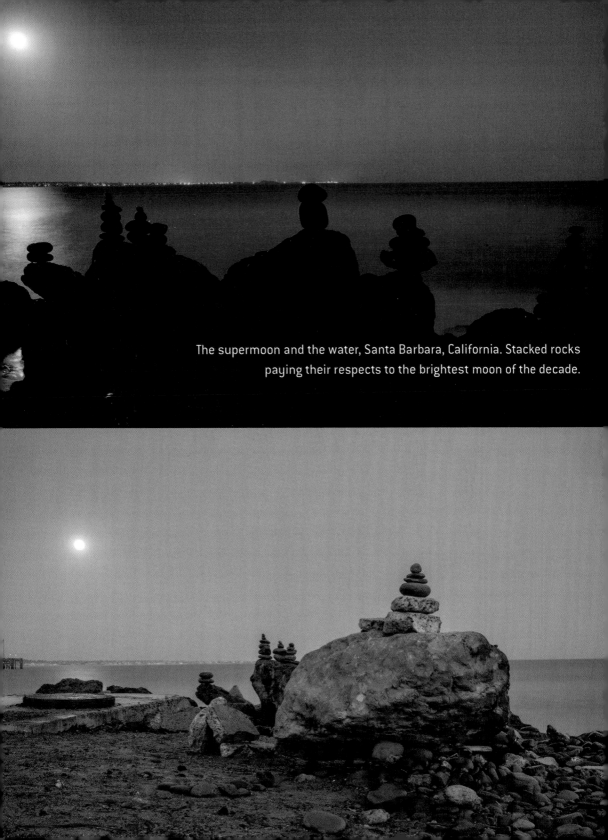

The supermoon and the water, Santa Barbara, California. Stacked rocks paying their respects to the brightest moon of the decade.

A fire that roars
Burning the wet sodden sand cabin
Built with so much time.
As it burns the air becomes damp.
Steam illumination.
But the fire is strong and fed with munitions
Of poorly trusted sources.
The flame is able-bodied in consuming the
 moist earth.
All the while
Thoughts trapped within.
Cheeks are wet, but not from tears.
Lungs fighting for air.
Yelling.
I hear you.
Everyone hears you.
But no one can save you.
The first line of escape is panicked digging.
But the foundation is too strong—time built
 that.
Then you try the door but it is soldered—man
 built that.
The roof collapses; pinned.

The last moments are looking into a mirror—
 one that the water put up, to bring more
 light, to bring good things to one another.
It fogs over and clears with an oscillating tint.
The scorching heat doesn't kill.
It's the steam from the living, breathing soul
 time created.
That makes its home within your chest. It is
 a painful wind. It is slow. It is long.
But its soul doesn't die. It haunts. It forgets
 it has passed. It wanders the planet and
 stars searching as time grinds on.
And when it comes crawling back, you
 whisper like a ghost—"I cannot hear. I
 cannot see. I can only remember."
Somewhere in my deepest thoughts, you
 still sit on a fallen tree catching ladybugs
 and forcing the wish that you could live
 forever as they fly home to save their
 burning houses.
In your soft cotton clothes, unknowing that
 you will never exit nirvana. And the tide
 comes in to mute the chaos.

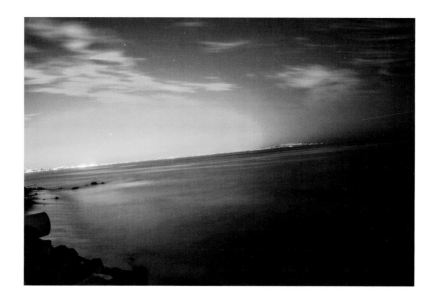

During the California brush fires in 2010, I would drive to
the coast off the PCH to capture the orange glow with long
exposures. Sometimes I could also see Ursa Minor (the Little
Dipper) or Ursa Major (the Big Dipper) and get my shoes wet in
the surf as I waited for my exposure to click at three minutes.
This is the Malibu shoreline during a fire on the coastline.
I pulled off the road to photograph the image as I saw it.

The price of living in paradise . . . sometimes the toll is heavy.

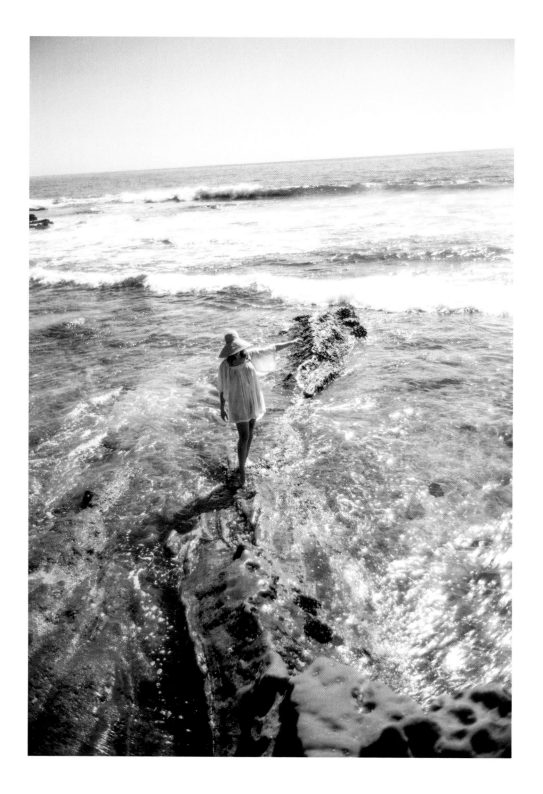

Liz in La Jolla, shot with digital M9 35mm lens from 1969.

Every year my friend Liz takes me to the land of holes, La
Jolla. We collect shells and make magical necklaces that hold
onto wishes—and when they fall off, the wishes come true.
But sometimes by the time they break, the wish isn't wanted
anymore. We dress as gypsies and open our eyes underwater.
Our hats fly off in the warm dry air as we ride our bikes to the
bookstore and then to the Pannikin coffee shop, where we listen
to Tupac on blown-out mobile speakers.

The fish tacos, that afternoon, are made of heaven and
 we wait for low tide to run on the ocean floor.
To dance on the waves,
To remember the earth is not a cold dark place.
Our troubles are soon to pass
And we can live in the moment once more.

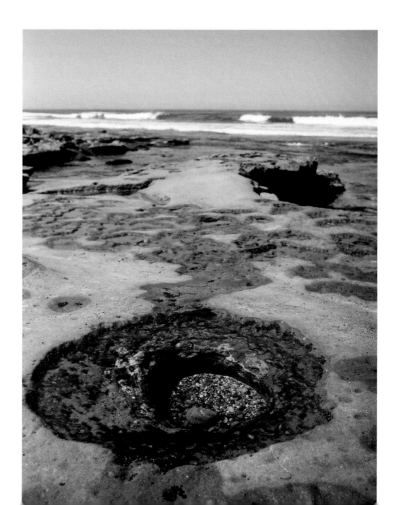

A hole in La Jolla: Each hole is a treasure trove of rocks and shells that look like they belong in a colorful cartoon.

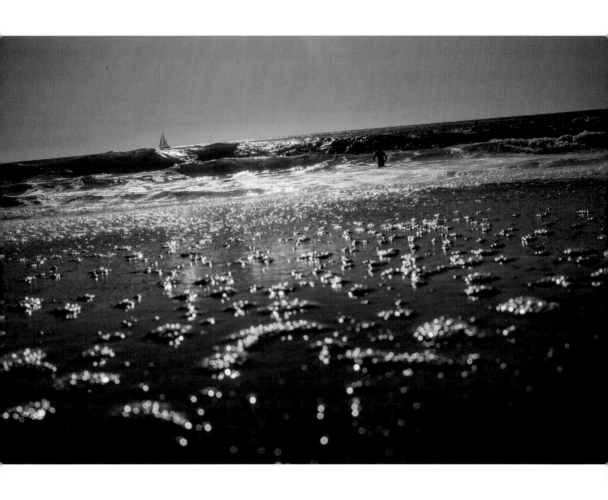

La Jolla surf

La Jolla surf lineup at dusk. The birds graze just inches above the water and sometimes it looks as if some of the surfers have sprouted wings, flying off to find another swell. This illusion is easy to see when your logic falls away from reality and you allow yourself to be tricked by the ocean's very own sleight of hand.

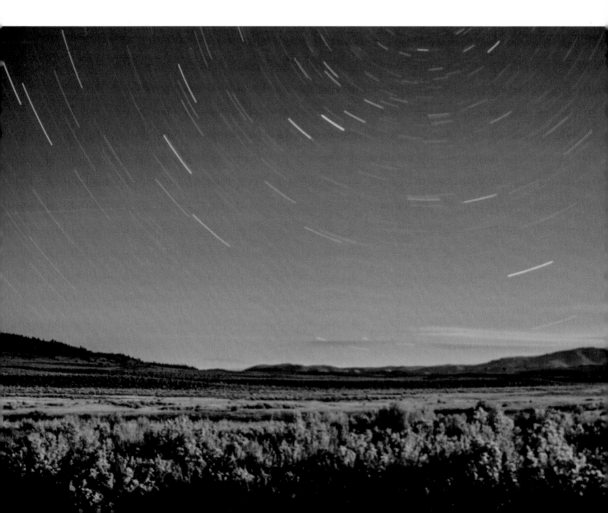

While *free*—
Being ~~trapped~~ by the ghost of
 what **used to be** chains
Will eat you *alive*
but If you allow its hunger
The previous sickness
To beg back in **now**
Sweet and fresh at first
Silently
Strung out and spun
Torn at **the edges**
Soporific grey skies

Blurr**ed** trees **out** the back window
On a winding familiar road
Muted memories **and**
It all comes running back
Flooding a well-written manuscript
Ink blinding the prose
Crashing with an allegory
Never written **down**
Memorized by someone
Somewhere else
And suddenly freedom takes itself
 away once more.

Long exposures made up a lot of nights in my teen years. I would take my camera, batteries, a couple of rolls of film, a shutter release, and tripod and walk in the middle of the forest or the desert. Sitting in silence. Pitch black. But after leaving the shutter open for thirty minutes I would get beautiful visions of images my eyes missed. Light travels so fast but sometimes it's okay to let it move around and shape itself into what it really is. So far away as we are spinning in the tide.

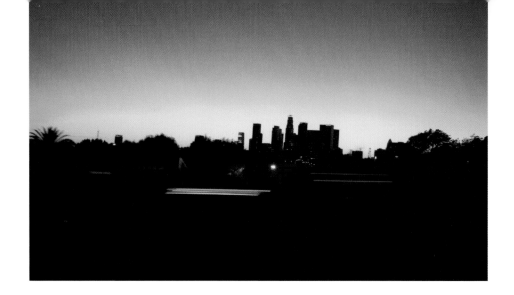

Downtown Los Angeles from the 405

"Los Angeles from the 405" is starting to turn into a series itself.

As a lifelong resident of L.A., I spend way too much time sitting in traffic, while I miss the city's mystic beauty.

Let us in; let us all in.

As Is (Thinking of You)

Here I am, I'm up all night thinking of you
Could you get out of my head?
I've got a lot of stuff to do
When I dream, I dream that you will be right there
When I wake up to find you missing I just stare
Off into space
Thinking of you
I listen to all of our music because I can and I wear the
 lyrics around my heart like a rubber band
When I sing the words I feel like you appear
Sing along with me with the thoughts that tickle your ear
But you're not near
And I'm still here
Thinking of you
If you've got the time
Access your memories
You can see what you want to see
And maybe you'll think of me
That would be the fair thing to do
While I'm thinking about you
I just don't want to let you go
I'm very fond of our love, I think you should know
That when I think, I think that you'll be waiting too
And when I wake up in the morning I'm feeling blue
'Cause you're thinking of me
Thinking of you
Wishing a wish
That can never come true

The sun is rising
On a new horizon
And you keep looking for your own
Way home

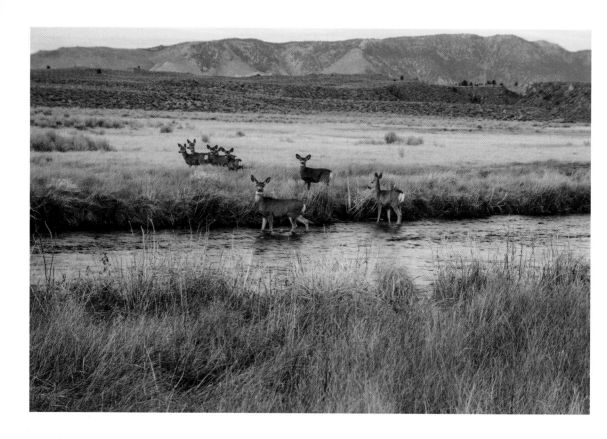

Nature's Beauty

These deer are native to California. They are photographed here in the Owens River near Mammoth Lakes in the Sierra Nevada. My father first took me to this place when I was very young to stream study before handing me my first fly-fishing rod. My mother and I still have our cabin in the Sierra where I took a lot of my early photographs.

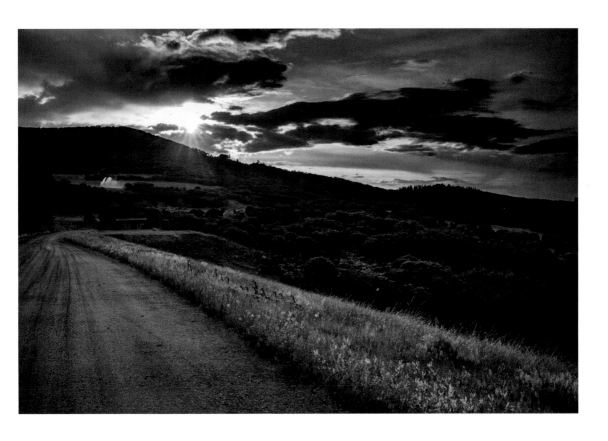

Families of Aspen geese, hidden in the grass, are clearly on the road to a peaceful evening.

This image makes me cry. I know that this hawk would not have a broken wing if it weren't for the road in its natural habitat. As I pulled my motorcycle onto the shoulder to call Animal Rescue, I couldn't help but wonder why the car that hit her didn't stop. Sometimes our human footprint is too big.

The Little Fishing Boy
Pinecrest Lake, 2012 film

Learning about death versus sport as the fundamental difference that crowns the fisherman wasn't relaxing or enjoyable, but as I got older, I found that the joy of fishing resides in the connection to the land, nature, and removing all the troubles of everyday life while finding a Zen moment. Breathing the fresh air, recognizing the sounds of wind galloping over wheat fields, and the silence of your mind as it focuses on the one task: to trick a fish into believing that I am the fly and I am the meal. The sport for me is in the mutual respect with nature, and sometimes even telling exaggerated stories around a campfire about fish we never caught. The enjoyment in sharing the photographic moment.

I remember the first time my father took me fishing, I had this same Pyrrhic victory face.

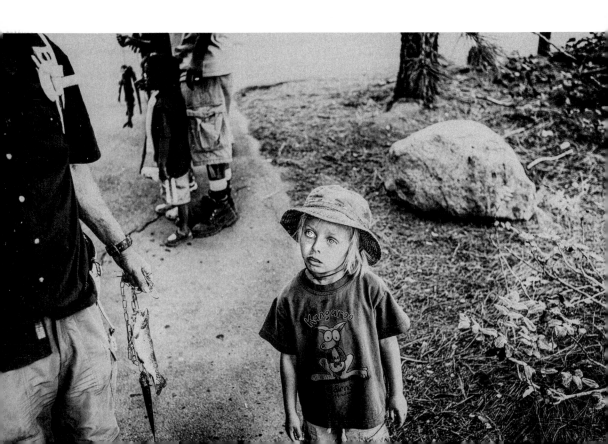

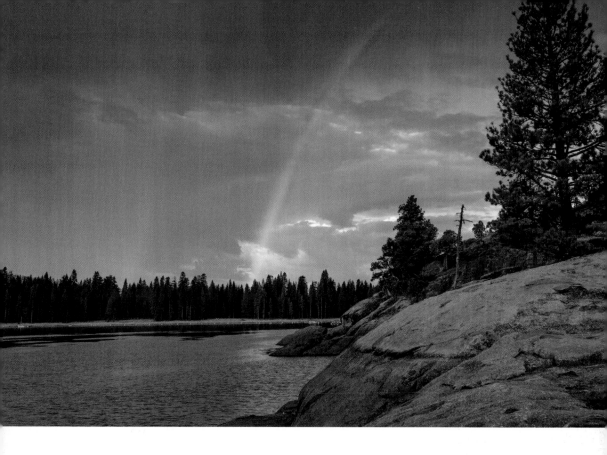

Pinecrest Lake Double Rainbow

There is nothing like waking up early to go fishing after a night camping out in the forest. I was lucky enough to see this rainbow as it happened. I can't help but think that somewhere out there, a man was making a viral YouTube video capturing it. Keith Calkins, a talented musician I know from art school, had taken me to one of his favorite fishing spots in California. But the fish only rise at daybreak (four a.m.). We were very successful in catching fish once the rain stopped. Unfortunately, a squad of raccoons came and stole our yield before we could enjoy breakfast. At least we had a nice view.

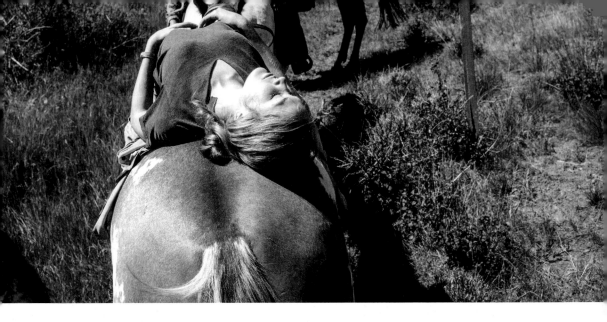

Aspen. A quick horse nap on the way to the summit.

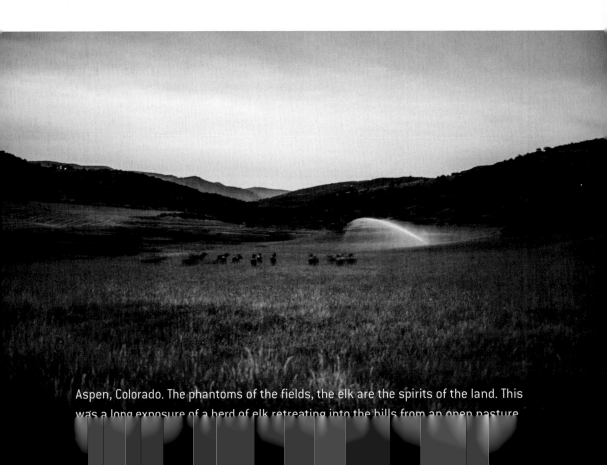

Aspen, Colorado. The phantoms of the fields, the elk are the spirits of the land. This
was a long exposure of a herd of elk retreating into the hills from an open pasture.

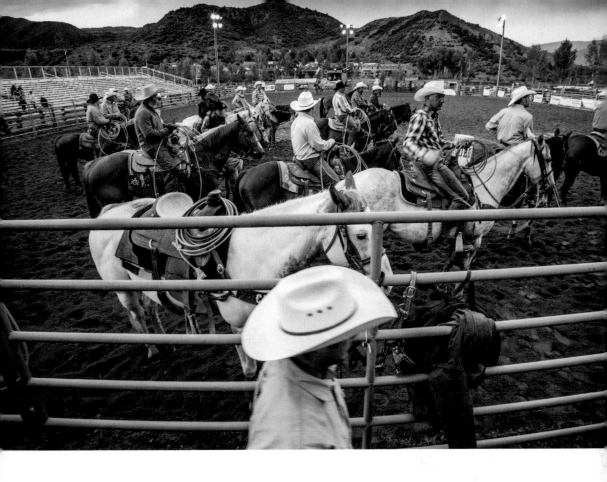

Horses, horseback riding, and fairs are part of our American culture that will seemingly live on long past fashion trends and modern pop culture. If you've never been to a country fair, treat yourself to a real slice of Americana.

AMERICA, F&#K YEAH . . .

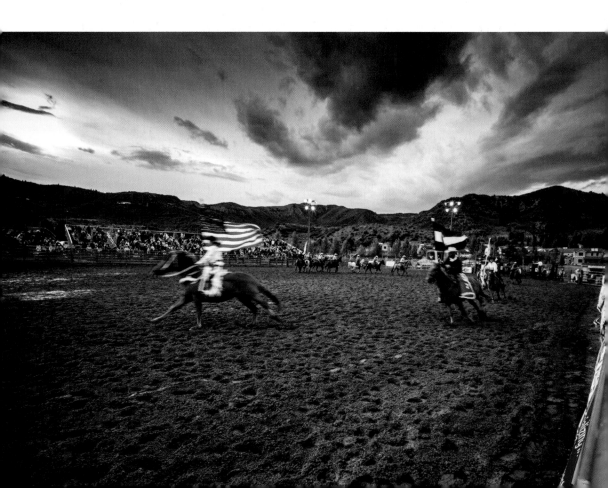

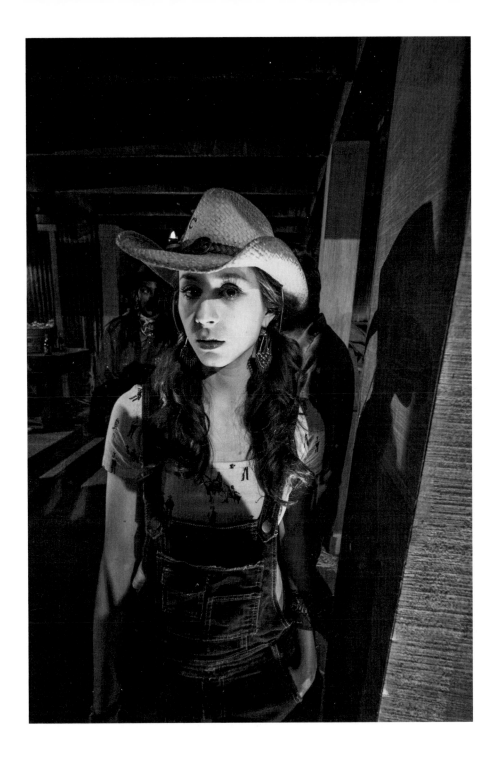

The wild Western Troian.

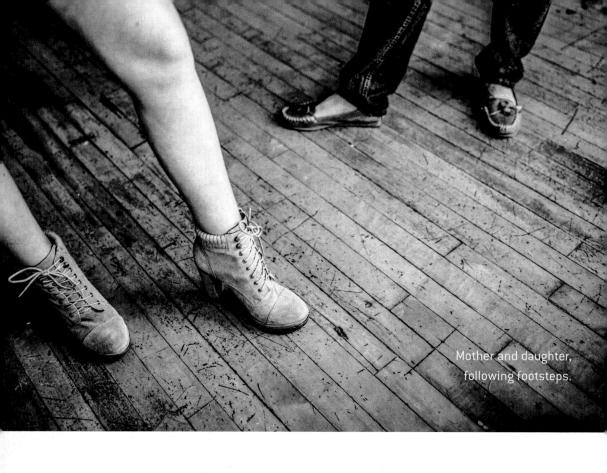

Mother and daughter,
following footsteps.

I'm staring at the
shoes, again.

A trip to the Getty.

Sitting next to a little piece of sun, in a tower above the sunset—a moment when everything was calm in a room that has seen it all. And right in front of me was a great love story. A long way to go.

Roman the dog. His tongue is permanently out of his mouth. A cartoon dog.

Spring break. Picture
of survivalists under
surveillance.

Hovering tourist. This man just jumped out of a fourth-story window; he is about to shatter both kneecaps. Just kidding. Also, tourists fake laugh a lot.

Congestion, 2013

I was at a pet shop the other day. Saw a kid. He cried so hard for a pup. Got one. Then he panicked and couldn't decide which one he wanted. Left without one.

What is it about love that makes us chase it so much? When I capture an image of people like this who seem content, I always wish I could be like them. I wish I could chase love less, and be in it more.

Five-finger fillet. Do not try this at home or ever. No fingers were abused capturing this image. Although, as I think back . . .

I say do both. Then go to a museum and a film. Kill an obsession by finding another one.

FML

We all say "FML" at least once. But someone "brave little toaster'd" that air conditioner. The reference is important. You should watch *The Brave Little Toaster* now.

Ray wants to know where it has been. . . .

Love is in the fair.

What is it about closed areas that makes us want to see more?
Everything is dangerous when it is given the power to be.

Seems like I am not the only one....

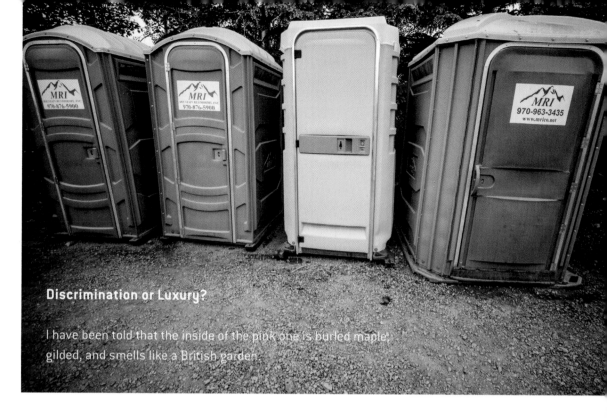

Discrimination or Luxury?

I have been told that the inside of the pink one is burled maple, gilded, and smells like a British garden.

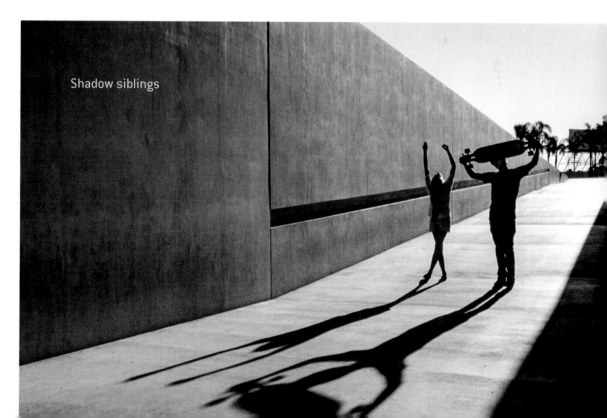

Shadow siblings

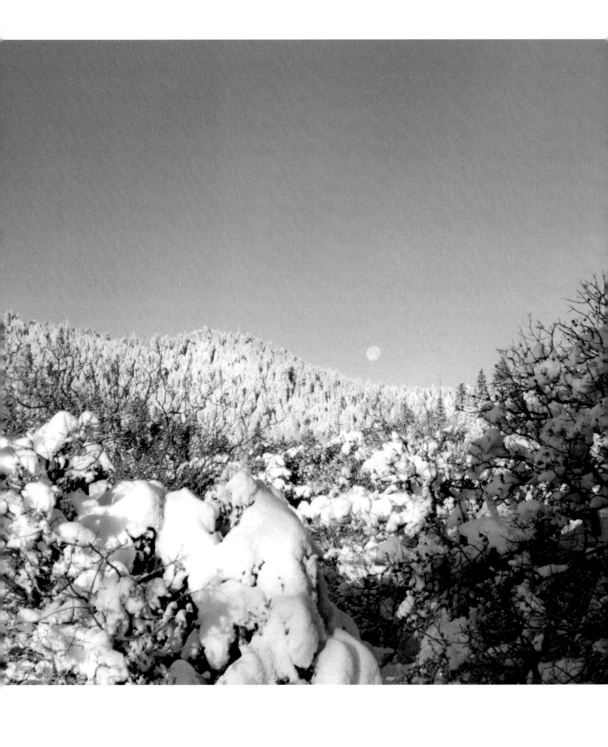

Sierra Caves

Venturing far out into the vast wilderness of the High Sierras, you may stumble upon these secret caves. During the winter, these rocky dens freeze, with long icicle bars over the rifts, imprisoning the cold darkness within. What could be inside? I ponder that it's treasures or bears, even so far as a portal to another world or a fracture in reality. Wait for the ice to thaw, and as the warmth comes back to the subterranean rock shelters it becomes too lush and overgrown with roots and crawling plants that lock it in, feeding off the ice turned to water turned to seedling fuel. Its secrets are fully protected by nature and guarded with an iron fist of radical climate. As the seasons change so does its own sustainable security, and as I walk down the road I toss a rock into a small fissure to hear the reverb of the enigma within. The moon looms low as if to keep one eye open, eternally watching the gates. Sworn in from the sun and stars. And maybe it's just an empty, wet hole that leads to nowhere, and being out here in the world is better. But that would be inconsistent with the heightened safekeeping.

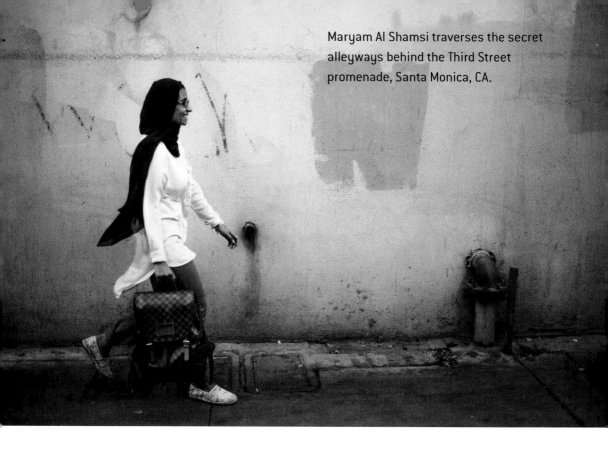

Maryam Al Shamsi traverses the secret alleyways behind the Third Street promenade, Santa Monica, CA.

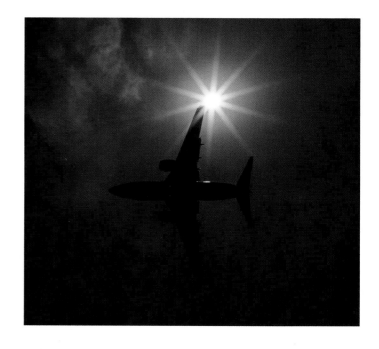

Chain me to the sky
No need for coming down
Been so lost in such a cloud I
Couldn't even find the ground

Well Heeled

In the old days people who had money and could afford good shoes were referred to as the "well heeled."

Architectural overlap and intersection.

Photographic sculpture—my bedroom, Hollywood, 2010.

Tangled up
in your arms
in the morning
before I can remember
Where I am
Where I've been
I get the feeling
As the wind blows toward September . . .

Mountains of the moon, Getty Museum gardens, Los Angeles, 2012.

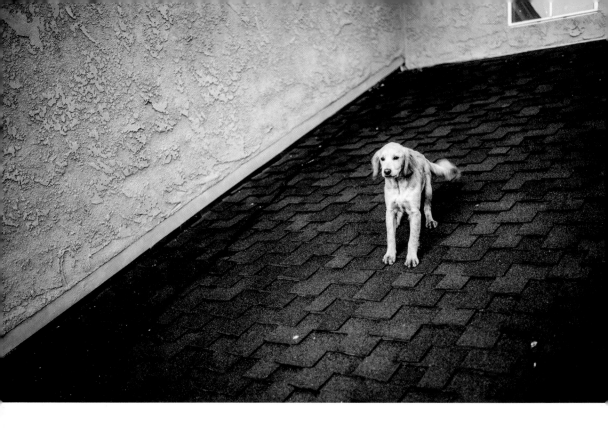

Dog on a Cold Tar Roof

Do you think I can make the pool from here?

Crystal knob light. Eat your heart out, Sam.
My homage to Sam Wagstaff.

Growing After the Burn

Help
I'm going under
Friends seem far away
Just getting it through the day

Wasted
And pulled over
but now it's our turn
to grow after the burn

Stop
We're sundowners
and we miss them
. . . most of the time

Soft cotton skin
and warm summer eyes
Flying above my head

Help
I'm feeling left out
from salesmen selling new
things we used to do

Our hearts can queue up
breaking in the sun
They say that it's done
the ghosts of our friends
floating all around
What do they know
We're not them

Whatever happened to you and

Lost in thoughts of spring
when everything we said
meant everything
Life
like an ocean
we just ride the waves
up above the pain

But I'll burn down the house
and sleep in the bed
I'm back where I know how to be

Whatever happened to you and me

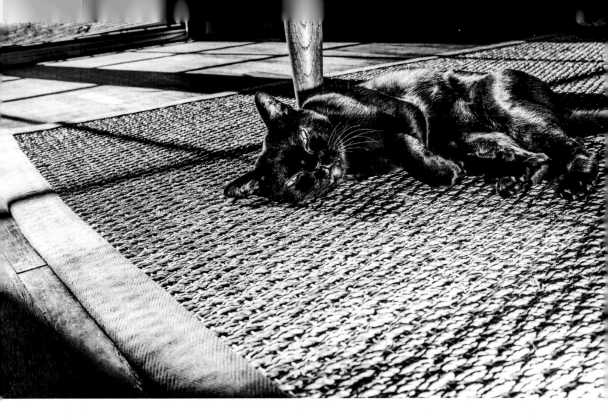

Minnie on chrome.

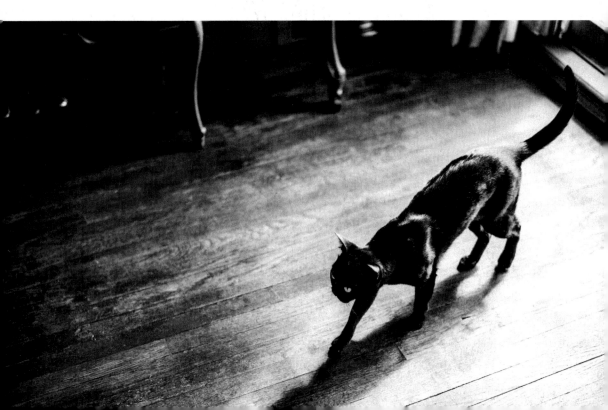

California,
Go outside and search the abyssopelagic lavender skies with roaming heat waves and branches resembling paint-dipped brushes accompanied by the snapping of violet horns under the weight of your souls.

Purple Jacaranda Tree

Just as the East Coast has its sugar magnolias and dogwoods blossoming in the spring . . . California has the jacaranda trees.

A floral accoutrement in the vignette of the sun
As we all acquiesced in the movement out of
the incarnadine springtime.
As we are all holding on to the last weeks of
juvenescence
As we are all walking beneath the crumbling
jacaranda empire
Knowing it will soon fall at our feet
And worship from the ground
As we have

Film develops an image, a feeling,
a memory, and an interpretation.
Life is a moment of memories.

Splashes of purple paint on the
dried-out asphalt
That used to dangle above.
Flowers litter the streets and
thousands of parked cars receive
lilac shadows.
The susurrus of a California day
Under the jacaranda tree

Lotus flower

Brother

Brother, my brother
Where have you been
Out looking for love
While I'm lost in sin
A desert can't keep you
I can't wait to see you
And laugh with you once again

Those hung-up girls that we used to date
The loveliest angels
In cities we hate
And still we're best friends
Through the blood and the tears
Losing our families and us gaining years

What can I say that you don't already know
You've followed me through the valleys
 and mountains of snow
You humble me greatly when my world
 gets too big
And you offer me comfort when words
 start to sting

Your morals and values
They come from the books
And you know what I'm thinking by giving
 a look
And our sides have been busted
Our swords are staying rusted
As we talk of the battles and victories
 we've took

Oh, brother, my brother, where are you now
My dreams are so clouded and I don't
 know how
To laugh hard without you
I'm so lost without you
And I wish you were coming home now

My brother, oh, brother
I look to the sky
To answer my questions like what, when,
 and why
And I'll see you one day
If not now then someday
And then I will play you your song

Santa Scarecrow

I would rather wait a long time
for the right answer than get
the wrong one in a hurry.

Capturing these flowers from my human perspective felt
too predictable. So when I composed this picture, I thought
about the critters on the ground, how they must see the
world around them. I wondered how they would feel about
stargazing late at night or falling in love under the flowers.

If they could fall in love at all,
If they could even comprehend love,
If they look up into the sky and wonder what life means
And other curious thoughts. . . .
Because when I see this photo, I ask myself all over again.

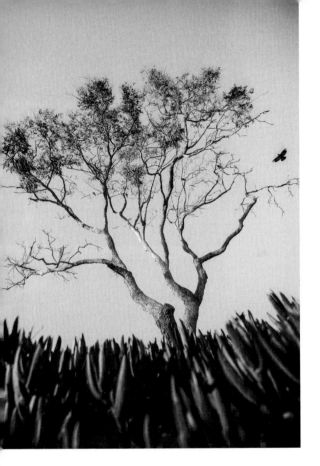

My Tree in Carpinteria

Shot on film, this picture shows my favorite tree in Carpinteria, a seaside town about an hour from Hollywood. I wanted to capture the nostalgic image I return to in my mind whenever I think about summer and romantic California love.

No matter how many times I visit this tree and look up, it feels like no time has passed since I first saw it and noticed the flocks of black-and-white birds that live and congregate on its branches.

I have learned so much sitting under this tree, looking out to the Pacific, pondering the ocean and the lights of the oil rigs off the coast. When I was a teenager, my friends and I would take small boats out to the rigs in the dead of night. The ocean felt so bottomless and dangerous in the dark. It could swallow us up and no one would know.

My summer romances under this tree with her. All bundled up, our high school team sweaters smelling like campfire and the silence of the coast broken by the waves and distant croon of the trains passing through. It was your train. It always was and always will be. And flattened coins still unfound. The tree still standing there, becoming the symbol of another teenage love story.

Stairway Film Reflections

This self-portrait is at Louis Vuitton on Rodeo Drive in Beverly Hills. Self-portraits have always been important to me for one reason: only you truly know how you feel. In this new age of technology, something has been lost with the digital selfie. Shooting a self-portrait on film does not allow for instant gratification but rather is a means of self-reflection at a later time. Photography has always been something that allowed me to connect with others. I was not a very social kid growing up—I kept to myself—but when I took a beautiful photo of someone or something, it gave me the courage to share the picture and open up. Art has always been my means of communication. Light is the emotion. The choice of film is the music, and the focal length and aperture are the story. I bring a camera with me everywhere mostly because I feel naked without one. Not that I feel I will miss something, but because it is part of who I am, a powerful way to share a moment that I've experienced. Life is an accumulation of memories and I take great pleasure in sharing them.

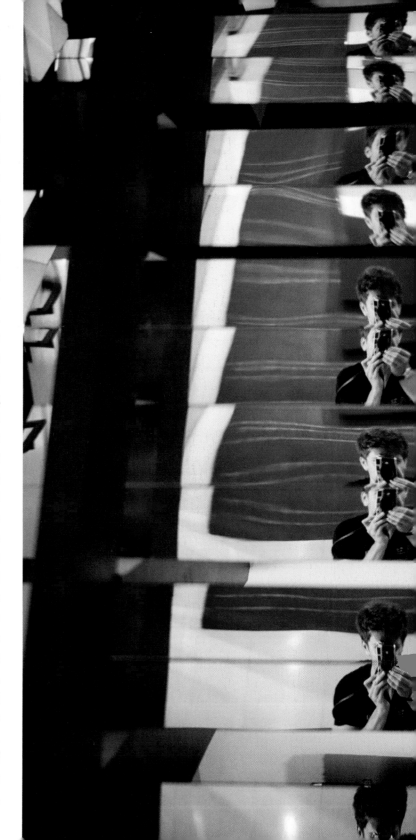

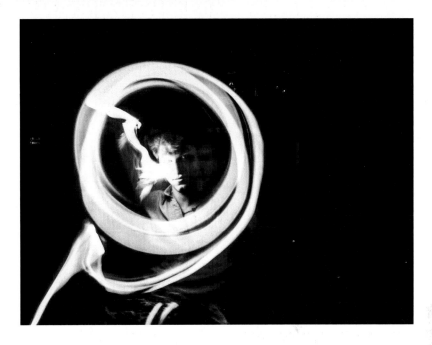

I was seventeen when I took this. Film, long exposure.
A portal into my personality.

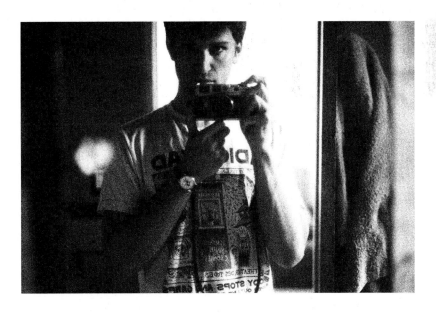

This self-portrait is important to me because of my uncle. The Mickey
Mouse watch is still my watch of choice. My wise uncle, Mike Rose, once
taught me to look at the watch and remember to not take myself too
seriously. He wears the same watch every day.

The first day we got Minin I put
him on my shoulders. To this day
he practically lives overlooking my
every move like a second head.

My mom channeling whatever Patti Smith she has in her.

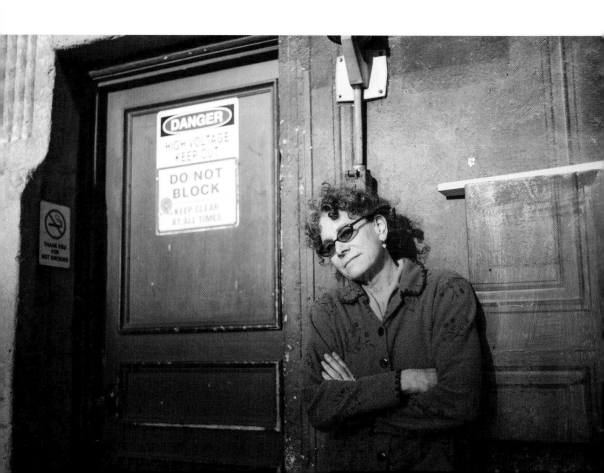

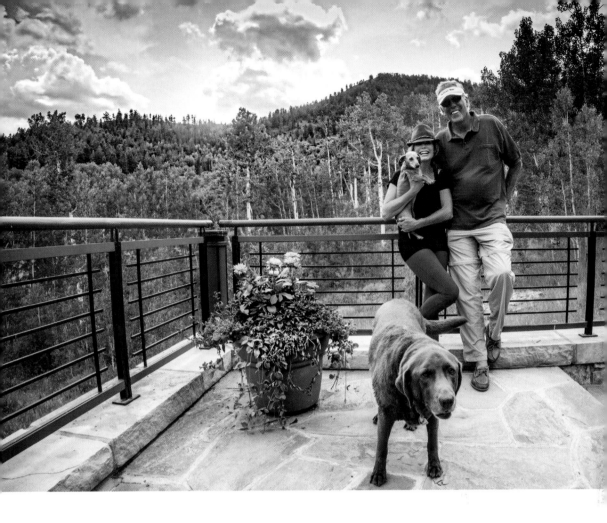

Mike and Debbi

My guardian angels. This is my aunt and uncle, Mike and Debbi, photographed at their home in Aspen, Colorado. Their dogs Coco and Frankie are pictured with them. The two of them have busy, full lives and have stressed to me how important it is to unplug and spend time with family. Their love, compassion, and patience are something I aspire to. We all need more family time.

Without family, without friends
And without love
We are nothing

Tibor, 2009

Tibor has sold me a slew of cameras since I was twelve years old. He is like a grandfather to me and even though he is a fierce salesman, he always tried to convince me to save my money. He would stop me from buying something I didn't need, telling me to figure out another way to accomplish an artistic idea without purchasing a shortcut.

"Money cannot buy you creativity . . . but it can help."

This shot is so out of focus because Tibor was explaining range-finder focusing and urging me to focus the lens on his shirt button. Even more than a decade after I first met him, Tibor always inspires me to think outside the box. He has taught me to avoid getting caught up with the latest gadgets, to stick to my simple tools, and always trust the glass (lens) to be exactly what I need.

Emmy Rossum, Los Angeles, 2012

The day we shot this, Emmy and I were out taking
photographs of the view overlooking Burbank from
Mulholland, and she somehow got chosen over the view.

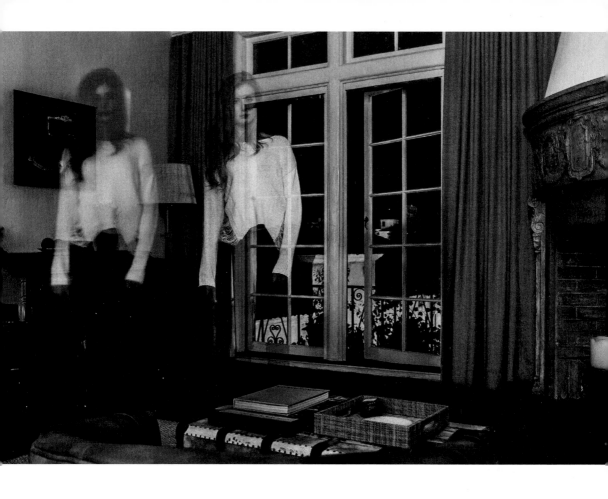

This double exposure is the ghost of my friend Remington in my living room, Hollywood, 2012.

Self-Portrait, "Camera Geek in a Circle," 2010

We are all mystified by our own image.

It's OK

"It's okay to dream"
Is what they tell me
When I'm not asleep
"You'll fly back one day
To talk about the things
That are happening today"
But I'm tired of moving on
In a sad song
With this stone parade
I'm a fastened butterfly on string
On your pin
And I can't get far away
I can't fly far away

I wish I could be you
And leave
But I've known you since
I can't remember when
I can't remember sleep
We speak in lullabies
Like, "It's okay to think about death
As long as we don't die"
And if missing out's a crime
Then I'll stay on your wall
Because I'm guilty all the time

Take me as I am
I'll be exactly who you wanted me to be
Pull me off your shelf
Tell me all your secrets that will haunt me
When you're not around
Anymore

So I'll lock my heart away
And with it goes my mind
But that all can be okay
As I drift onto your lies
Like if you let us go our cement wings could fly
High
And I'll do just what you say
And I'll sit and hang around for this all to be okay
Because in the darkest place
I can still feel the light
From every other day

We can still see your face
And it's okay
In this dark display
It's okay
"Nice knowing you" is all that we say

Self-portrait, blue filter.

Beauty, sleep in the garden.

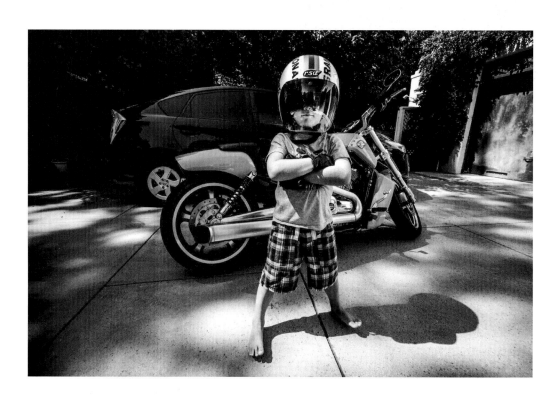

This is my friend Liz's nephew Teddy. He seemed to like my helmet and Harley Davidson.

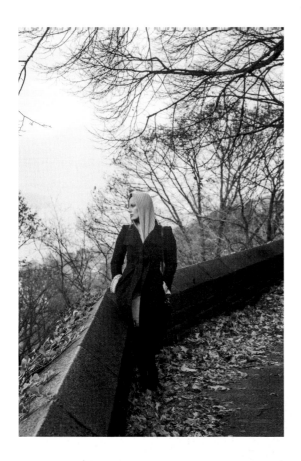

Liz at the Cloisters.

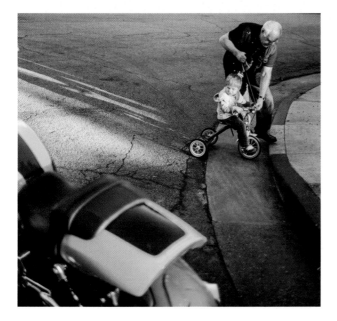

One Day

One day
just like you.
Supportive friends and
shopping lists.
Paychecks that
pay the rent—
that feed you.
Something to say
worth listening to.
Won't be too insecure.
Won't kiss without asking.
Won't have to change the subject
to get a thought out of your head.

Won't have to lie for your parents.
Will feel a vacation.
Will appreciate what you have had.
Might like it.
Might love it.
Might hate it.
Sometimes you will make love.
Sometimes you will fuck.
Sometimes do both or neither
 because you're just enough.
Break their heart.
Break your own.
Hold hands without breathing.
Cry hard at a funeral.
Lose someone close.
(Death is more approachable when loved
 ones experience it first)
Lock yourself in the bathroom.
Have a good laugh about it.
Make kids or make friends.
Keep in touch.
Lose touch with who you are.
Find nothing
Smile more.
Explain less
One day just like you.

The characters one
may encounter at flea
markets have a personal
responsibility to always
be cool. Always.

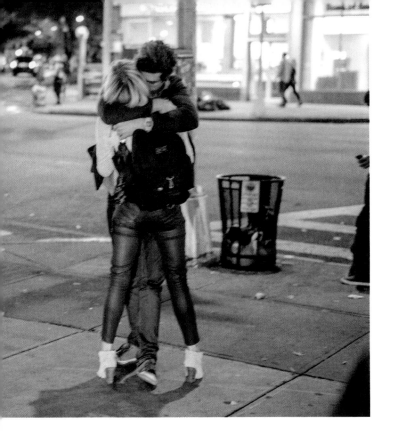

An embrace that was so strong tears were shed, and it wasn't even closing time.

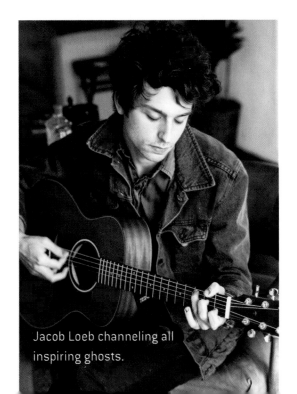

Jacob Loeb channeling all inspiring ghosts.

1960 haunted guitar.

Self-portrait playing with shapes and forms.

Cyclops

Season three self-portrait. I feel already that my perspective and who I am
has changed so much from when I took this photo.

Self-Portrait, "Writing"

Fade Away

You want a shiny car
So we drive it fast and drive it far
I want an empty house
So we can hide inside like a mouse
Just look at me, pretty girl, and stare at me
Baby, you're my world
I want to live right now
I don't want to die and fade away
Don't want to end up that way

We want an empty mind so we can fit all the
 new things that we find
And I want a loyal friend to stick with me
 until the very end
And we want our parents back to tell us that
 they've got our back
I want to live right now
I don't want to die and fade away

Who knew know now
The writing on the wall
So soon no know
That love was not your fault

I don't want to write another love song if I've
 got no one to sing along
And if you decide to break my heart, make
 sure you're not inside when it falls apart

We can stay and live right now
We can stay and just pretend

Why would we even fall in love
If we know how it is going to end
How it always ends

I want to live right now
I don't want to die and fade away
I wish we could turn back time
I wouldn't change one single thing

Holding you all through the night
You're the first thing that I see
You're rushing through your dreams 'cause
 you wanted to wake up next to me
When life has almost passed us by and there
 is not much left to achieve
Don't let it slow your pace
Because what they told you was only what
 they could believe

The world is so confusing
Nothing is ever as it seems
But those who have done us wrong
Well, they can love us
Inside their dreams

But I want to live right now, I don't want to die
Fadeaway
I wish we could turn back time
And redo every perfect day

Reeve Carney, New York City, 2012

Reeve writes his music and then performed *Spider-Man* on Broadway. He is currently on Showtime's *Penny Dreadful*.

I love this shot of James coming into a packed room to meet his fans at a signing for his nationwide *Actors Anonymous* book tour. Many hundreds of people waited in line to buy his book and get his autograph following the reading.

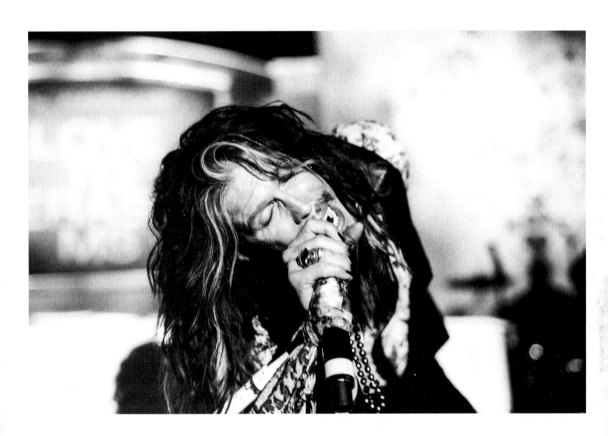

Steven Tyler, Race to Erase MS charity benefit, May 2, 2014. Steven poured his heart into this performance and truly captured the spirit of giving and helping others. . . . Impressive.

Outside of Shia's art room.

Inside.

Shia LaBeouf in his performance-art demo in Hollywood, February 2014.

After hearing about his display against fame on the red carpet I was eager to see his #IAMSORRY installation. I waited in line for a couple of hours and then was led into a room filled with trinkets varying from a whip, a *Transformers* toy, a bowl of tweets printed on paper, a bowl of Hershey's Kisses, a comic book, a bottle of whiskey, a pair of pliers, cologne, and a vase of white flowers. I decided to go with the flowers as I feel it is a gesture in the theater world to bring flowers on opening night of a performance. I walked into another room with Shia sitting at a wooden table, his head covered with a bag that said "I Am Not Famous Anymore" and eyeholes gazing out with tears dampening the paper. I asked him to remove the bag and he did. I sat across from him for a while, taking in the void within the room. It was a completely eerie feeling coming from the rather positive attitudes that lingered outside in the line. I told him I thought he should not have been removed from *Orphans*, the Broadway show with Alec Baldwin, and that he is very talented and creative to come up with this. He laughed a bit and then went right back into tears like a true pro. It takes a lot of stamina to keep those emotions rolling for hours like that. I have a new reverence for him as an artist after that show. He brought me to tears myself as I took the situation out of context and viewed him as an individual in pain. All eyes on him and battling whatever he is battling or just doing this to do it, he still put on an entertaining show by doing nothing except allowing a personal connection with strangers. Hats off. I asked if I could take this photo. He nodded, and I snapped, thanked him, and left. Interesting how the human condition is noticeable on every level when you are put into a room alone with someone and they put all their trust in you to act appropriately.

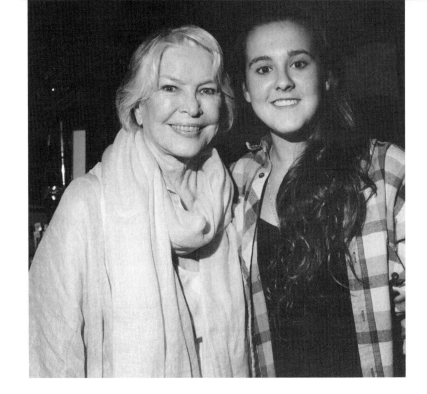

Ellen Burstyn brought a family member to visit the set of *Pretty Little Liars* the night before she won an Emmy for performance in a miniseries.

Panel of Experts

At a screening of John Waters's *Cry-Baby*, Johnny Depp and Ricki Lake express their feelings about shooting the cult classic as a tribute to Johnny Ramone at Hollywood Forever Cemetery. Johnny Depp talked with me after about his career choices and following his heart.

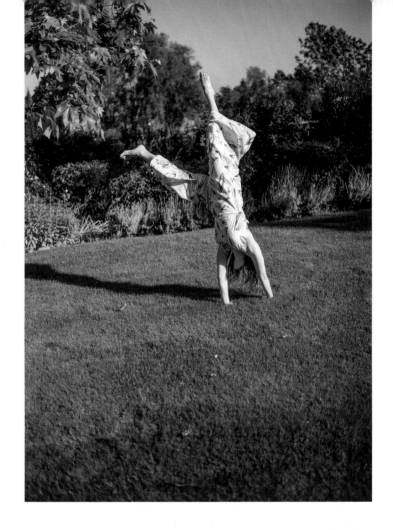

Cartwheels. I love photographing Liz. She is a collector of vintage clothing but loves current fashion too. Her spirit seems to always come through in the images.

It feels like she is from another time.

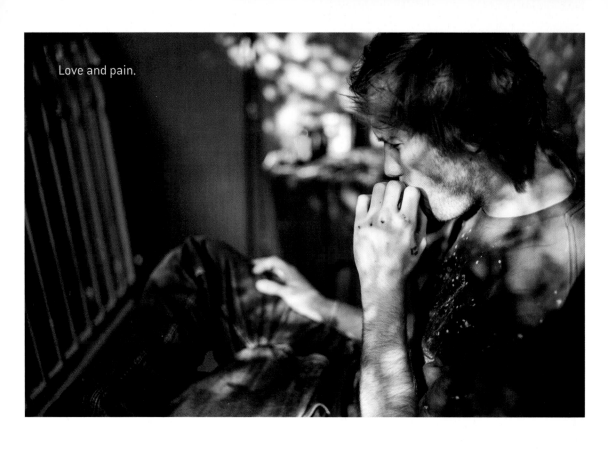

Love and pain.

Janel doing Jackie O.

Julian Morris. Hopefully that's not an apple for the teacher.

All of you know Jay. But most of you don't know one of my closest friends, Keith. Jay obviously thought he was cool too.

Diamond Eye

Working and even just rubbing shoulders with other talented artists often feels like such a remarkable privilege. Singer Neil Diamond came and sang directly to our table. The spotlight caught his eyes for a split second as he sang the crowd favorite, "Sweet Caroline."

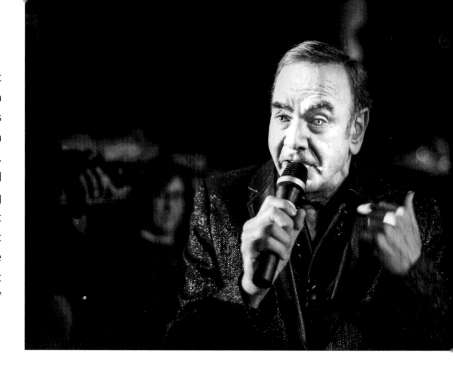

This is Ed Templeton and Deanna Templeton— high school sweethearts and artists who I truly admire. This image was taken at Paris Photo, Los Angeles, 2013

Self-portrait, fishing in color. I'm clearly my father's son. He taught me to love the Sierra, fly-fishing, and to capture it with my lens.

Self-portrait of insomnia.

I can't sleep.
She's there to hold my weight with her
Sweet kissing.
She looks just like my sister
But she feels like the lover and I'm missing
How she keeps waiting in my hallway,
Except
She never comes to my side of town.

I can hear her through my door.
Her breath is louder but still like a wax cymbal, poor and
Screaming itself silent, soft and nimble
On the radio's last station.

When she kisses other people they must feel this way
 too.
All coated with an ice that slowly grips the bones with
 a vice
Deep in a chest
Buried in blue.
Around the heart. Around their heart. Around her heart.
Strong and won't let go. Rigor mortis is a final art.
A final sculpture of how it looks to let go of this life,
To let go of your part.

She danced with a flower dress in a garden of dead
 sheep
 She had slaughtered in my sleep
And when I woke up with a jolt
A secret I keep to hold her as she cries and lies that she
 only wished them well and let them go.

To close my eyes.
It's only when we laugh that we forget all those sharp
 thorns
That pressed into our fingertips

As we checked the pulse of roses
And stained our sun-bleached jeans
On the stories that our mothers told and
Fathers scold us.

When we are numb to what's next. Unnerved by the
 empty stage.
She can eat my tears
So they don't fall
 On my cheeks.
Hers taste like sugar. Must be something in the air.
Must be something to compare.

The salt in our breath
Appears in front of us
Like a ghostly smile, cold for a while before the heat
Makes it disappear.

Old friends just met
And how quick they forget
All the times they drew blood
And stayed up all night
And tracked in the mud
But the music helps.
To wake up the mind.
But now I can't sleep, love,
Because I'm up
With crazy glue
Patching rocks
On mountains we climb.

Wasting our time
Spending our time
But when you can die whenever you want
 It all works out just fine.

Chuck Grant
Beauty captured.

In each of our lives
we experience
a moment
of total
surrender . . . if we're lucky.

Ghost of Myself

Self-portrait at the water tower in Malibu Creek State Park.
The sound spirals in there like a ball bearing.

Self-portrait on 120 film. I actually think
my hair looks like a wig in this picture.

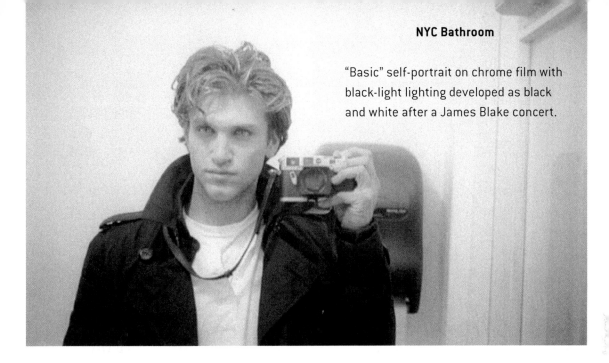

NYC Bathroom

"Basic" self-portrait on chrome film with black-light lighting developed as black and white after a James Blake concert.

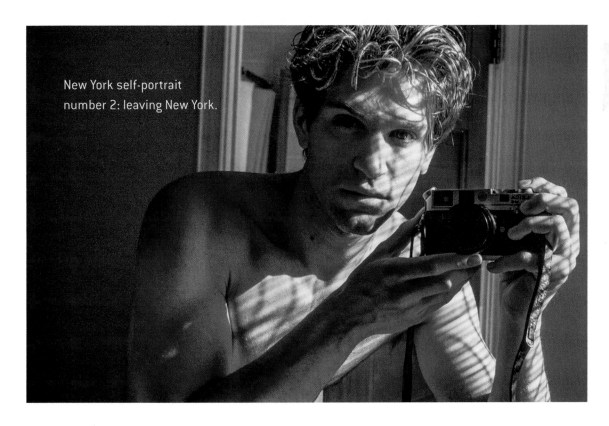

New York self-portrait number 2: leaving New York.

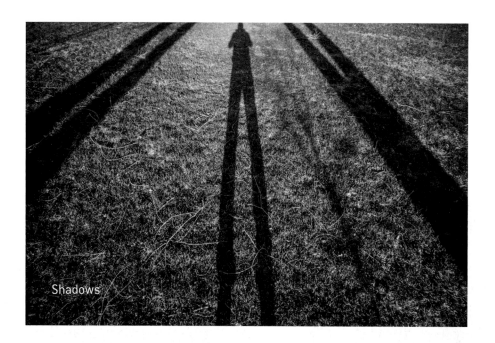

Shadows

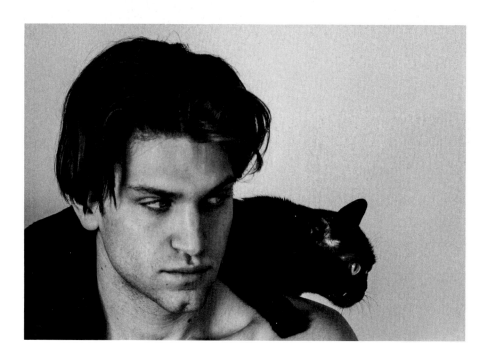

Self-portrait with Minin, my cat. I change his name so much.
Currently his name is Daniel; my mother hates it.

Rooftop Series

I had just seen a play about Mark Rothko called *Red*, starring
Alfred Molina. It ignited a fire in me to create something,
anything, so naturally I headed for the roof.

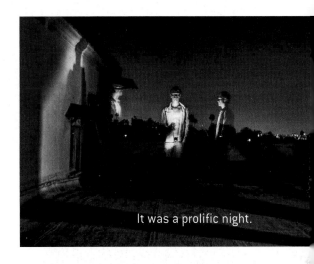

It was a prolific night.

Sometimes the right shot is elusive.

Just the vapors of creativity are left.

Go forth and create.

Homage to Robert Mapplethorpe

Getting ready for this shot, I was so anxious because Robert is someone I have admired for so long. As an artist, he truly followed his own path and broke many barriers. I still dream of playing Mapplethorpe someday as an actor, to celebrate his life.

Self-Portrait of Contemplation

Film (above) vs. digital (below)

I find myself always struggling to decide between the romantic chemical development of analog photography and the instant, algorithmic expression of digital.

Alas, shooting and processing film is a time-consuming/ expensive hobby, but the results are noticeably timeless and un-pixelated.

Long Live Film.

Highland Boulevard

For some reason this shot always puts me in touch with the wonder of the streets of Hollywood and how eager I was to learn more and more about acting, how I dreamed that someday I would be able to put that training to good use. I was so hungry for a different life.

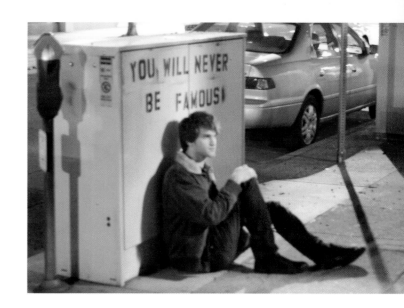

MY FASCINATION HAS ALWAYS BEEN KEEPING IMAGES.

FROM A VERY YOUNG AGE, I FELT STRONGLY ABOUT MOMENTS.

TO CHERISH THESE MOMENTS TO THE FULLEST WHILE I LIVE
THROUGH MY LIFE STORY AND EXPERIENCE ALL OF its BEAUTY.

TO ALLOW LOVE
TO CONSTANTLY AND
RELENTLESSLY
DRIVE MY AMBITION
TO CREATE.

MY OBSESSION TO PHOTOGRAPH AS MUCH AS I CAN.

STEMS FROM A KNOWN FACT THAT EVERYTHING CHANGES.

WHAT IS AROUND TODAY MAY NOT
 BE
 TOMORROW.

SOMETIMES, ALL YOU CAN TAKE ARE MEMORIES.

BUT IF YOU'RE LUCKY ENOUGH TO CAPTURE THE MOMENT,
YOU CAN FEEL THE MEMORY AGAIN THROUGH THE PHOTO.

It LIVES FOREVER
IMMORTALLY FIXED.

PHOTOGRAPHY IS ONE OF THE MOST IMPORTANT
MEANS OF HUMAN COMMUNICATION AND THIS WAS
MY JOURNEY THROUGH

life. love. beauty

THANK YOU FOR VISITING MY MIND, MY HEART, MY WORLD.